new lace KNITTING

DESIGNS FOR WIDE OPEN SPACES

ROSEMARY (ROMI) HILL

INTERWEAVE
interweave.com

editor Ann Budd

technical editor Lori Gayle

associate art director Charlene Tiedemann

cover and interior design Kerry Jackson

photographer Joe Hancock

stylist Allie Liebgott

hair and makeup Kathy MacKay

Interweave
A division of F+W Media, Inc.
4868 Innovation Drive
Fort Collins, CO 80525
interweave.com

Manufactured in China by RR Donnelley Shenzhen

Library of Congress Cataloging-in-Publication Data

Hill, Romi.
 New lace knitting : designs for wide open spaces /
Romi Hill.
 pages cm
 Includes index.
 ISBN 978-1-62033-753-0 (pbk.)
 ISBN 978-1-62033-754-7 (PDF)
 1. Knitted lace--Patterns. 2. Scarves. 3. Shawls.
I. Title.
 TT805.K54H55 2015
 746.2'26041--dc23
 2014049754

10 9 8 7 6 5 4 3 2 1

3361405643705S

acknowledgements

Many thanks to the amazing team at Interweave. A special thanks goes to Lisa Shroyer, who nudged me at exactly the right time and—even though she probably doesn't know it—ultimately was the catalyst for my finally embarking on this project. Many thanks to Allison Korleski and Kerry Bogart, two amazing women whose support throughout this process meant the world to me. And words of praise seem pale in comparison to the incredible editing team that is Ann Budd and Lori Gayle. I am so fortunate to have worked with you. Super extra giant loads of thank yous to my wonderful test and sample knitting friends, Teresa Baleja and Jeane Mulreany. This book could never have happened without you.

Particular thanks to Roxanne at Zen Yarn Garden and Melissa at Sweet Fiber, who provided last-minute emergency yarn support with the utmost graciousness. I was incredibly lucky also to receive yarn support from All for Love of Yarn, Anzula, Artyarns, Baah! Yarn, Brooklyn Tweed Yarns, The Fibre Company, Filatura di Crosa, Kolláge, Madelinetosh, Quince & Co., Rowan, Royale Hare, Shibui, Sincere Sheep, Swans Island, SweetGeorgia, and Windy Valley Musk Ox. I am so grateful to all the yarn companies that so generously sent their lovely yarns for this book. You helped make the vision in my mind's eye real.

Much love and gratitude to my family, who suffered patiently throughout the entire book process and supported me without question, even though I missed so much of their year.

And to all of you out there who have knitted my patterns and supported me so kindly: thank you for believing in me, for being patient with me while I worked on this project, and for being all-around wonderful.

Knit on!
—ROMI

CONTENTS

introduction
A LOVE *of* LACE KNITTING

For as long as I can remember, I've been fascinated by patterns, both human-made and natural. My mother told me that, as a child, I would trace the grain in wood and the patterns in my grandmother's crochet, and talk to them as if they were old friends. And I know that my early years with my grandmother—watching her tiny hook move dexterously to create lacy stitches in fine cotton thread—were what ultimately led to my fascination with first, knitting, then lace knitting. Although I learned to crochet years before I learned to knit (after begging my mother incessantly for lessons), my deepest love was always the neat and tidy knitted stitches arranged perfectly, one on top of the other—so very orderly.

Fast forward to later in life. After college and a job, after I met my husband and had a child, I began knitting again. And then...I found the Internet knitting community. What riches! Colors, patterns, traditions, techniques! I devoured it all ravenously, a basically self-taught and starving knitter turned loose in a candy shop of new ideas and yarns. And I began knitting lace. To this day, I have never gotten over my love affair with lace; the geometric patterns of positive and negative space entrance me. I hope my grandmother would look at me today, smile her knowing little smile, and approve.

For years, this book has been a tiny pinpoint of an idea niggling in the back of my mind. As I became more familiar with lace knitting, I became more and more fascinated with the way lace patterns were constructed. I loved how the placement of increases and decreases could alter a pattern, perhaps making it wave, and how changes in the types of decreases could transform the look of a pattern so completely. I knitted and knitted. First, I used other people's designs; then, I began to design my own pieces incorporating lace. And now, here we are.

This book is a collection of themes and variations. The lace patterns are traditional; not new by any means. But I have used them to put together a collection of lace garments and accessories that can be worn today, and any day. With different weights and types of yarn, varied placement and amounts of lace patterning, and differing constructions, this collection will, I hope, kindle my love of lace in you as well.

BEFORE YOU BEGIN

I have a simple overall philosophy for lace knitting, and, in fact, for *all* knitting: "Enjoy yourself."

Of course, that doesn't mean the same to everyone. I'm an "If you're going to do it, do it right" kinda gal. Yes, I'm a perfectionist.

I want all of my stitches to be lovely and even; I rip and reknit all the time. I use certain increase and decrease schemes in my designs only after trying numerous ones to choose the best. Even before I began designing my own knitwear, I had never ever knitted a pattern that I didn't change in some way. And because I need to know how a pattern will look and could look with a variation, I swatch. I also wash and block my swatches. If they're lace swatches, I pin them out. I let them sit around and spring back to their resting state. Then I measure them. I may even obsess over them a little.

But I know that everyone knits a little differently, and everyone knits for different reasons. Different things bring different people pleasure. And yes—I am using the word "different" a whole heck of a lot. Because I know that all knitters make their own choices, the following section is designed to help you make informed decisions about what you want to pay attention to and what you don't. You need to know what you're *not* interested in doing. If you've knitted lace before, this section may repeat what you already know, but I think it's worth reading all the same.

When I began teaching knitters about lace knitting, I created a sheet called "Romi's Golden Rules." Here's the expanded and annotated version.

RULE 1: ALWAYS SWATCH AND DRESS (WASH AND PIN OUT) YOUR SWATCH

This is the first rule because it's imperative that you swatch, then wash and block the swatch, especially for lace garments that need to fit in a particular way. Blocking can change lace gauge so drastically that the 2" (5 cm) square you knitted can turn into a 6" (15 cm) square. If you're knitting a shawl, the exact gauge isn't as important, and the shawl may still be wearable. But if it's a sweater, instead of fitting your own frame, it may be a better fit for the neighbor's horse. The more open space that's in a pattern, the more the needle size, yarn weight, and fiber composition will affect the finished and blocked project.

There's another reason, too, to dress your swatch—lace looks terrible before it's blocked. For all its final beauty, there's nothing more bedraggled than an unblocked piece of lace. And some fibers (such as baby alpaca) look

even worse than others. If you have a lovely blocked swatch to look at while knitting, you'll believe that the magic of blocking will happen for you, even though it's almost unimaginable before it happens.

RULE 2: INVEST IN GOOD MATERIALS

Use **yarn** that you absolutely love to knit and a pattern you're gaga over. Every skein of yarn used for the projects in this book was a sensual pleasure—to see and to touch. If I didn't enjoy the yarn or the color, I didn't use it. In fact, I was crushed to have to ask for help in knitting the samples in this book because I wanted to fondle every little bit of every skein.

The **needles** you use to knit lace are also extremely important. They should always feel comfortable in your hands. If they're uncomfortable, you may tense up and change your gauge, and you certainly won't enjoy the process. Most knitters prefer pointy tips for lace knitting, but it's a personal choice.

You'll need **T-pins** (hundreds of them) for blocking. Invest in high-quality stainless-steel T-pins that are uniformly smooth (without burrs). Cheap pins may snag or leave marks on your lovely lace and may react with any natural dyes in your yarn.

Blocking wires—both straight and flexible—are huge time-savers, and they allow more accurate blocking. When you block a large lace piece, you'll need to move and stretch the fabric a fair amount. Blocking wires will keep you from having to pin and unpin over and over again.

A good system of **blocking squares** will help you pin your piece "to square." Otherwise, the amazingly stretchy and malleable lace fabric may end up rather lopsided.

If you can manage it, purchase a **blocking horse** (also called a woolly board), a wooden frame that forms a "torso" used to block traditional Fair Isle sweaters. I used it for the Salt Grass Pullover (shown on page 94) for absolutely perfect results. I wouldn't part with mine.

RULE 3: CAST ON AND BIND OFF MORE LOOSELY THAN YOU THINK YOU SHOULD

Lace fabric is incredibly stretchy, so you need to cast on and bind off more loosely than for other fabrics. If you don't believe me, knit a swatch. You almost cannot cast on too loosely (though I've seen it done). My lace designs always use a knitted-on edging or a special stretchy bind-off to provide a flexible finish that won't pull in when the lace is blocked. If you decide to use the standard method of binding off, be sure to do it very loosely. In any case, if you follow the pattern instructions in this book, you should be fine.

RULE 4: KNIT LOOSELY

Yarnovers and fine yarns can make tight knitters agonize as they try to move the stitches along their needles. If you're a tight knitter, try to loosen up a bit. I had to do it; it makes a huge difference in enjoyment and speed.

RULE 5: USE SOME MEANS TO KEEP TRACK OF REPEATS (IT'S NOT CHEATING)

I usually place a marker between pattern repeats to make it easier to catch mistakes. But keep in mind that the stitches on a chart represent what the row looks like *after* it has been knitted. That's why a double decrease at the edge of a pattern repeat box on a chart may involve stitch(es) from the previous or following repeat. The pattern repeats on charts don't indicate marker placements unless specified—they're only a device for making the chart a manageable size.

(My favorite marker is a plastic drinking straw that's been cut into small pieces. The straws are lightweight, thin, and inexpensive. Perfect!)

RULE 6: LEARN TO READ A CHART

If you can read a lace chart, you'll be able to envision the look of the finished piece. Some lace patterns—including those in this book—are only presented in chart form. It's easy to compare your knitting to a chart to find (and fix) places where you've made a mistake.

RULE 7: LEARN TO READ YOUR KNITTING

Like being able to compare your knitting to a chart, being able to follow the lines of stitches in your knitting can often let you know if you've made a mistake. If you know how the various stitches are supposed to look, you can recognize when something is off.

RULE 8: IF YOU'RE FRUSTRATED, YOUR LACE NEEDS A TIME OUT

This rule is *always* applicable. Knitting is supposed to be enjoyable, rewarding, and even relaxing. If it isn't, just put it aside. It will be there later. There's no reason to frustrate yourself.

RULE 9: IT WILL BLOCK OUT

Imperfections in stitch size, shape, and overall evenness will miraculously disappear when the blocking magic happens. For example, if you forget a yarnover and add it on the following row by picking up the bar between stitches, or if you add one too many yarnovers and drop one on the following row, it's unlikely that anyone will know after your piece is blocked. With pins, you can create scalloped edgings, smooth out shawl and garment shaping, and change width and length, throughout the blocking process. On the other hand, you can block imperfections into a piece of lace, as well. If something doesn't look quite right after blocking, the first thing you should try is blocking again. Lace is an incredibly flexible fabric.

RULE 10: WEAVE IN THE LOOSE ENDS AFTER BLOCKING

Do you remember that the cast-on and bind-off needed to be loose? Make sure the yarn ends are also loose by waiting until after you block the piece to weave and sew them in. They will settle into their final position after blocking, which can make a huge difference!

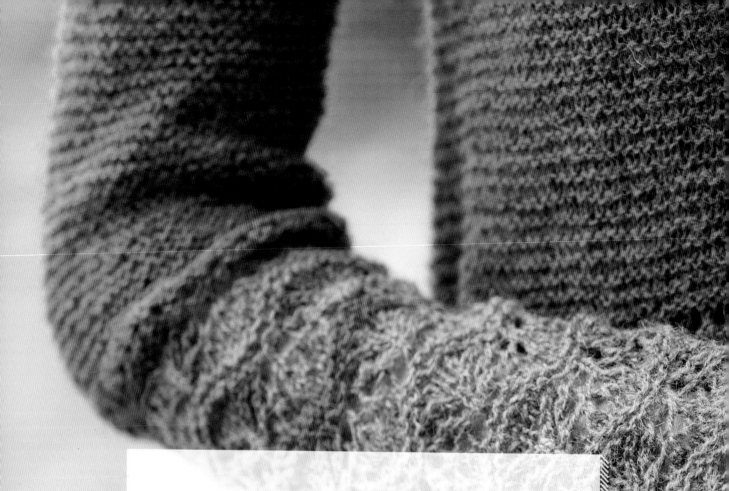

WAVES *and* RIPPLES

KNOWN BY MANY NAMES—Feather and Fan and Old Shale among them—this simple ripple or wave pattern is found in countless variations across many countries' knitting traditions. Created by merely grouping the increases together, then grouping the decreases, rather than by pairing them next to each other in a row of lace, this stitch pattern is a perfect introduction to lace knitting. The lovely ripples are so much greater than the sum of their parts—simple increases and decreases. The Talus Cardigan, on page 10, uses a single red stripe to enhance the wave created by a stitch variant. Neoma's Shawl, on page 24, makes use of two colors—in tiers—to create a different look. A variation on the pattern is just as beautiful when worked in a single color, as in the Gentle Sky Cowl on page 20.

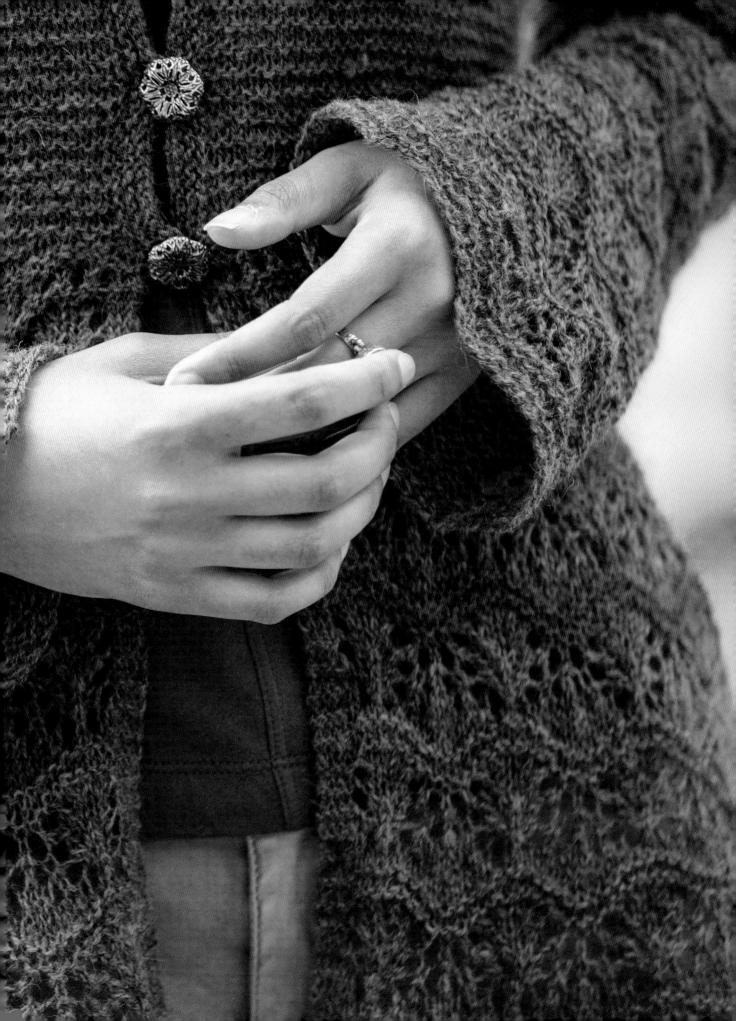

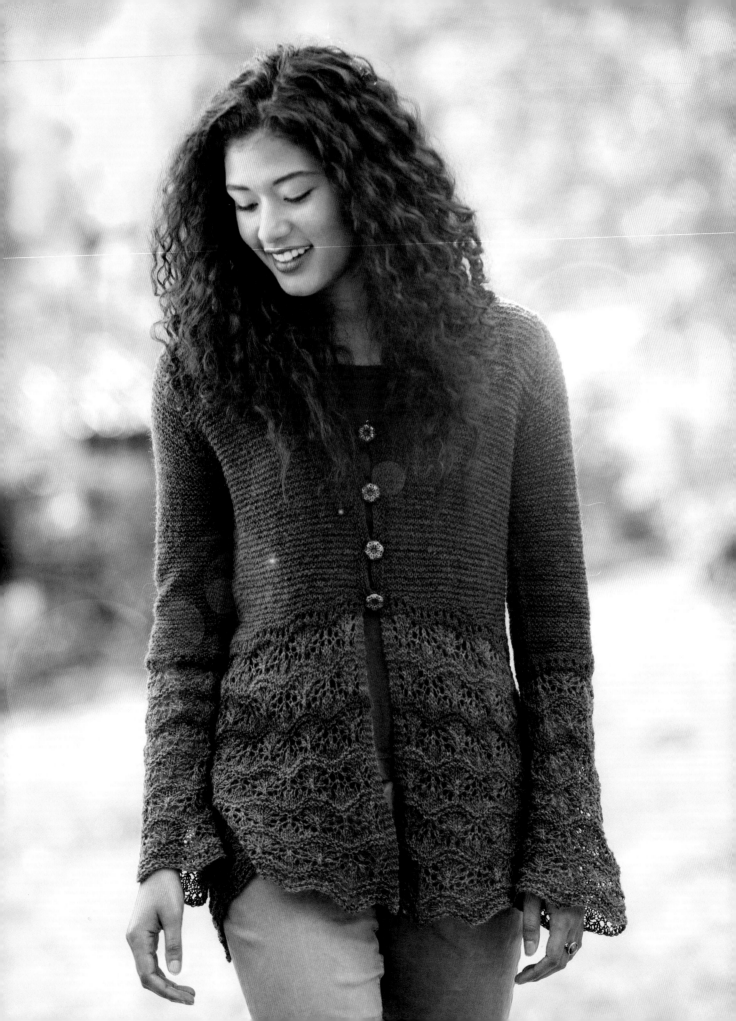

TALUS
cardigan

Based on a traditional Shetland Hap Shawl, this lightweight and springy cardigan makes use of an updated variation of a wavy lace pattern. The name "talus"—a slope formed by a pile of shale at the base of a cliff or steep incline—is a play on the name of the Old Shale pattern variant used in the lace sections. The cardigan is worked from the top down for minimal seaming.

FINISHED SIZE
About 32¾ (37½, 41¼, 45½, 49½)" (83 [95, 105, 115.5, 125.5] cm) bust circumference.

Sweater shown measures 37½" (95 cm).

YARN
Light fingering (#0 Lace).

Shown here: Sincere Sheep Norn (100% North American Shetland wool; 750 yd [686 m]/4 oz): Kung Hey Fat Chol (red; A), 2 (2, 2, 3, 3) skein(s); Deepest Desire (gray; B), 1 (1, 1, 2, 2) skein(s).

Note: This is Elemental Affects yarn dyed by Sincere Sheep.

NEEDLES
Body and sleeves: size U.S. 4 (3.5 mm): 16" and 24" or 32" (40 and 60 or 80 cm) circular (cir).

Collar and front bands: size U.S. 3 (3.25 mm): 16", 24", and 32" (40, 60, and 80 cm) cir.

Adjust needle size if necessary to obtain the correct gauge.

NOTIONS
Markers (m); removable markers; smooth cotton waste yarn; tapestry needle; blocking wires; T-pins; four ¾" (2 cm) lightweight buttons.

GAUGE
20 sts and 40 rows/rnds = 4" (10 cm) in garter stitch on larger needles.

24 sts and 26 rows = 4" (10 cm) in Chart A lace pattern on larger needles.

notes

» Swatch with Color B because less of it is used for this project than Color A.

» The body is worked back and forth in rows, but the sleeves are worked in rounds, which requires alternating knit and purl rounds. Some knitters experience gauge differences between working in rows and in rounds, so it is advisable to swatch both flat and in the round. If necessary, use different size needles for the knit and purl rounds to keep the stitches even.

» Because garter stitch looks the same on both sides of the fabric, you may find it helpful to identify the right side with a removable marker when working in rows.

» The curved lower body edge and shawl collar are shaped with traditional wrap-and-turn short-rows (see Glossary). It's not necessary to work the wraps together with the wrapped stitches when you come to them because they will be concealed by the garter ridges.

stitch guide

M1: Insert left needle tip from back to front under the horizontal strand between the needles, then knit the lifted strand through the front loop to twist it—1 st inc'd.

YOKE

With A and longer cir needle in larger size, use the knitted method (see Glossary) to CO 40 (44, 48, 52, 60) sts.

Row 1: (RS) K1f&b (see Glossary) for left front, place marker (pm), k6 (6, 6, 6, 8) left sleeve sts, pm, k26 (30, 34, 38, 42) back sts, pm, k6 (6, 6, 6, 8) right sleeve sts, pm, k1f&b for right front—42 (46, 50, 54, 62) sts.

Rows 2 and 4: (WS) K1 through back loop (tbl), knit to last st, k1tbl.

Row 3: K1f&b, k1, slip marker (sl m), [k1, yo, knit to 1 st before next m, yo, k1, sl m] 3 times, k1, k1f&b—50 (54, 58, 62, 70) sts; 3 sts each front, 8 (8, 8, 8, 10) sts each sleeve, 28 (32, 36, 40, 44) back sts.

Row 5: K1tbl, M1 (see Stitch Guide), k1, yo, k1, sl m, [k1, yo, k1tbl, knit to 2 sts before next m, k1tbl, yo, k1, sl m] 3 times, k1, yo, k1, M1, k1tbl—60 (64, 68, 72, 80) sts; 5 sts each front, 10 (10, 10, 10, 12) each sleeve, 30 (34, 38, 42, 46) back sts.

Row 6: Rep Row 2.

Row 7: (RS) K1tbl, M1, knit to 2 sts before next m, k1tbl, yo, k1, sl m, [k1, yo, k1tbl, knit to 2 sts before next m, k1tbl, yo, k1, sl m] 3 times, k1, yo, k1tbl, knit to last st, M1, k1tbl—10 sts inc'd: 2 sts inc'd each front, each sleeve, and back.

Row 8: K1tbl, knit to last st, k1tbl.

Row 9: K1tbl, knit to 2 sts before next m, k1tbl, yo, k1, sl m, [k1, yo, k1tbl, knit to 2 sts before next m, k1tbl, yo, k1, sl m] 3 times, k1, yo, k1tbl, knit to last st, k1tbl—8 sts inc'd: 1 st each front, 2 sts each sleeve, 2 back sts.

Row 10: K1tbl, knit to last st, k1tbl.

Rep the last 4 rows (Rows 7–10 only) 8 (9, 10, 12, 13) more times—222 (244, 266, 306, 332) sts: 32 (35, 38, 44, 47) sts each front, 46 (50, 54, 62, 68) sts each sleeve, 66 (74, 82, 94, 102) back sts.

Row 11: K1tbl, M1, knit to 2 sts before next m, k1tbl, yo, k1, sl m, [k1, yo, k1tbl, knit to 2 sts before next m, k1tbl, yo, k1, sl m] 3 times, k1, yo, k1tbl, knit to last st, M1, k1tbl—10 sts inc'd: 2 sts inc'd each front, each sleeve, and back.

Row 12: K1tbl, knit to last st, k1tbl.

Row 13: K1tbl, knit to 3 sts before next m, k2tog through the back loops (k2togtbl), yo, k1, sl m, [k1, yo, sl 1 purlwise tbl and return onto left needle tip as a twisted st, k2tog, knit to 3 sts before next m, k2togtbl, yo, k1, sl m] 3 times, k1, yo, sl 1 purlwise tbl and return onto left needle tip as a twisted st, k2tog, knit to last st, k1tbl—no change to st count.

Row 14: K1tbl, knit to last st, k1tbl.

Rep the last 4 rows (Rows 11–14 only) 2 (3, 3, 2, 3) more times—252 (284, 306, 336, 372) sts: 38 (43, 46, 50, 55) sts each front, 52 (58, 62, 68, 76) sts each sleeve, 72 (82, 90, 100, 110) back sts; 54 (62, 66, 70, 78) yoke rows completed; piece measures 5½ (6¼, 6½, 7, 7¾)" (14 [16, 16.5, 18, 19.5] cm) measured straight

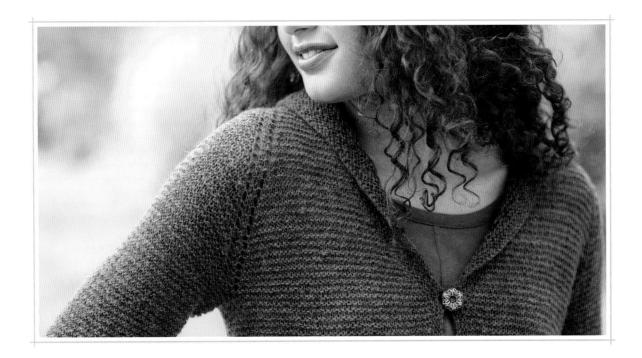

choosing buttons for lace

Selecting appropriate buttons for laceweight garments can be tricky to say the least! The buttons on this sweater were chosen because they're an almost featherlight metal filigree. Before committing to particular buttons, try pinning them to the garment for a few hours and evaluate the effect. Buttons that are too heavy will drag down the fronts and cause the sweater to hang poorly. "Auditioning" the buttons beforehand will allow you to avoid a fashion mishap down the road.

down from CO at center back (do not measure along diagonal raglan increase lines).

DIVIDE FOR BODY AND SLEEVES

Mark each end of the last row completed for the base of the front V-neck shaping; these markers will be used for working the collar and front bands later.

Next row: (RS) K1tbl, knit to last 2 left front sts m, k1tbl, k1, remove m; place next 52 (58, 62, 68, 76) left sleeve sts onto waste-yarn holder, remove m; use the backward-loop method (see Glossary) to CO 4 (5, 6, 7, 7) underarm sts, pm for left side seam, CO 4 (5, 6, 7, 7) more underarm sts; k1, k1tbl, knit to last 2 back sts, k1tbl, k1, remove m; place next 52 (58, 62, 68, 76) right sleeve sts onto waste-yarn holder, remove m; CO 4 (5, 6, 7, 7) underarm sts, pm for right side seam, CO 4 (5, 6, 7, 7) more underarm sts; k1, k1tbl, knit to last right front

st, k1tbl—164 (188, 206, 228, 248) sts total: 42 (48, 52, 57, 62) sts each front, 80 (92, 102, 114, 124) back sts.

BODY

Working the first and last st of each row as k1tbl as established, cont even in garter st until body measures 7 (6¾, 7, 7, 6¼)" (18 [17, 18, 18, 16] cm) from dividing row and 12½ (13, 13½, 14, 14)" (31.5 [33, 34.5, 35.5, 35.5] cm) from CO, measured straight down at center back.

SHAPE CURVED LOWER EDGE

Work short-rows (see Glossary) as foll:

Short-Row 1: (RS) K1tbl, knit to last 6 sts, wrap next st, turn work. Place removable m between last worked st and wrapped st.

Short-Row 2: (WS) Knit to last 6 sts, wrap next st, turn work. Place removable m between last worked st and wrapped st—6 sts outside m at each side.

Short-Rows 3 and 4: Knit to 6 sts before removable marker (which is 6 sts before previously wrapped st), remove m, wrap next st, turn work; replace removable m between last worked st and wrapped st.

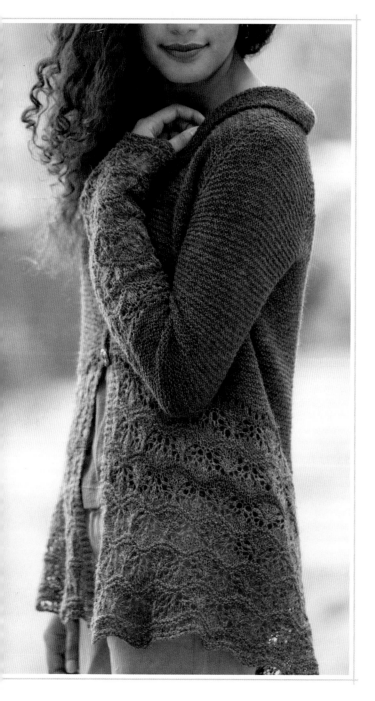

Rep the last 2 short-rows 11 (13, 14, 16, 17) more times, ending with a WS row—last wrapped st at each side is the 78 (90, 96, 108, 114)th st in from the edge; 8 (8, 14, 12, 20) sts between markers.

Next row: (RS) Knit to last st, k1tbl.

Next row: (WS) K1tbl, knit to last st, k1tbl—2 rows added at each side; 28 (32, 34, 38, 40) rows added at center; piece measures 7¼ (7, 7¼, 7¼, 6½)" (18.5 [18, 18.5, 18.5, 16.5] cm) from dividing row at each side (front edges), and 2½ (3, 3¼, 3½, 3¾)" (6.5 [7.5, 8.5, 9, 9.5] cm) longer at center back.

LACE BORDER

Row 1: (RS) Using the knitted method, CO 3 sts, work [k1tbl] 3 times over new sts, k1tbl, purl to last st, k1tbl—3 sts inc'd.

Row 2: (WS) CO 3 sts as before, [k1tbl] 3 times over new sts, k1tbl, knit to last 4 sts, [k1tbl] 4 times—170 (194, 212, 234, 254) sts.

Work Row 3 for your size as foll.

Sizes 32¾ (37½)" (83 [95] cm) only
Row 3: (RS) [K1tbl] 4 times, [yo, k2tog] 81 (93) times, yo, [k1tbl] 4 times—171 (195) sts.

Sizes 41¼ (45½, 49½)" (105 [115.5, 125.5] cm) only
Row 3: (RS) [K1tbl] 4 times, [yo, k2tog] 23 (25, 26) times, [yo, k2tog, yo, k1tbl] 3 (4, 6) times [yo, k2tog] 47 (51, 53) times, [yo, k1tbl, yo, k2tog] 3 (4, 6) times, [yo, k2tog] 23 (25, 26) times, yo, [k1tbl] 4 times—219 (243, 267) sts.

All sizes
Row 4: (WS) [K1tbl] 4 times, knit to last 4 sts, [k1tbl] 4 times.

Row 5: [K1tbl] 4 times, purl to last 4 sts, [k1tbl] 4 times.

Join color B.

Row 6: With B, [p1tbl] 4 times, purl to last 4 sts, [p1tbl] 4 times.

With B, work Rows 1–19 of Chart A (see page 17), working each patt rep box 6 (7, 8, 9, 10) times—195 (219, 243, 267, 291) sts.

With A, work Rows 20–23 of Chart A.

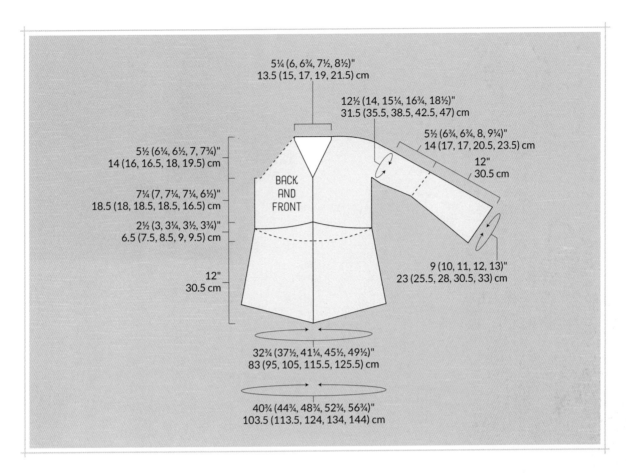

5¼ (6, 6¾, 7½, 8½)"
13.5 (15, 17, 19, 21.5) cm

12½ (14, 15¼, 16¾, 18½)"
31.5 (35.5, 38.5, 42.5, 47) cm

5½ (6¾, 6¾, 8, 9¼)"
14 (17, 17, 20.5, 23.5) cm

12"
30.5 cm

5½ (6¼, 6½, 7, 7¾)"
14 (16, 16.5, 18, 19.5) cm

BACK AND FRONT

7¼ (7, 7¼, 7¼, 6½)"
18.5 (18, 18.5, 18.5, 16.5) cm

2½ (3, 3¼, 3½, 3¾)"
6.5 (7.5, 8.5, 9, 9.5) cm

9 (10, 11, 12, 13)"
23 (25.5, 28, 30.5, 33) cm

12"
30.5 cm

32¾ (37½, 41¼, 45½, 49½)"
83 (95, 105, 115.5, 125.5) cm

40¾ (44¾, 48¾, 52¾, 56¾)"
103.5 (113.5, 124, 134, 144) cm

With B, work Row 24 of Chart A.

With B, work Rows 1–24 of Chart A, working each patt rep box 7 (8, 9, 10, 11) times—219 (243, 267, 291, 315) sts.

With B, work Rows 1–24 of Chart A, working each patt rep box 8 (9, 10, 11, 12) times—243 (267, 291, 315, 339) sts.

With B, work Rows 1–4 of Chart B—245 (269, 293, 317, 341) sts.

With B, BO as foll: P2, return 2 sts onto left needle tip, *k2togtbl, return 1 st to left needle tip; rep from * until 1 st rem. Fasten off rem st.

SLEEVES

Place 52 (58, 62, 68, 76) held sleeve sts onto shorter cir needle in larger size. With RS facing, join A at center of underarm CO, pick up and knit 5 (6, 7, 8, 8) sts from CO edge, k1, k1tbl, knit to last 2 sleeve sts, k1tbl, k1, then pick up and knit 5 (6, 7, 8, 8) sts to end at center of

underarm—62 (70, 76, 84, 92) sts total. Pm and join for working in rnds.

Beg with a purl rnd, work in garter st (alternate knit 1 rnd, purl 1 rnd), for 17 rnds—18 rnds total; 9 garter ridges; piece measures about 1¾" (4.5 cm) from pick-up rnd.

Dec rnd: Ssk, knit to last 2 sts, k2tog—2 sts dec'd.

[Work 11 rnds even (beg and ending with a purl rnd), then rep dec rnd] 3 (4, 4, 5, 6) times, then purl 1 more rnd—54 (60, 66, 72, 78) sts rem; piece measures 5½ (6¾, 6¾, 8, 9¼)" (14 [17, 17, 20.5, 23.5] cm) from pick-up rnd.

LACE CUFF
Rnds 1 and 2: With A, purl.

Rnd 3: With A, *k2tog, yo; rep from *.

Rnds 4 and 5: With A, purl.

Rnd 6: With B, knit.

Left Sleeve Only

Note: Use Chart C (see page 19) for sizes 37½ (45½)" (95 [115.5] cm); use Chart C-1 (see page 19) for sizes 32¾ (41¼, 49½)" (83 [105, 125.5] cm).

With B, work Rnds 1–19 of chart for your size.

With A, work Rnds 20–23 of chart.

With B, work Rnd 24 of chart.

With B only, work Rnds 1–24 of chart 2 more times.

Note: Use Chart D for sizes 37½ (45½)" (95 [115.5] cm); use Chart D-1 for sizes 32¾ (41¼, 49½)" (83 [105, 125.5] cm).

With B, work Rnds 1–4 of chart.

With B, BO as foll: P2, return 2 sts onto left needle tip, *k2togtbl, return 1 st to left needle tip; rep from * until 1 st rem. Fasten off rem st.

Right Sleeve Only

Note: Use Chart C for sizes 37½ (45½)" (95 [115.5] cm); use Chart C-2 for sizes 32¾ (41¼, 49½)" (83 [105, 125.5] cm).

With B, work Rnds 1–19 of chart for your size.

With A, work Rnds 20–23 of chart.

With B, work Rnd 24 of chart.

With B only, work Rnds 1–24 of chart 2 more times.

Note: Use Chart D for sizes 37½ (45½)" (95 [115.5] cm); use Chart D-2 for sizes 32¾ (41¼, 49½)" (83 [105, 125.5] cm).

With B, work Rnds 1–4 of chart.

With B, BO as for left sleeve.

FINISHING
COLLAR AND FRONT BANDS

Note: Pick up about 3 sts for every 4 rows along vertical edges; pick up 1 st for each st along horizontal edges.

Row 1: (RS) With A, longer cir in smaller size, RS of body facing, and beg in corner of notch at start of lace border, pick up and knit 54 (52, 54, 54, 48) sts evenly

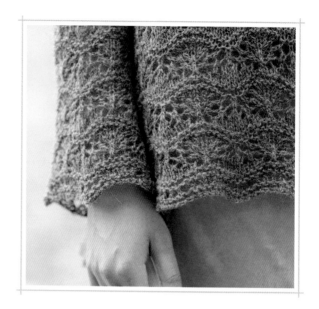

spaced along straight edge of right front to m, 40 (46, 49, 52, 58) sts along right front V-neck to raglan line, 6 (6, 6, 6, 8) sts across top of right sleeve, 26 (30, 34, 38, 42) sts across back neck, 6 (6, 6, 6, 8) sts across top of left sleeve, 40 (46, 49, 52, 58) sts along left front V-neck to marker, and 54 (52, 54, 54, 48) sts along straight edge of left front to end in corner of other lace border notch—226 (238, 252, 262, 270) sts total.

Place removable m on each side of center 12 back neck sts—53 (61, 66, 71, 81) sts between back m and V-neck m on each side of marked center back sts.

Row 2: (WS) Knit all sts tbl.

Rows 3 and 4: Knit.

Work short-rows as foll.

Short-Row 5: (RS) Knit across right front, right sleeve, back, left sleeve, and left V-neck sts to m, sl m, k3, wrap next st, place rem 51 (49, 51, 51, 45) sts (including wrapped st) onto spare needle or waste yarn, turn work—175 (189, 201, 211, 225) sts rem on needle.

Change to longer cir needle in larger size.

Short-Row 6: (WS) Knit across left V-neck, left sleeve, back, right sleeve, and right V-neck to m, sl m, k3, wrap next st, place rem 51 (49, 51, 51, 45) sts (including wrapped st) onto a spare needle or waste yarn—124 (140, 150, 160, 180) collar sts rem; 56 (64, 69, 74, 84) sts on each side of 12 marked center sts.

Short-Row 7: Knit to first center back m, sl m, k12, sl m, wrap next st, turn work.

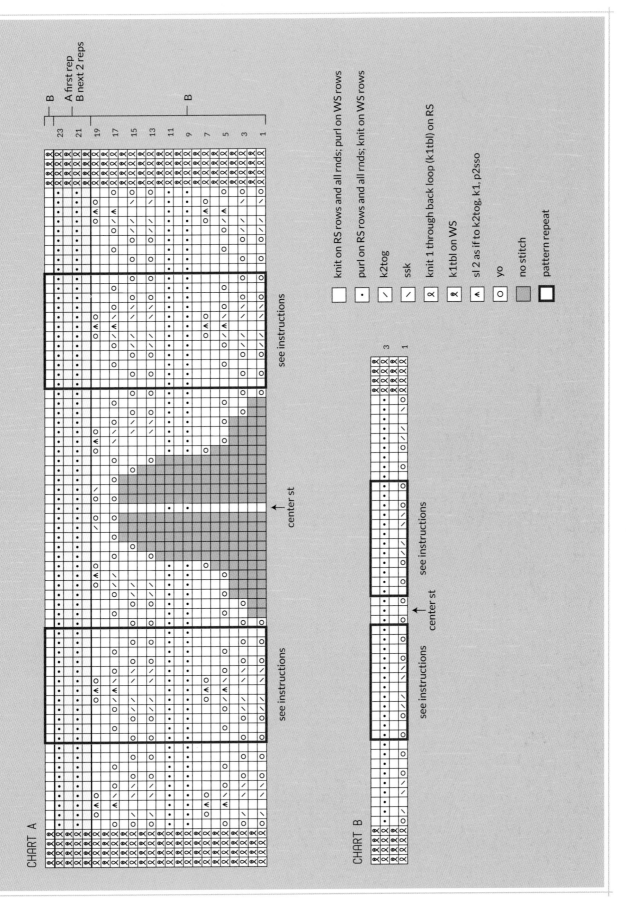

CHART A

CHART B

B

A first rep
B next 2 reps

B

23 21 19 17 15 13 11 9 7 5 3 1

see instructions

center st

see instructions

see instructions

3 1

see instructions

center st

see instructions

knit on RS rows and all rnds; purl on WS rows

purl on RS rows and all rnds; knit on WS rows

k2tog

ssk

knit 1 through back loop (k1tbl) on RS

k1tbl on WS

sl 2 as if to k2tog, k1, p2sso

yo

no stitch

pattern repeat

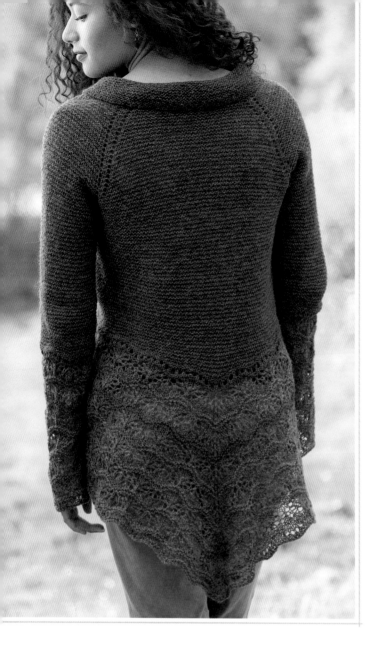

Next 2 rows: Knit to last 4 sts, wrap next st, turn work, ending with a WS row—4 unworked sts rem at each side, including wrapped st.

Mark positions for four button loops on right front, the highest 1 st above marker at base of right V-neck, the lowest at the notch where the body meets the lace border, and the rem two evenly spaced in between.

Next row: (RS) Knit to end, allow larger needle with collar sts to dangle out of the way, place 51 (49, 51, 51, 45) held left front sts onto smaller cir needle, knit to end with smaller needle—124 (140, 150, 160, 180) collar sts on larger needle; 51 (49, 51, 51, 45) left front sts on smaller needle.

Next row: (WS) Using smaller needle to work all sts, knit left front sts, knit to last collar st, place 51 (49, 51, 51, 45) held right front sts onto empty needle, k2tog (last collar st tog with first right front st), yo, ssk, [knit to 2 sts before marked button loop position, k2tog, yo, ssk] 2 times, knit to end, yo, pick up and knit 1 st from corner of notch—1 yo at each of 4 button loop positions—piece measures 4¾ (5½, 5½, 6, 6½)" (12 [14, 14, 15, 16.5] cm) from pick-up row at center back, and ¾" (2 cm) at each end of row.

BO all sts as foll: Sl 1 purlwise wyb, k1 in yo, [return 2 sts to left needle, k2togtbl, k1 in same yo] 7 times—first button loop completed. *Return 2 sts onto left needle, k2togtbl, k1; rep from * until next st on left needle is a yo, return 2 sts onto left needle, k2togtbl, k1 in yo, [return 2 sts onto left needle, k2togtbl, k1 in same yo] 7 times—second button loop completed. Rep from * 2 more times for third and fourth button loops. **Return 2 sts onto left needle, k2togtbl, k1; rep from ** until 2 sts rem, return 2 sts onto left needle, k2togtbl, fasten off last st.

With yarn threaded on a tapestry needle, sew short selvedges at ends of front bands to top of lace border notches, taking care to keep the opening of the lowest buttonhole the same size as the other buttonholes.

Soak garment in lukewarm water for at least 20 minutes. Squeeze out excess water, being careful not to wring or twist the fabric. Lay flat to measurements, pinning out edges of lacy sections on bottom and sleeves; the collar and front bands are not shown on the schematic. Allow to air-dry thoroughly before removing pins.

Sew buttons to left front. Weave in loose ends.

Short-Row 8: Sl m, k12, sl m, wrap next st, turn work—1 wrapped st on each side of marked center back sts.

Short-Rows 9 and 10: Knit to previously wrapped st, knit wrapped st, k1, wrap next st, turn work.

Short-Rows 11–18: Rep Rows 9 and 10 four more times—wrapped st at each side is the 11th st from center back m.

Short-Rows 19 and 20: Knit to previously wrapped st, knit wrapped st, k2, wrap next st, turn work.

Rep the last 2 short-rows 12 (15, 16, 18, 21) more times—last wrapped st at each side is the 50 (59, 62, 68, 77)th st from center back m, and 7 (6, 8, 7, 8)th st from end of needle.

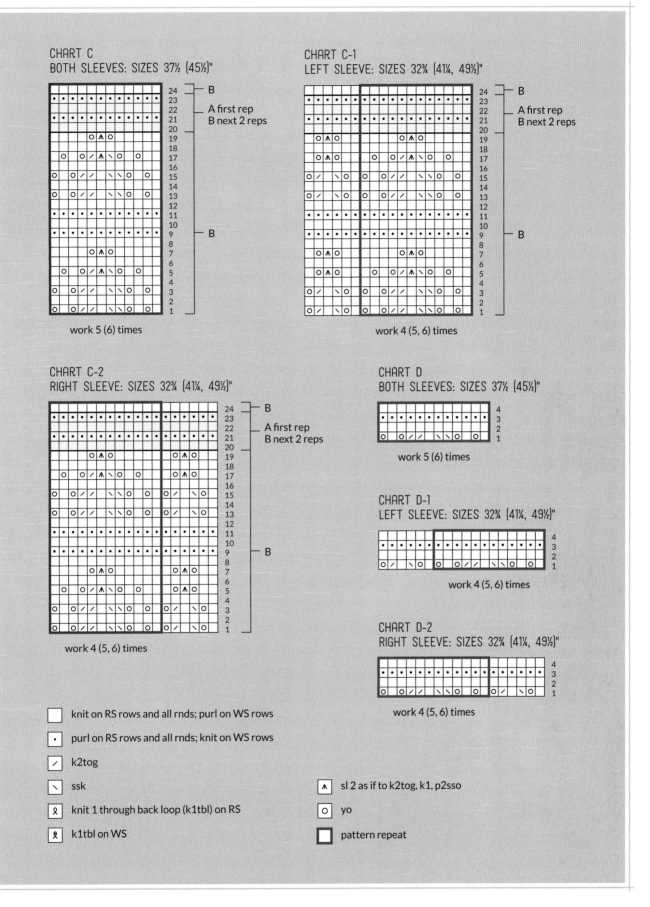

CHART C
BOTH SLEEVES: SIZES 37½ (45½)"

work 5 (6) times

CHART C-1
LEFT SLEEVE: SIZES 32¾ (41¼, 49½)"

work 4 (5, 6) times

CHART C-2
RIGHT SLEEVE: SIZES 32¾ (41¼, 49½)"

work 4 (5, 6) times

CHART D
BOTH SLEEVES: SIZES 37½ (45½)"

work 5 (6) times

CHART D-1
LEFT SLEEVE: SIZES 32¾ (41¼, 49½)"

work 4 (5, 6) times

CHART D-2
RIGHT SLEEVE: SIZES 32¾ (41¼, 49½)"

work 4 (5, 6) times

knit on RS rows and all rnds; purl on WS rows

purl on RS rows and all rnds; knit on WS rows

k2tog

ssk

knit 1 through back loop (k1tbl) on RS

k1tbl on WS

sl 2 as if to k2tog, k1, p2sso

yo

pattern repeat

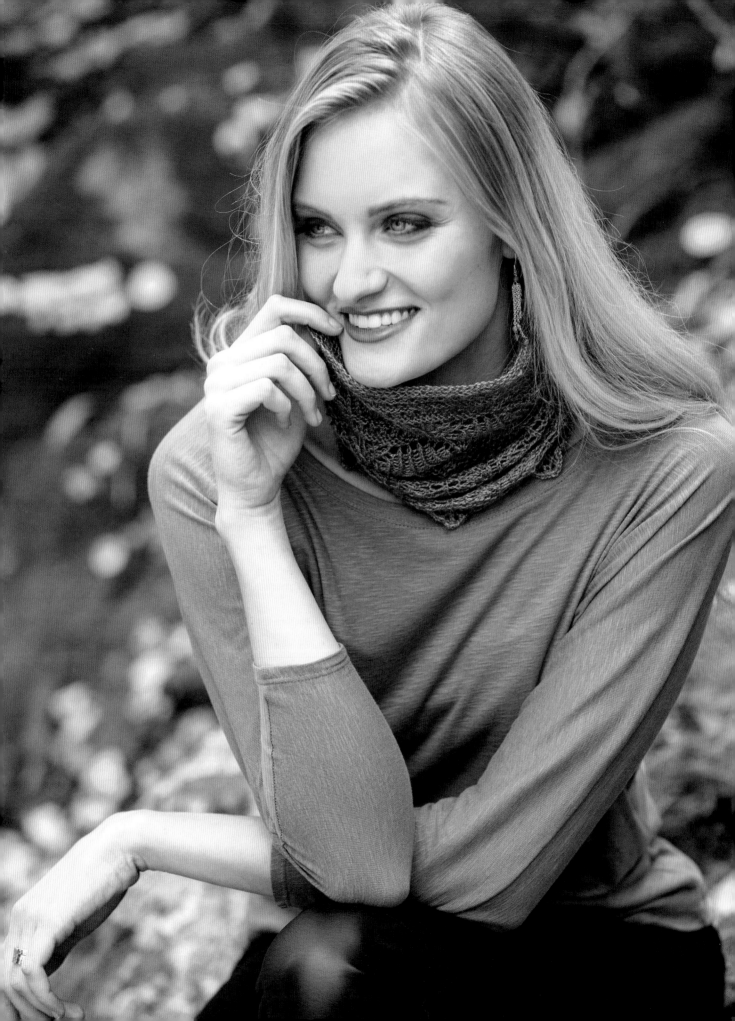

GENTLE SKY
cowl

Everyone has—or should have—a special ball or skein of luxurious decadence. Mine is a blend of qiviut and silk. It sits in my studio in all of its soft perfection, and sometimes I take a few minutes to stroke it fondly. This simple cowl is designed to take advantage of your special ball. Repeat the last chart until you're almost out of yarn so you can use every last precious inch.

FINISHED SIZE
About 17" (43 cm) in circumference and 11" (28 cm) tall, blocked.

YARN
Light fingering (#0 Lace).

Shown here: Windy Valley Muskox Royal Blend (50% qiviut, 50% mulberry silk; 218 yd [199 m]/1 oz [28.3 g]): #4002 Vintage Pink, 1 skein.

NEEDLES
Size U.S. 4 (3.5 mm): 16" (40 cm) circular (cir).

Adjust needle size if necessary to obtain the correct gauge.

NOTIONS
Markers (m); blocking wires; T-pins.

GAUGE
24 sts and 36 rnds = 4" (10 cm) in Chart B stitch pattern, blocked.

notes

» The stitch patterns used in Charts B and D work up wider and shorter than the pattern from Chart E, which is narrower and longer, gauge-wise. Do not fear. Simply insert blocking wires through the cowl and stretch it to the finished measurements while it's wet. When it dries, the stitch patterns will have evened out, and your cowl will be straight-sided and the correct width.

» To minimize the chance of twisting the stitches, the first two rows are worked back and forth before joining to work in the round. The cast-on tail is used to sew the small slit created by the first two rows closed during finishing.

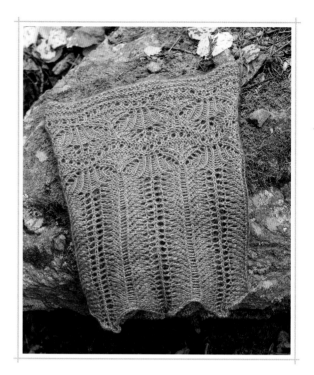

CHART A

work 51 times

CHART B

work 6 times

CHART C

work 51 times

CHART D

* should be k tbl

work 6 times

CHART E

work 6 times

	knit
•	purl
ℤ	knit 1 through back loop (k1tbl)
ℤ	purl 1 through back loop (p1tbl)
o	yo

/	k2tog
\	ssk
☐	pattern repeat
⟋ℤ	sl 1 st to cn and hold in front, k1tbl, then k1tbl from cn
⟍ℤ	sl 1 st to cn and hold in back, k1tbl, then k1tbl from cn

COWL

Using the knitted method (see Glossary), CO 102 sts. Do not join to work in round (see Notes).

Rows 1 and 2: Knit.

Place marker (pm) and join for working in rnds, being careful not to twist sts.

Purl 1 rnd.

Work Rnds 1–17 of Chart A.

Work Rnds 1–17 of Chart B.

Work Rnds 1–6 of Chart C.

Work Rnds 1–16 of Chart D.

Work Rnds 1 and 2 of Chart E as many times as desired (cowl shown has 22 reps), then work Rnd 1 once more, leaving a tail at least 2 yd (2 m) long for binding off.

Work stretchy BO as foll, working 2 sts into each yo: K2, *return these 2 sts onto left needle tip, k2tog through the back loops (tbl), k1; rep from * until 2 sts rem, return these 2 sts onto left needle tip, k2togtbl—1 st rem. Fasten off rem st.

FINISHING

Using CO tail threaded on a tapestry needle, sew edges of first 2 rows tog.

Wash cowl in wool wash. Gently squeeze out water, then roll in towels to remove excess moisture. Insert blocking wires through damp cowl, place on a flat surface, and stretch to measurements, patting bottom edge into shape. Pin wires in place.

Allow to air-dry thoroughly before removing wires and pins.

Weave in loose ends.

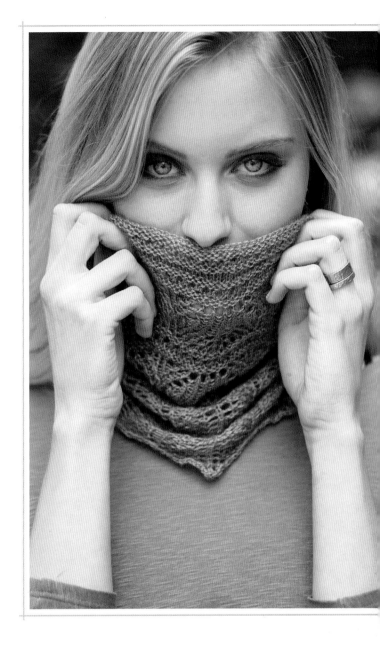

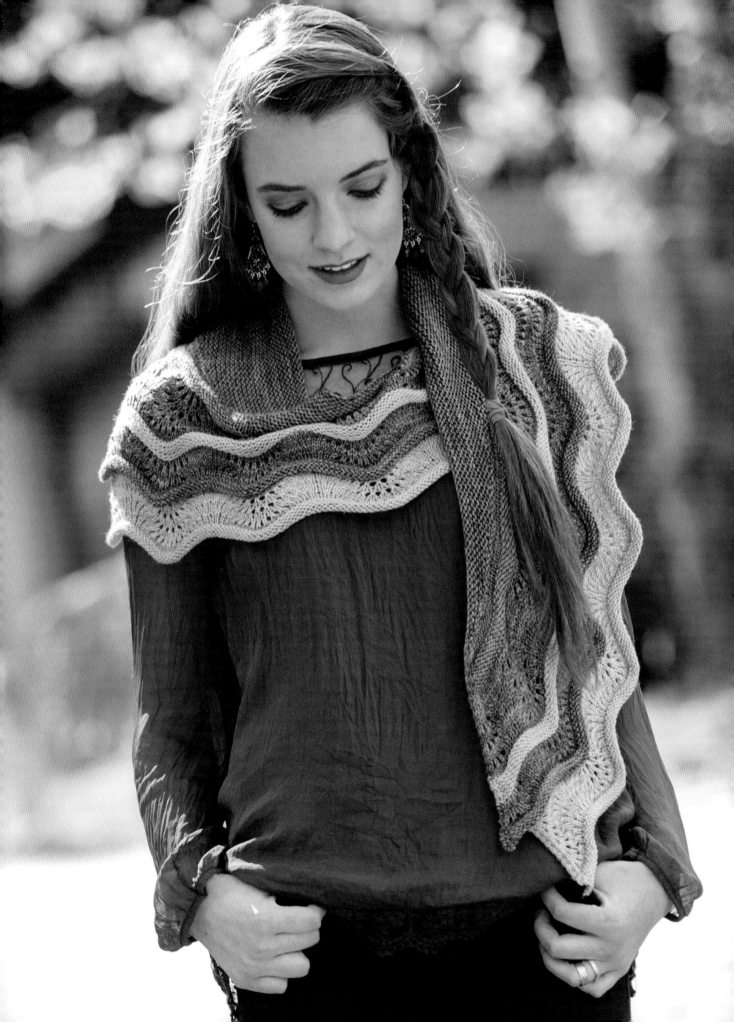

NEOMA'S
shawl

As I struggled to find the right name for this two-tiered shawl, I happened to meet up with a friend and was introduced to her lovely mother-in-law, Neoma, who lights up the day with her smile and personality. Her namesake shawl is just the right size to keep your shoulders warm, and its waves of color will look lovely with any outfit. It's a deceptively simple knit!

FINISHED SIZE
About 66" (167.5 cm) wide and 13" (33 cm) tall.

YARN
Fingering weight (#1 Super Fine).

Shown here: Anzula Squishy (80% superwash merino, 10% cashmere, 10% nylon; 385 yd [352 m]/115 g): Shiitake (dark taupe; A) and Mauve (light rose; B), 1 skein each.

NEEDLES
Main shawl body: size U.S. 5 (3.75 mm): 24" or 32" (60 or 80 cm) circular (cir).

Spare needle for pick-up: size U.S. 2 (2.75 mm): 24" or 32" (60 or 80 cm) cir.

Adjust needle size if necessary to obtain the correct gauge.

NOTIONS
Markers (m); removable markers; tapestry needle; flexible blocking wires; T-pins.

GAUGE
18 sts and 28 rows = 4" (10 cm) in pattern from Rows 11–22 of Chart A, worked on larger needles.

OVERSHAWL

With A and larger cir needle, use the knitted method (see Glossary) to CO 175 sts.

Work short-rows (see Glossary) as foll.

Row 1: (RS) K1fbf (see Stitch Guide), knit to last 2 sts, wrap next st, turn work—177 sts.

Row 2: (WS) Knit to last 5 sts, wrap next st, turn work—170 sts between wrapped sts.

Place removable marker in the work to mark RS (see Notes for other marker usage).

Next row: Knit to 3 sts before last wrapped st, wrap next st, turn work.

Rep the last row 49 more times, ending with a WS row—52 rows total; 26 garter ridges on RS; 20 sts rem unworked in the center between last 2 wrapped sts.

TRANSITION

Row 1: (RS) Knit to last st (no need to work wraps tog with wrapped sts; see Notes), k1fbf—179 sts.

Row 2: (WS) [K1tbl] 2 times, knit to last 2 sts, [k1tbl] 2 times.

Row 3: [K1tbl] 2 times, k1f&b (see Glossary), [k9, M1 (see Stitch Guide)] 9 times, k11, [M1, k9] 9 times, k1f&b, k2—199 sts.

Row 4: [K1tbl] 2 times, purl to last 2 sts, [k1tbl] 2 times.

Row 5: [K1tbl] 2 times, M1, knit to last 2 sts, M1, k2 —201 sts.

Row 6: Rep Row 4.

LACE SECTION

With A, work Rows 1–9 of Chart A (see page 28)— 311 sts.

With A, work Rows 10–23 of Chart A.

Join B and work Rows 24–29 of Chart A.

Drop B at end of RS Row 29 but do not cut yarn; it will be used later for the undershawl.

With A, work Rows 30–32 of Chart A.

notes

» The shawl is worked from the upper edge down. The overshawl is worked first, then stitches for the undershawl are picked up from the WS purl bumps of the overshawl.

» The garter-stitch section is shaped with short-rows. It's not necessary to work the wraps together with the wrapped stitches when you come to them because they will be concealed by the garter ridges.

» Use a removable marker to identify the right side when working the garter-stitch section.

» While working short-rows, you may find it helpful to place a removable marker at each turning point, then remove and reposition it after each new turn. As an alternative method, place a small regular marker on the needle at each turn to make it easy to count the number of short-rows worked. Remove these markers as you come to them after completing the short-row section.

stitch guide

K1fbf: Knit into the front, back, and front (again) of the same stitch—1 st inc'd to 3 sts.

M1: Insert left needle tip from back to front under the horizontal strand between the needles, then knit the lifted strand through the front loop to twist it—1 st inc'd.

M1P: Insert left needle tip from back to front under the horizontal strand between the needles, then purl the lifted strand to twist it—1 st inc'd.

With A, work Row 1 of Chart B (see page 28)—413 sts.

With A, work Rows 2–13 of Chart B.

With WS facing and taking care not to work too loosely, work stretchy BO as foll: K2, *return 2 sts onto left needle tip, k2tog through back loop (tbl), k1; rep from * until 2 sts rem on right needle, return 2 sts onto left needle tip, k2togtbl—1 st rem. Fasten off rem st.

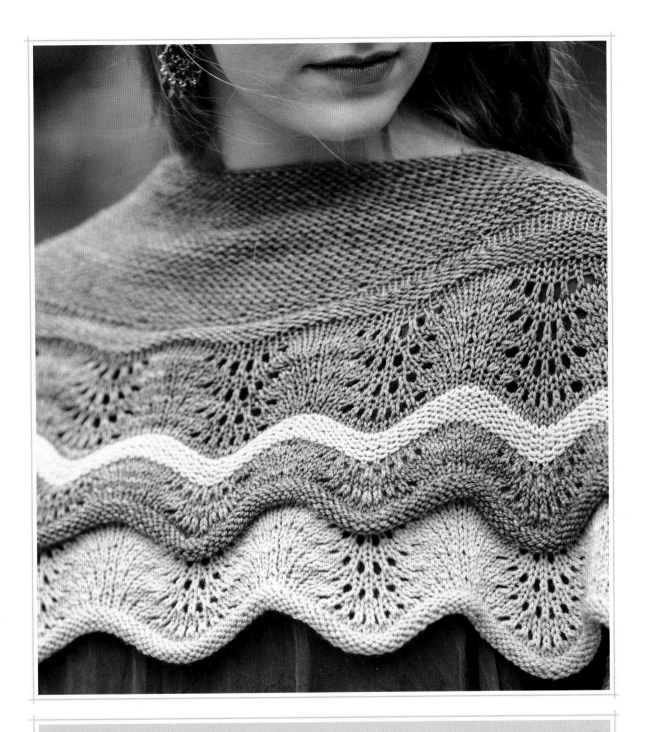

hiding short rows

Because the upper portion of this shawl is worked in garter stitch, short-row wraps can be hidden with just a little extra attention. They don't need to be knitted together with each respective wrapped stitch. When you come to a turning point where a stitch needs to be wrapped, pull the stitch before the wrap a little tighter than usual. Slip the stitch to be wrapped onto the tip of the right needle, wrap the working yarn around, then return the wrapped stitch to the left needle. When you turn and begin to knit back, make sure the wrap and the next stitch are pulled tight. Short-row wraps can loosen up the stitches around them, but will blend in beautifully in garter stitch with a little extra love and care.

CHART A

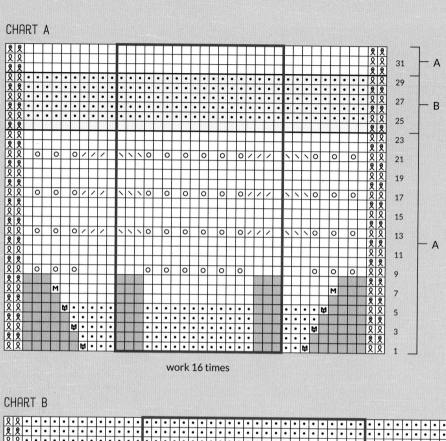

work 16 times

CHART B

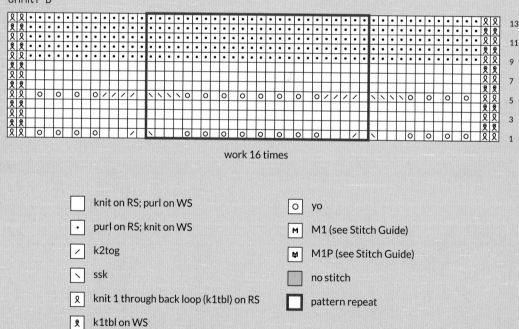

work 16 times

	knit on RS; purl on WS			yo
•	purl on RS; knit on WS		M	M1 (see Stitch Guide)
∕	k2tog		M	M1P (see Stitch Guide)
∖	ssk			no stitch
ℛ	knit 1 through back loop (k1tbl) on RS			pattern repeat
ℛ	k1tbl on WS			

UNDERSHAWL

With WS facing, smaller needle, and B already attached to lace section, pick up and knit 2 sts across first 2 edge sts, then 1 st in each of the next 307 B purl bumps from Row 29 of Chart A, then 2 sts across last 2 edge sts—311 sts total.

LACE SECTION

Change to larger cir needle.

Work Row 1 of Chart C—413 sts.

Work Rows 2–29 of Chart C.

BO firmly as foll: K2, *return 2 sts onto left needle tip, k2togtbl, k1; rep from * until 2 sts rem on right needle, return 2 sts onto left needle tip, k2togtbl—1 st rem. Fasten off rem st.

FINISHING

Wash with wool wash. Thread a flexible blocking wire through top edge of shawl and pin securely in a gentle curve. Smooth scalloped edges of both

over- and undershawls into place, using two T-pins in the last lace row of each scallop to hold the rounded "points" in shape during blocking. The Rev St st rows will curl to the WS to add textural interest.

Allow to air-dry thoroughly before removing wire and pins.

Weave in loose ends.

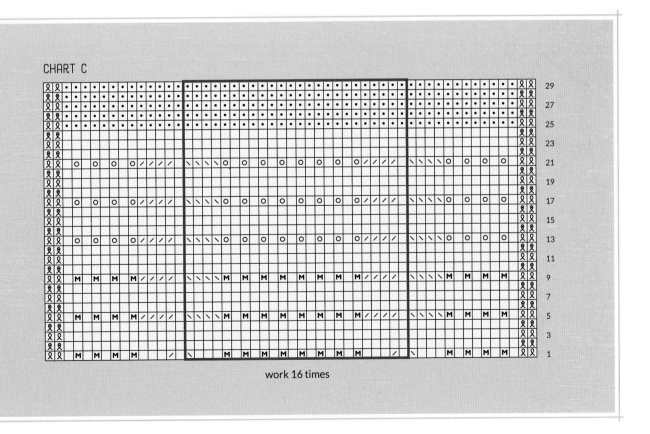

CHART C

work 16 times

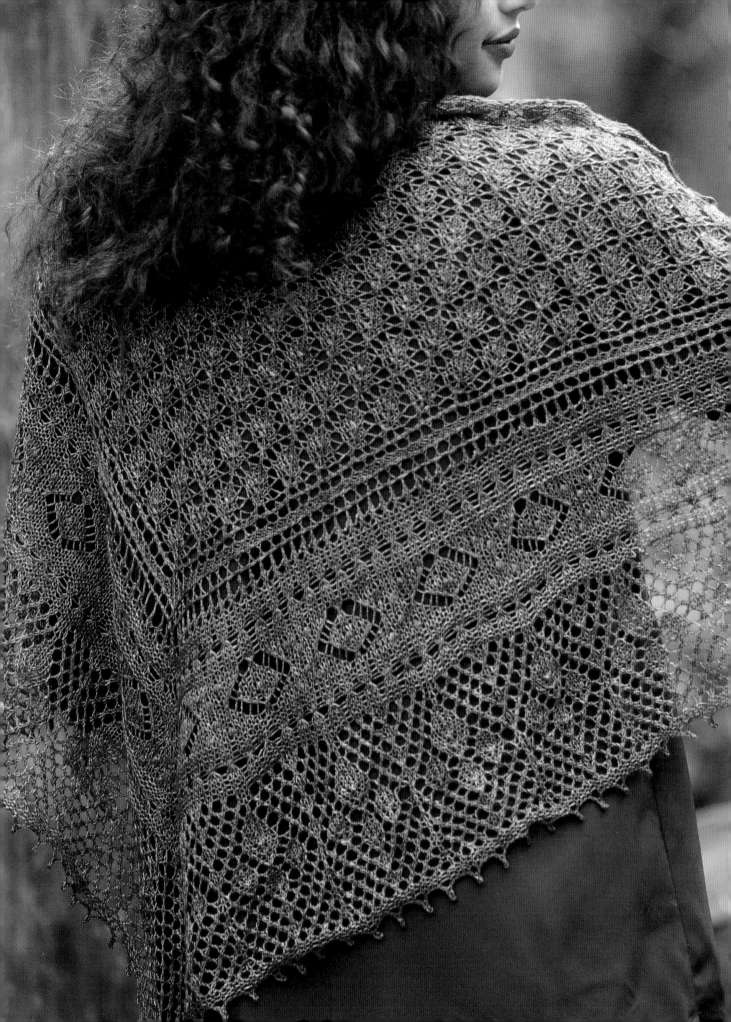

CHAPTER TWO

DIAMOND *fantasia*

THIS CHAPTER IS BUILT AROUND one of the first patterns to catch my eye when I began knitting lace. The soft-edged diamond shape is formed by centered decreases and surrounded by a chevron trellis. I kept the entire motif intact in the Town Square Shawl, on page 38, but the chevron trellis is used alone in the Manzanita Tee, on page 32. The lovely soft-edged diamond is then isolated and masquerades as a leaf for beautifully simple allover patterning in the Fallen Leaf Shell, on page 46.

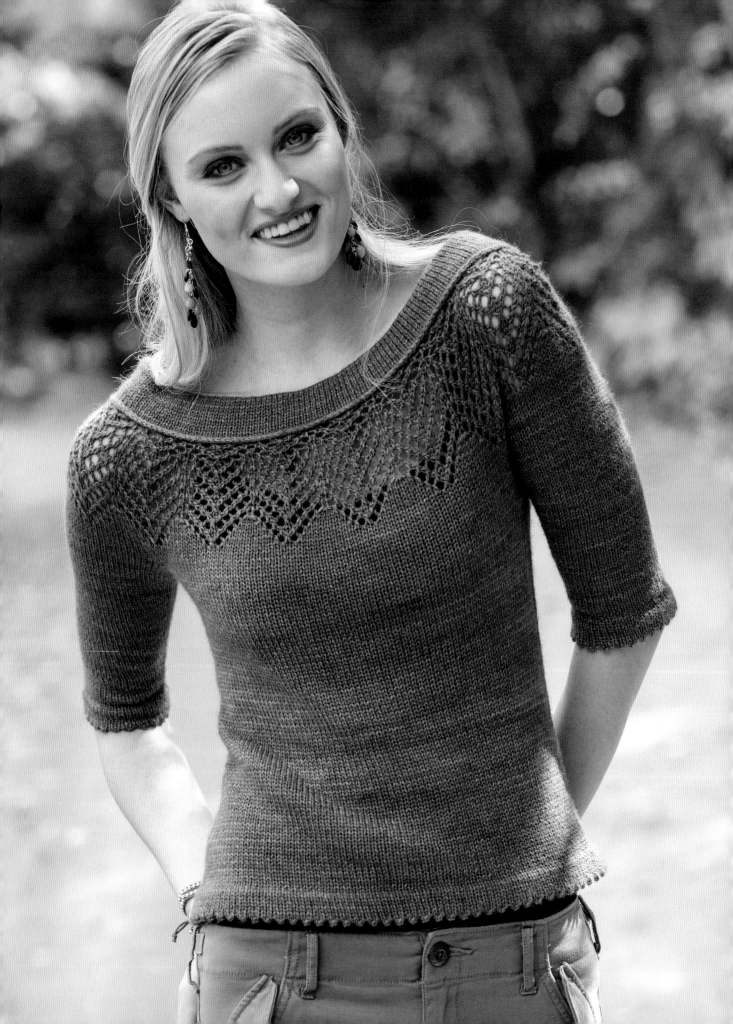

MANZANITA
tee

A simple chevron pattern is isolated from the overall lace stitch featured in this chapter to give new style to a simple yoked pull-over. The soft neckline can be worn flat or as a cowl, enhancing the patterning and making an unusual eye-catching statement. The tee is perfect with jeans or office attire. The body is worked from the top down and features waist shaping and picot hem edges.

FINISHED SIZE
About 31¼ (34½, 38¼, 41, 44¾)" (79.5 [87.5, 97, 104, 113.5] cm) bust circumference.

Sweater shown measures 31¼" (79.5 cm).

YARN
Sportweight (#2 Fine).

Shown here: The Fibre Company Road to China Light (65% baby alpaca, 15% silk, 10% cashmere, 10% camel; 159 yd [145 m]/50 g): Carnelian, 5 (6, 7, 8, 9) skeins.

NEEDLES
Body and sleeves: size U.S. 5 (3.75 mm): 24" or 32" (60 or 80 cm) circular (cir), and 16" (40 cm) cir or set of 4 or 5 double-pointed (dpn).

Hem facings: size U.S. 4 (3.5 mm): 24" or 32" (60 or 80 cm) cir, and 16" (40 cm) cir or set of 4 or 5 dpn.

I-Cord BO: size U.S. 7 (4.5 mm): 1 dpn; size U.S. 2 (2.75 mm): 24" or 32" (60 or 80 cm) cir.

Adjust needle size if necessary to obtain the correct gauge.

NOTIONS
Stitch markers (m); waste yarn; tapestry needle; blocking wires.

GAUGE
22 sts and 32 rnds = 4" (10 cm) in St st, worked in rounds on body needles.

YOKE

With waste yarn and longer body cir needle, use a provisional method (see Glossary) to CO 144 (160, 176, 192, 208) sts.

Change to working yarn and knit 1 row. With knit side still facing, place marker (pm) and join for working in rnds, being careful not to twist sts.

Work Rnds 1–8 of Chart A (see page 37), inc in Rnd 7 as shown—216 (240, 264, 288, 312) sts.

Work Rnds 1–4 of Chart B 2 (2, 3, 3, 4) times.

Work Rnds 1–4 of Chart C, inc in Rnd 4 as shown—252 (280, 308, 336, 364) sts.

Work Rnds 1–10 of Chart D—30 (30, 34, 34, 38) lace rnds total; piece measures about 3¾ (3¾, 4¼, 4¼, 4¾)" (9.5 [9.5, 11, 11, 12] cm) from CO.

Work even in St st (knit every rnd) until piece measures (4, 4½, 5¼, 5½, 6)" (10 [11.5, 13.5, 14, 15] cm) from CO.

DIVIDE FOR BODY AND SLEEVES

K76 (85, 93, 101, 109) front sts, place next 50 (55, 61, 67, 73) sts onto holder for left sleeve, use the backward-loop method (see Glossary) to CO 5 (5, 6, 6, 7) sts, pm for left side "seam," CO 5 (5, 6, 6, 7) sts as before, k76 (85, 93, 101, 109) back sts, place next 50 (55, 61, 67, 73) sts onto another holder for right sleeve,

CO 5 (5, 6, 6, 7) sts, pm for right side "seam" and beg of rnd, then CO 5 (5, 6, 6, 7) more sts—172 (190, 210, 226, 246) sts total; 86 (95, 105, 113, 123) sts each for front and back; rnds beg at marker in center of right underarm CO sts.

LOWER BODY

Work even in St st until piece measures 3¼ (4, 4½, 4½, 5)" (8.5 [10, 11.5, 11.5, 12.5] cm) from dividing rnd.

SHAPE WAIST

Dec rnd: K2, ssk, knit to 4 sts before side-seam m, k2tog, k2, sl m, k2, ssk, knit to last 4 sts, k2tog, k2—4 sts dec'd; 2 sts each from back and front.

[Knit 9 rnds even, then rep dec rnd] 2 times—160 (178, 198, 214, 234) sts rem; 80 (89, 99,107, 117) sts each for back and front.

Work even for 2 (2½, 2¾, 3, 3¼)" (5 [6.5, 7, 7.5, 8.5] cm).

Inc rnd: K3, M1L (see Glossary), knit to 3 sts before m, M1R (see Glossary), k3, sl m, k3, M1L, knit to 3 sts before m, M1R, k3—4 sts inc'd, 2 sts each for back and front.

[Knit 7 rnds even, then rep dec rnd] 2 times—172 (190, 210, 226, 246) sts; 86 (95, 105, 113, 123) sts each for front and back.

Work even until piece measures 14 (15, 15½, 16, 16½)" (35.5 [38, 39.5, 40.5, 42] cm) from dividing rnd.

HEM

Picot rnd: *K2tog, yo; rep from *.

Change to hem facing longer cir needle and knit 8 rnds.

BO as foll: K2, *return 2 sts onto left needle tip, k2tog through back loop (tbl), k1; rep from * until 2 sts rem on right needle, return 2 sts onto left needle tip, k2togtbl—1 st rem. Fasten off rem st.

SLEEVES

With shorter body cir needle or dpn and beg at center of underarm, pick up and knit 6 (5, 6, 6, 7) sts along CO edge, k50 (55, 61, 67, 73) held sleeve sts, then pick up and knit 6 (7, 8, 8, 9) sts to end at center of underarm—62 (67, 75, 81, 89) sts total. Pm and join for working in rnds.

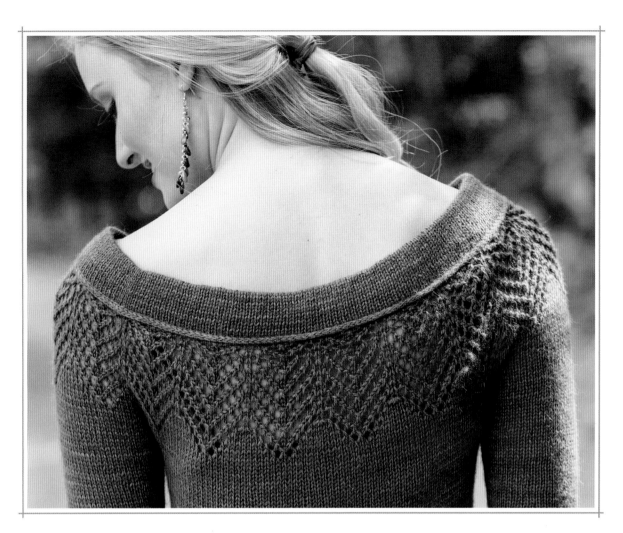

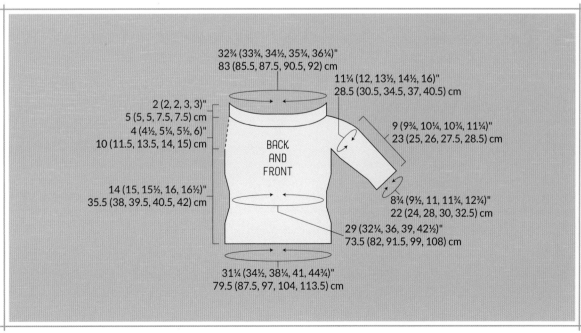

32¾ (33¾, 34½, 35¾, 36¼)"
83 (85.5, 87.5, 90.5, 92) cm

11¼ (12, 13½, 14½, 16)"
28.5 (30.5, 34.5, 37, 40.5) cm

2 (2, 2, 3, 3)"
5 (5, 5, 7.5, 7.5) cm
4 (4½, 5¼, 5½, 6)"
10 (11.5, 13.5, 14, 15) cm

9 (9¾, 10¼, 10¾, 11¼)"
23 (25, 26, 27.5, 28.5) cm

BACK
AND
FRONT

14 (15, 15½, 16, 16½)"
35.5 (38, 39.5, 40.5, 42) cm

8¾ (9½, 11, 11¾, 12¾)"
22 (24, 28, 30, 32.5) cm

29 (32¼, 36, 39, 42½)"
73.5 (82, 91.5, 99, 108) cm

31¼ (34½, 38¼, 41, 44¾)"
79.5 (87.5, 97, 104, 113.5) cm

Next rnd: Knit to last 2 sts, k2 (k2tog, k2tog, k2tog, k2tog)—62 (66, 74, 80, 88) sts rem.

Work even in St st for 1 (1½, 1¾, 2, 2¼)" (2.5 [3.8, 4.5, 5, 5.5] cm).

Dec rnd: K2, ssk, knit to last 4 sts, k2tog, k2—2 sts dec'd.

[Knit 7 rnds even, then rep dec rnd] 6 (6, 6, 7, 8) more times—48 (52, 60, 64, 70) sts rem.

Work even in St st until sleeve measures 9 (9¾, 10¼, 10¾, 11¼)" (23 [25, 26, 27.5, 28.5] cm) from pick-up rnd.

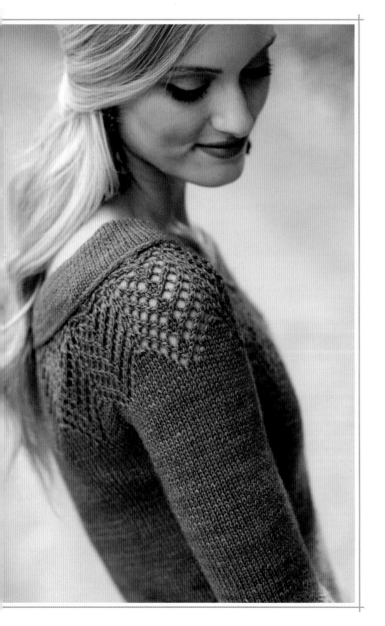

HEM
Picot rnd: *K2tog, yo; rep from *.

Change to hem facing shorter cir needle or dpn and knit 8 rnds.

BO as for body.

FINISHING
COLLAR
Remove waste yarn from provisional CO and place exposed sts onto longer body cir needle (see Notes)—144 (160, 176, 192, 208) sts.

Turn garment inside out. The collar is worked with the WS of the sweater facing so the RS of the collar will show when folded over. Pm and join for working in rnds.

Cont for your size as foll:

Size 31¼" (79.5 cm) only
Inc rnd: P1, [yo, p4] 35 times to last 3 sts, yo, p3—180 sts.

Size 34½" (87.5 cm) only
Inc rnd: P4, [yo, p6] 12 times, yo, p8, [yo, p6] 12 times, yo, p4—186 sts.

Size 38¼" (97 cm) only
Inc rnd: P8, [yo, p12] 6 times, yo, p16, [yo, p12] 6 times, yo, p8—190 sts.

Size 41" (104 cm) only
Inc rnd: P24, [yo, p48] 3 times, yo, p24—196 sts.

Size 44¾" (113.5 cm) only
Dec rnd: [P1, p2tog] 2 times, p92, p2tog, p1, p2tog, p2, p2tog, p1, p2tog, p92, [p2tog, p1] 2 times—200 sts.

Cut a length of waste yarn about 48" (122 cm) long and thread on a tapestry needle. Draw waste yarn through the 180 (186, 190, 196, 200) live sts on needle; this marks the rnd at base of collar for joining later.

Work in St st (knit all collar rnds with WS of garment still facing) for 4 (4, 4, 6, 6)" (10 [10, 10, 15, 15] cm).

Insert empty hem facing cir needle along path of waste yarn without removing waste yarn—180 (186, 190, 196, 200) sts from marked rnd. Fold collar in half with its knit side on the outside to bring the two cir needles parallel,

with the needle holding live collar sts below the needle holding marked sts.

With size 2 (2.75 mm) cir needle, join the sts on the two parallel needles, without knitting any sts, as foll: *Sl 1 collar st knitwise from bottom needle, sl 1 marked rnd st purlwise from top needle, then lift the first st on right needle tip over the second and off the needle; rep from * to end—180 (186, 190, 196, 200) sts rem on size 2 (2.75 mm) cir needle.

With body dpn, use the knitted method (see Glossary) to CO 2 sts onto left needle tip. Change to size 7 (4.5 mm) dpn, and work 3-st I-cord BO as foll: K3 (2 new sts and 1 collar st), return 3 sts onto left needle tip while holding the yarn in back (wyb), *k2, k2togtbl (last I-cord st tog with 1 collar st), return 3 sts onto left needle tip wyb; rep from * until 3 I-cord sts rem; all collar sts have been BO. Cut yarn, leaving a 10" (25.5 cm) tail. Use the Kitchener st (see Glossary) to graft last 3 I-cord sts to base of I-cord CO.

HEMS

Fold body and sleeve hems to WS along picot rounds. With yarn threaded on a tapestry needle, sew in place on WS as invisibly as possible.

Wash in wool wash. Insert blocking wires along sides of neck to ensure it dries straight. Lay flat and allow to air-dry thoroughly before removing wires.

Weave in loose ends.

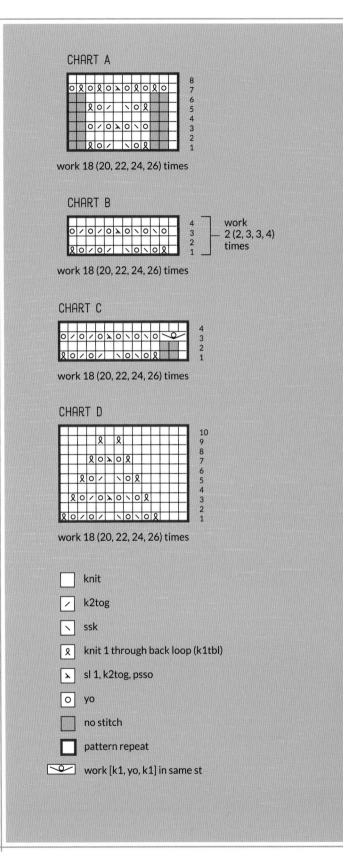

CHART A
work 18 (20, 22, 24, 26) times

CHART B
work 2 (2, 3, 3, 4) times
work 18 (20, 22, 24, 26) times

CHART C
work 18 (20, 22, 24, 26) times

CHART D
work 18 (20, 22, 24, 26) times

knit

k2tog

ssk

knit 1 through back loop (k1tbl)

sl 1, k2tog, psso

yo

no stitch

pattern repeat

work [k1, yo, k1] in same st

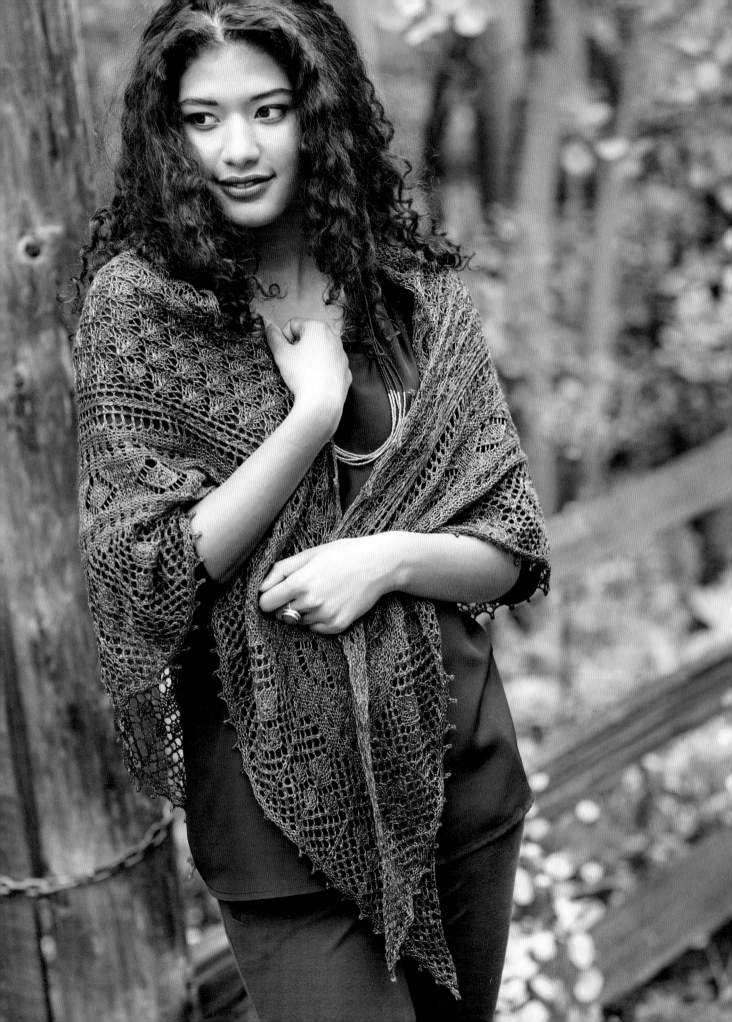

TOWN SQUARE
shawl

The diamond motif used in this shawl is deconstructed and then played upon as a theme with variations. A twist on the traditional triangular construction, this shawl has no spine along the center of the upper triangle. Instead, the shawl is cast on along the top and is shaped with short-rows. Nupps (small Estonian bobbles) add texture between the border and upper triangle, and the shawl is finished off with the featured diamond motif and a picot bind-off.

FINISHED SIZE
About 84" (213 cm) wide and 35" (89 cm) tall at center.

YARN
Laceweight (#0 Lace).

Shown here: All for Love of Yarn Brilliance Lace (55% superwash Bluefaced Leicester wool, 45% silk; 875 yd [800 m]/100 g): Kiss Me Pink, 1 skein.

NEEDLES
Main triangle and borders: size U.S. 3 (3.25 mm): 24" or 32" (60 or 80 cm) circular (cir).

Cast-on: size U.S. 5 (3.75 mm): 24" or 32" (60 or 80 cm) cir.

Adjust needle size if necessary to obtain the correct gauge.

NOTIONS
Markers (m); cable needle (cn); removable markers or coil-less safety pins; blocking wires; T-pins; tapestry needle.

GAUGE
18 sts and 30 rows = 4" (10 cm) in Chart E pattern on smaller needle.

notes

» Short-rows in Charts A and B are used to shape the main triangle. Each right-side row begins and ends with a 2-stitch twist. Each wrong-side row begins by slipping the first stitch of the first twist, and ends by turning before working the second stitch of the last twist. This reduces the number of working stitches in the center section by 2 and shapes the triangle with a little help from a few ordinary decreases along the way. You may find it helpful to mark the turning points with markers that can be removed and replaced at each turn.

» If you use markers to set off individual pattern repeats, you'll need to move the markers in the following chart rows to accommodate a double decrease that falls next to an outlined pattern repeat: Rows 7, 9, 11, 19, 21, and 23 of Chart A; Row 3 of Chart C; Rows 1 and 9 of Chart D-2; and Rows 3, 7, 11, and 15 of Chart E.

» For perky little nupps, make sure not to pull yarn too tightly. If you have a difficult time keeping the stitches relaxed, add an extra yarnover at the end of the nupp stitches on right-side rows. On the following wrong-side row, drop the extra yarn-over to provide extra slack and make it easier to purl the 7 nupp stitches together. See Impeccable Nupps below.

stitch guide

M1P: Insert left needle tip from back to front under the horizontal strand between the needles, then purl the lifted strand—1 st inc'd.

M1: Insert left needle tip from back to front under the horizontal strand between the needles, then knit the lifted strand—1 st inc'd.

Nupp: Very loosely, work ([k1, yo] 3 times, k1) in same st—7 sts made from 1 st. Purl the 7 nupp sts tog on the following row as shown on chart.

T2L: Sl 1 st to cn and hold in front, k1tbl, then k1tbl from cn.

T2R: Sl 1 st to cn and hold in back, k1tbl, then k1tbl from cn.

T2R-dec: Sl 2 sts to cn and hold in back, k1tbl, then k2togtbl from cn—3 sts dec'd to 2 sts.

K2-into-3: K2tog without removing sts from left needle, yo, then work same 2 sts k2tog again, and remove sts from needle—3 sts made from 2 sts.

K3-into-3: K3tog without removing sts from left needle, yo, then work same 3 sts k3tog again, and remove sts from needle—3 sts made from 3 sts.

5-into-1 dec: Sl 2 sts individually knitwise, k3tog, pass 2 slipped sts over—5 sts dec'd to 1 st.

Picot: Use the knitted method (see Glossary) to CO 3 sts. K2togtbl, k1tbl last new CO st, pass first st over second st on right needle, k1tbl next shawl st, pass first st over second st on right needle—all new CO sts have been removed; 1 shawl st rem on right needle.

impeccable nupps

As daunting as they may seem, nupps are a great way to add texture and interest to stitch patterns and garments. The secret to gorgeous nupps is simple: work them much more loosely than you think, so you'll be able to purl all the loops together on the following row! To help keep the nupp stitches loose, try holding two needles together when you create each nupp, then remove the extra needle. Because this pattern already uses needles on the large side, holding a smaller needle—a U.S. 5 (3.75 mm) for example—together with the working needle for the nupp stitches will make the nupp loops large enough so they can be purled together easily on the next row. It may feel sloppy at first, but the nupps will look neat and tidy once the loops are worked together to close the top of the nupp—and "it will all block out."

MAIN TRIANGLE

With larger needles, use the knitted method (see Glossary) to CO 217 sts.

Change to smaller needles and knit 2 rows—1 garter ridge on RS.

Work Row 1 of Chart A (see page 42) across all sts, working the 8-st repeat box 21 times and ignoring the short-row turn symbol at the end of the chart because the very first Row 1 is worked over all sts—215 sts.

Work Row 2 of Chart A to last st, turn work—1 unworked st at end of short-row.

Work Rows 3–24 of Chart A, working each short-row to turning point indicated on chart, and dec as shown—209 sts total; with RS facing, 186 worked sts between turning gaps (including sl st at start of Row 24) with 12 unworked sts before and 11 unworked sts after them.

Work Rows 1–24 of Chart A, working the 8-st repeat box 17 times, and turning at the end of Row 1 as shown—201 sts total; with RS facing, 154 worked sts between turning gaps (including Row 24 sl st), with 24 unworked sts before and 23 unworked sts after them.

Work Rows 1–24 of Chart A, working the 8-st repeat box 13 times—193 sts total; with RS facing, 122 worked sts between turning gaps (including Row 24 sl st), with 36 unworked sts before and 35 unworked sts after them.

Work Rows 1–24 of Chart A, working the 8-st repeat box 9 times—185 sts total; with RS facing, 90 worked sts between turning gaps (including Row 24 sl st), with 48 unworked sts before and 47 unworked sts after them.

Work Rows 1–24 of Chart A, working the 8-st repeat box 5 times—177 sts total; with RS facing, 58 worked sts between turning gaps (including Row 24 sl st), with 60 unworked sts before and 59 unworked sts after them.

Work Rows 1–24 of Chart A, working the 8-st repeat box 1 time—169 sts total; with RS facing, 26 worked sts between turning gaps (including Row 24 sl st), with 72 unworked sts before and 71 unworked sts after them.

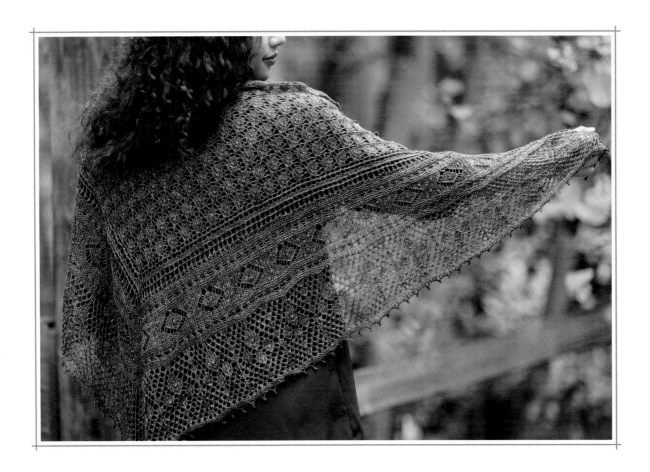

CHART A

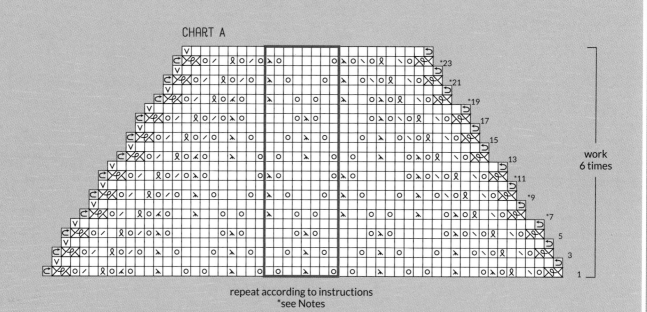

work 6 times

repeat according to instructions
*see Notes

knit on RS; purl on WS

ℓ knit 1 through back loop (k1tbl) on RS

ℓ k1tbl on WS

∕ k2tog on RS; p2tog on WS

∖ ssk on RS; p2togtbl on WS

⋏ k3tog

⅄ sl 1, k2tog, psso

ƽ 5-into-1 dec (see Stitch Guide)

o yo

M M1P on RS; M1 on WS (see Stitch Guide)

⅃ work [k1, p1] in yo of previous row

v sl 1 st wyf on WS

no stitch

pattern repeat

↺ or ↻ turn at end of short-row

⧖ T2L (see Stitch Guide)

⧗ T2R (see Stitch Guide)

⧘ T2R-dec (see Stitch Guide)

CHART B

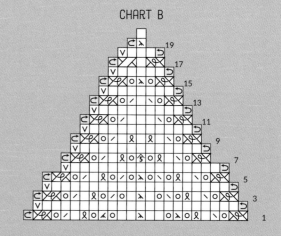

CHART C

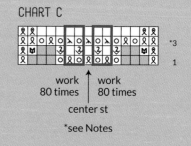

work 80 times work 80 times

center st

*see Notes

Work Rows 1–20 of Chart B—163 sts total; with RS facing, 1 worked st between turning gaps, with 81 unworked sts both before and after it.

TRANSITION

Cut yarn. Slide sts to beg of left needle tip, and rejoin yarn to all sts, ready to work a RS row.

Work Row 1 of Chart C—325 sts.

Work Row 2 of Chart C—489 sts.

Work Rows 3 and 4 of Chart C—331 sts; 1 center st and 165 sts each side.

DIAMOND INNER BORDER

Work Rows 1–10 of Chart D-1 (see page 44)—351 sts.

Work Rows 1–10 of Chart D-2—371 sts.

Work Rows 1–10 of Chart D-3 (see page 45)—391 sts; 1 center st and 195 sts each side.

OUTER BORDER

Work Rows 1–34 of Chart E—455 sts; 1 center st and 227 sts at each side.

FINISHING

BO all sts as foll: [Picot (see Stitch Guide), BO 4 sts, return st on right needle after last BO onto left needle] 56 times—3 sts rem before center st. Work next 7 sts as picot, k1tbl, pass first st over second st on right needle, k2togtbl, pass first st over second st on right needle, re-turn rem st on right needle (center st) onto left needle, picot, k1tbl, pass first st over second st on right needle, BO 3 sts, return st on right needle onto left needle—224 sts rem. [Picot, BO 4 sts, return st on right needle to left needle] 55 times—4 sts rem. Work last 4 sts as picot, BO 3 sts, return st on right needle onto left needle, picot—1 st rem. Fasten off last st.

Wash in wool wash. Gently squeeze out water, then roll in towels to remove excess moisture. Insert blocking wires into damp shawl through ends of outer border picots and upper edge diamond points. Place on a flat surface and pin to measurements. Allow to air-dry thoroughly before removing wires and pins.

Weave in loose ends.

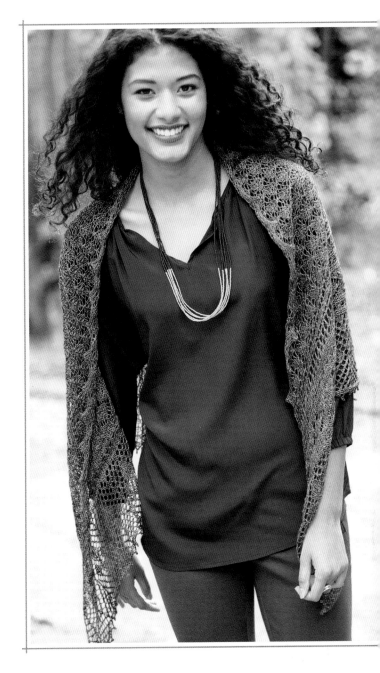

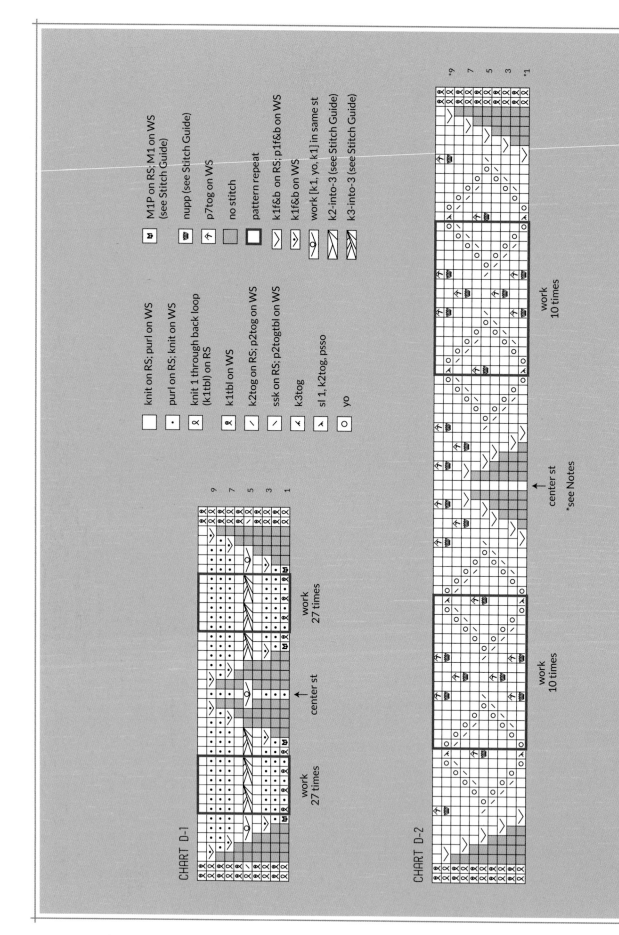

CHART D-1

CHART D-2

knit on RS; purl on WS

purl on RS; knit on WS

knit 1 through back loop (k1tbl) on RS

k1tbl on WS

k2tog on RS; p2tog on WS

ssk on RS; p2togtbl on WS

k3tog

sl 1, k2tog, psso

yo

M1P on RS; M1 on WS (see Stitch Guide)

nupp (see Stitch Guide)

p7tog on WS

no stitch

pattern repeat

k1f&b on RS; p1f&b on WS

k1f&b on WS

work [k1, yo, k1] in same st

k2-into-3 (see Stitch Guide)

k3-into-3 (see Stitch Guide)

work 27 times

work 27 times

center st

work 10 times

work 10 times

center st
*see Notes

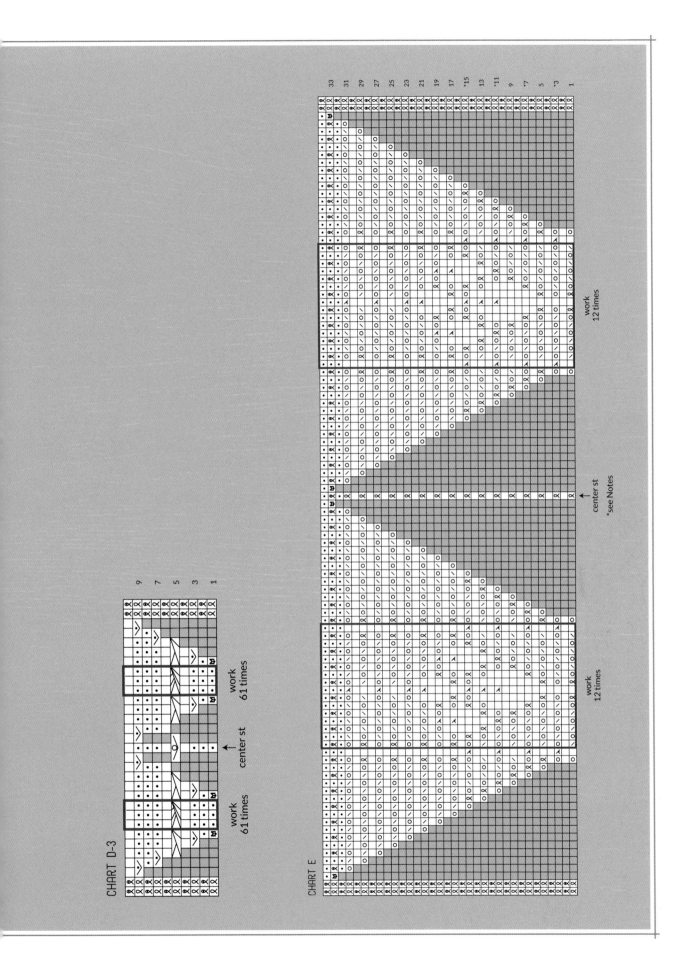

CHART D-3

work
61 times

center st

work
61 times

CHART E

work
12 times

center st
*see Notes

work
12 times

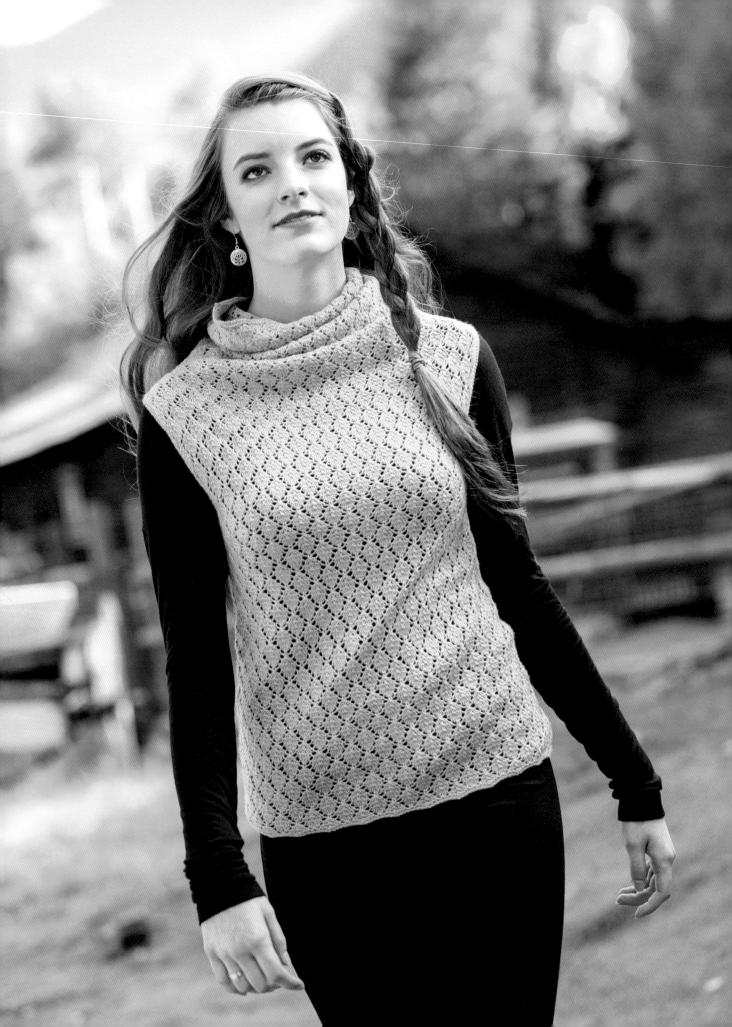

FALLEN LEAF
shell

A long and wide funnel neck teams up with a simple allover lace pattern in this elegant shell. The fluid lacy material allows folds to drape beautifully around the neckline and frame the face. The body is worked in rounds from the bottom to the armholes, the upper back and front are worked separately from the base of the armholes to the shoulders, then the stitches are joined and the cowl is worked in the round. Firm blocking brings out the beauty of the lace stitches.

FINISHED SIZE
About 34¾ (40, 45¼, 50¾, 56)" (88.5 [101.5, 115, 129, 142] cm) bust circumference.

Shell shown measures 34¾" (88.5 cm).

YARN
Lace or light fingering weight (#0 Lace).

Shown here: Swans Island Natural Colors Collection Fingering (100% merino; 525 yd [480 m]/100 g): Wheat (golden yellow), 3 (3, 4, 4, 5) skeins.

NEEDLES
Body: size U.S. 2 (2.75 mm): 16" and 24" or 32" (40 and 60 or 80 cm) circular (cir).

Cowl and armhole edging: size U.S. 1 (2.25 mm): 16" (40 cm) cir.

Adjust needle size if necessary to obtain the correct gauge.

NOTIONS
Stitch markers (m); stitch holder or spare circular needle (same size or smaller than main needle); waste yarn; blocking wires; T-pins; tapestry needle.

GAUGE
24 sts and 40 rnds = 4" (10 cm) in Chart A stitch pattern on larger needles.

notes

- » Adjust needle size if the lace pattern gauge worked in rounds is different from the lace pattern worked back and forth in rows.

- » To minimize the chance of twisting the stitches, the first two rows are worked back and forth before joining to work in the round. The small slit created by the first two rows is sewn closed using the cast-on tail during finishing.

- » If you use markers to set off individual pattern repeats, you may need to move each marker one stitch to accommodate a decrease that falls at the start or end of a red-outlined repeat, before the first repeat, or after the last repeat.

- » The armhole heights shown on the schematic apply to the upper body and are a general guideline for blocking purposes. In practice, the lace structure tends to make armholes slightly looser. The applied edging will stabilize the openings to the correct measurements.

stitch guide

5-into-1 dec: Sl 3 sts as if to k3tog, k2tog, pass 3 slipped sts over dec'd st—5 sts dec'd to 1 st.

3-into-2 dec: Going behind the first st on left needle, skip first st, insert right needle tip into the back loops of the second and third sts, work them as k2tog through their back loops (k2togtbl) without removing sts from needle, knit the first st, then slip all sts from left needle—3 sts dec'd to 2 sts; mimics the appearance of a left-leaning double dec while dec only 1 st.

Move end-of-rnd marker 1 st right: Knit last st of the rnd indicated by arrow symbol (see charts), remove marker, slip the st just worked back onto left needle, replace marker for new beg of rnd. The transferred st will be worked again at the start of the next rnd.

Move end-of-rnd marker 1 st left: After working last st of the rnd, remove marker, k1, replace marker for new beg of rnd.

BODY

With longer cir needle in larger size and using the knitted method (see Glossary), CO 208 (240, 272, 304, 336) sts. Do not join to work in round (see Notes).

Knit 2 rows.

Place marker (pm) and join for working in rnds, being careful not to twist sts.

Purl 1 rnd.

Work Rnds 1–12 of Chart A (see page 51) a total of 12 (12, 13, 14, 15) times, moving marker at the end of Rnds 6, 8, and 10 as shown (see Notes).

Note: To adjust the length below the armhole, add or subtract chart repeats here, ending with Rnd 12 of chart. Every 12-round repeat added or removed will lengthen or shorten the lower body by about 1¼" (3.2 cm).

Work Rnds 1–8 of Chart B (see page 52), moving marker at end of Rnd 6 as shown—210 (242, 274, 306, 338) sts; piece measures 15½ (15½, 16¾, 17¾, 19)"

(39.5 [39.5, 42.5, 45, 48.5] cm) from CO, including first 2 knit rows and initial purl rnd.

DIVIDE FOR ARMHOLES

With RS facing, work Row 1 of Chart C across first 105 (121, 137, 153, 169) back sts, then place rem 105 (121, 137, 153, 169) sts onto holder or spare cir needle to work later for front.

BACK

Working in rows on back sts only, work Rows 2–10 of Chart C—99 (115, 131, 147, 163) sts rem.

Work Rows 1–12 of Chart D a total of 5 (5, 6, 7, 7) times—armhole measures about 7 (7, 8¼, 9½, 9½)" (18 [18, 21, 24, 24] cm).

Place sts on waste-yarn holder. Cut yarn.

FRONT

Return held front sts to needle. With RS facing, join yarn at armhole edge, then work Charts C and D as for back—99 (115, 131, 147, 163) sts. Leave sts on needle; do not cut yarn.

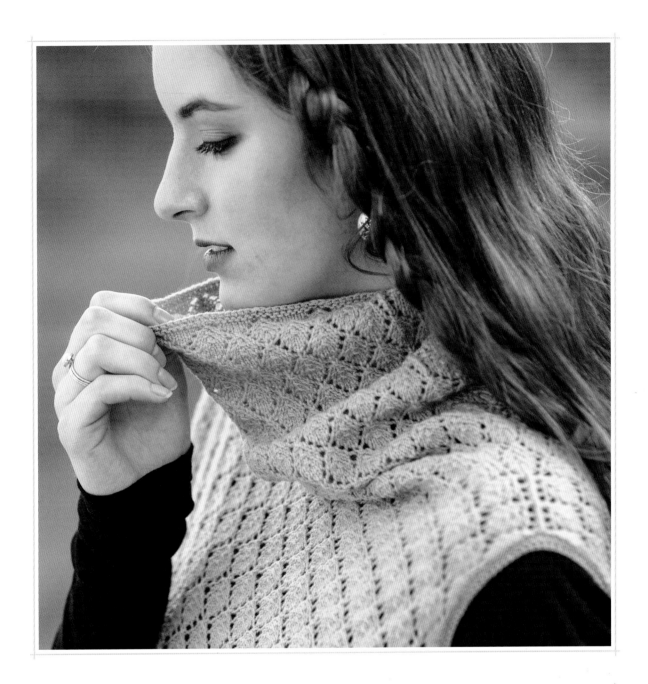

blocking decreases

Because lace is so easily stretched into shape during blocking, decrease schemes that look lumpy on the needles—such as the one used to shape the sides of this cowl neck—will easily block into a smooth line. A piece worked in a more solid fabric, such as stockinette, might still appear lumpy even after blocking. To set the desired shape, run the blocking wires inside the wet cowl at each side, set at an angle that tapers from shoulders to neck opening. Stretch the fabric tight, straight, and smooth between the wires, pin in place, and allow to dry thoroughly.

SHAPE SHOULDERS AND COWL

Return held back sts onto needle and join for working in rnds; start of rnd is at beg of front sts where working yarn is attached—198 (230, 262, 294, 326) sts.

Remove end-of-rnd marker, sl 1 first front st purlwise with yarn in back (wyb), replace marker—last 2 sts of rnd are now 2 twisted edge sts, 1 st each from front and back on each side of armhole opening.

Work Rnd 1 of Chart E-1; each k2tog is worked over 2 twisted edge sts to join the top of an armhole—196 (228, 260, 292, 324) sts rem.

Work Rnds 2–6 of Chart E-1—184 (216, 248, 280, 312) sts rem.

Work Rnds 1–6 of Chart E-2 (see page 53), working each patt rep box 10 (12, 14, 16, 18) times—168 (200, 232, 264, 296) sts rem.

Sizes 45¼ (50¾, 56)" (115 [129, 142] cm) only

Work Rnds 1–6 of Chart E-2 once more, working each patt rep box 13 (15, 17) times—216 (248, 280) sts rem.

Sizes 50¾ (56)" (129 [142] cm) only

Work Rnds 1–6 of Chart E-2 once more, working each patt rep box 14 (16) times—232 (264) sts rem.

All sizes

Piece measures 1¼ (1¼, 1¾, 2½, 2½)" (3.2 [3.2, 4.5, 6.5, 6.5] cm) from joining rnd at beg of Chart E-1; for blocking purposes, this is the top of the shoulder slope.

Cont on 168 (200, 216, 232, 264) sts as foll:

Work Rnds 1–12 of Chart E-3—160 (192, 208, 224, 256) sts rem.

Work Rnds 1–12 of Chart F 4 (3, 3, 3, 3) times, working patt rep box 20 (24, 26, 28, 32) times.

Note: To adjust cowl length, add or subtract chart repeats here, ending with Rnd 12 of chart. Every 12-round repeat added or removed will lengthen or shorten the cowl by about 1¼" (3.2 cm).

Work Rnds 1–18 of Chart G, working each patt rep box 8 (10, 11, 12, 14) times—144 (176, 192, 208, 240) sts rem.

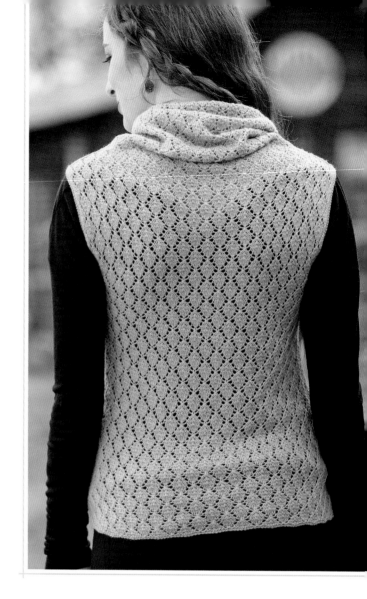

Cont according to your size as foll:

Size 34¾" (88.5 cm) only

Work Rnds 1–12 of Chart F twice, working patt rep box 18 times.

Work Rnds 1–18 of Chart G, working each patt rep box 7 times, and changing to smaller cir needle at beg of Rnd 11—128 sts rem.

Size 40" (101.5 cm) only

Work Rnds 1–12 of Chart F, working patt rep box 22 times.

Work Rnds 1–18 of Chart G, working each patt rep box 9 times—160 sts rem.

Work Rnds 1–12 of Chart F, working patt rep box 20 times

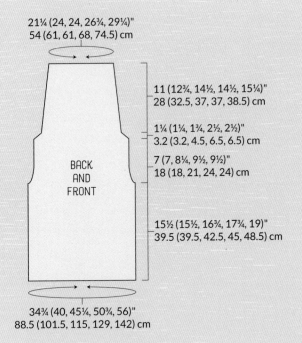

21¼ (24, 24, 26¾, 29¼)"
54 (61, 61, 68, 74.5) cm

11 (12¾, 14½, 14½, 15¼)"
28 (32.5, 37, 37, 38.5) cm

1¼ (1¼, 1¾, 2½, 2½)"
3.2 (3.2, 4.5, 6.5, 6.5) cm

7 (7, 8¼, 9½, 9½)"
18 (18, 21, 24, 24) cm

BACK
AND
FRONT

15½ (15½, 16¾, 17¾, 19)"
39.5 (39.5, 42.5, 45, 48.5) cm

34¾ (40, 45¼, 50¾, 56)"
88.5 (101.5, 115, 129, 142) cm

CHART A

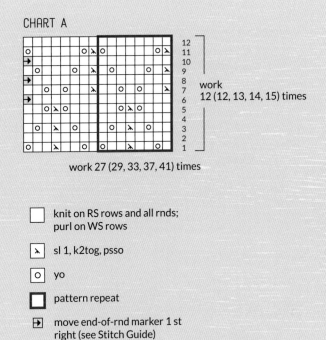

work
12 (12, 13, 14, 15) times

work 27 (29, 33, 37, 41) times

☐ knit on RS rows and all rnds;
purl on WS rows

↗ sl 1, k2tog, psso

○ yo

☐ pattern repeat

→ move end-of-rnd marker 1 st
right (see Stitch Guide)

Work Rnds 1–18 of Chart G, working each patt rep box 8 times, changing to smaller cir needle at beg of Rnd 11—144 sts rem.

Sizes 45¼ (50¾)" (115 [129] cm) only

Work Rnds 1–12 of Chart F, working patt rep box 24 (26) times.

Work Rnds 1–18 of Chart G, working each patt rep box 10 (11) times—176 (192) sts rem.

Work Rnds 1–12 of Chart F, working patt rep box 22 (24) times.

Work Rnds 1–18 of Chart G, working each patt rep box 9 (10) times—160 (176) sts rem.

Work Rnds 1–18 of Chart G once more, working each patt rep box 8 (9) times, changing to smaller cir needle at beg of Rnd 11—144 (160) sts rem.

Size 56" (142 cm) only

Work Rnds 1–12 of Chart F, working patt rep box 30 times.

Work Rnds 1–18 of Chart G, working each patt rep box 13 times—224 sts rem.

Work Rnds 1–18 of Chart G, working each patt rep box 12 times—208 sts rem.

Work Rnds 1–18 of Chart G, working each patt rep box 11 times—192 sts rem.

Work Rnds 1–18 of Chart G, working each patt rep box 10 times, and changing to smaller cir needle at beg of Rnd 11—176 sts rem.

All sizes

Purl 1 rnd, then knit 1 rnd—110 (128, 146, 146, 152) rnds total from top of shoulders at end of Chart E-2; piece measures about 11 (12¾, 14½, 14½, 15¼)" (28 [32.5, 37, 37, 38.5] cm) from top of shoulders.

Note: The following bind-off creates a naturally stretchy edge, so there's no need to work it loosely.

Working firmly, BO as foll: P2, *return these 2 sts onto left needle tip, k2tog through back loop (tbl), return this st onto left needle tip, p1; rep from *.

FINISHING

Use CO tail to close small opening at lower body edge.

Note: Do not be afraid to pull fabric tight to block. Wet-block to measurements (see Notes for armholes), evening out sides of cowl by placing blocking wires through sides and stretching them out into a cone shape with the smaller end on top. Run the ends of blocking wires out through armholes and pin in place. Run blocking wires through sides of shell, coming out through the armholes and the bottom. Pin securely to measurements. Allow to air-dry thoroughly before unpinning.

ARMHOLE EDGING

With shorter cir needle in smaller size, RS facing, and beg at base of armhole, pick up and knit 108 (120, 132, 144, 156) sts evenly spaced around armhole opening (about 9 [10, 10, 9, 10] sts for every 12 patt rows). Pm and join for working in rnds.

Rnd 1: *K1tbl; rep from *.

Rnd 2: Purl.

Rnd 3: Knit.

BO firmly as for neck opening.

If necessary, re-block armholes to measure about 8 (9, 10, 10½, 11½)" (20.5 [23, 25.5, 26.5, 29] cm) high.

Weave in loose ends.

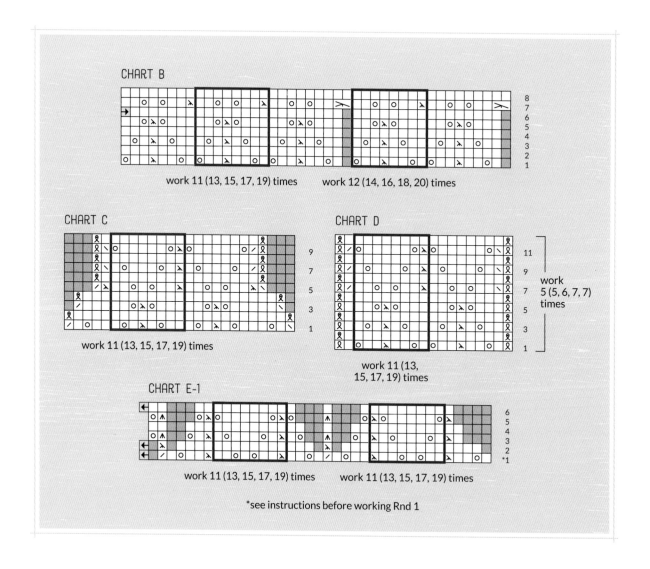

CHART B

work 11 (13, 15, 17, 19) times work 12 (14, 16, 18, 20) times

CHART C

work 11 (13, 15, 17, 19) times

CHART D

work 11 (13, 15, 17, 19) times

work 5 (5, 6, 7, 7) times

CHART E-1

work 11 (13, 15, 17, 19) times work 11 (13, 15, 17, 19) times

*see instructions before working Rnd 1

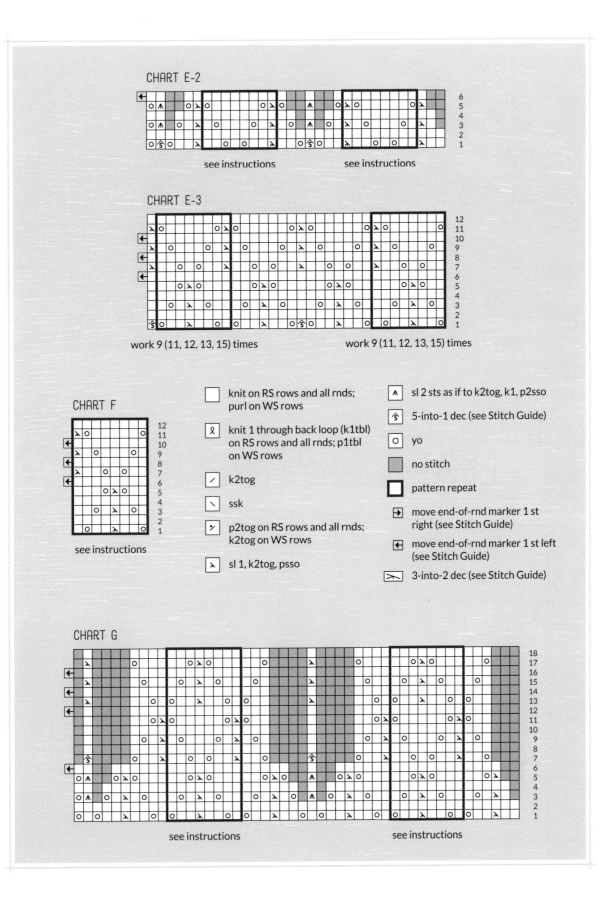

CHART E-2

see instructions see instructions

CHART E-3

work 9 (11, 12, 13, 15) times work 9 (11, 12, 13, 15) times

CHART F

see instructions

	knit on RS rows and all rnds; purl on WS rows
Ⴘ	knit 1 through back loop (k1tbl) on RS rows and all rnds; p1tbl on WS rows
╱	k2tog
╲	ssk
⥅	p2tog on RS rows and all rnds; k2tog on WS rows
⅄	sl 1, k2tog, psso

⋀	sl 2 sts as if to k2tog, k1, p2sso
5̂	5-into-1 dec (see Stitch Guide)
○	yo
▨	no stitch
▢	pattern repeat
→	move end-of-rnd marker 1 st right (see Stitch Guide)
←	move end-of-rnd marker 1 st left (see Stitch Guide)
⋈	3-into-2 dec (see Stitch Guide)

CHART G

see instructions see instructions

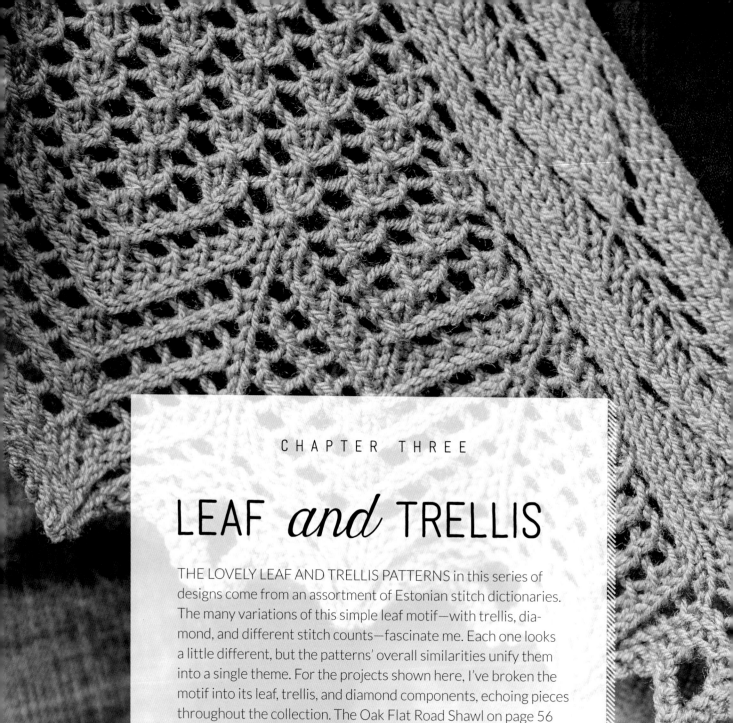

CHAPTER THREE

LEAF *and* TRELLIS

THE LOVELY LEAF AND TRELLIS PATTERNS in this series of designs come from an assortment of Estonian stitch dictionaries. The many variations of this simple leaf motif—with trellis, diamond, and different stitch counts—fascinate me. Each one looks a little different, but the patterns' overall similarities unify them into a single theme. For the projects shown here, I've broken the motif into its leaf, trellis, and diamond components, echoing pieces throughout the collection. The Oak Flat Road Shawl on page 56 features the leaf portion of the motif as spine and edging, while the Aspengold Scarf on page 78 adds a diamond to the same leaf motif. The Hope Valley Flounce Skirt on page 64 brings all the elements together as a progression: diamonds, chevrons, and leaves. Then, in the Winter Wheat Shawl on page 70, the diamond is separated and shown with variations, completely changing the look of the overall stitch pattern.

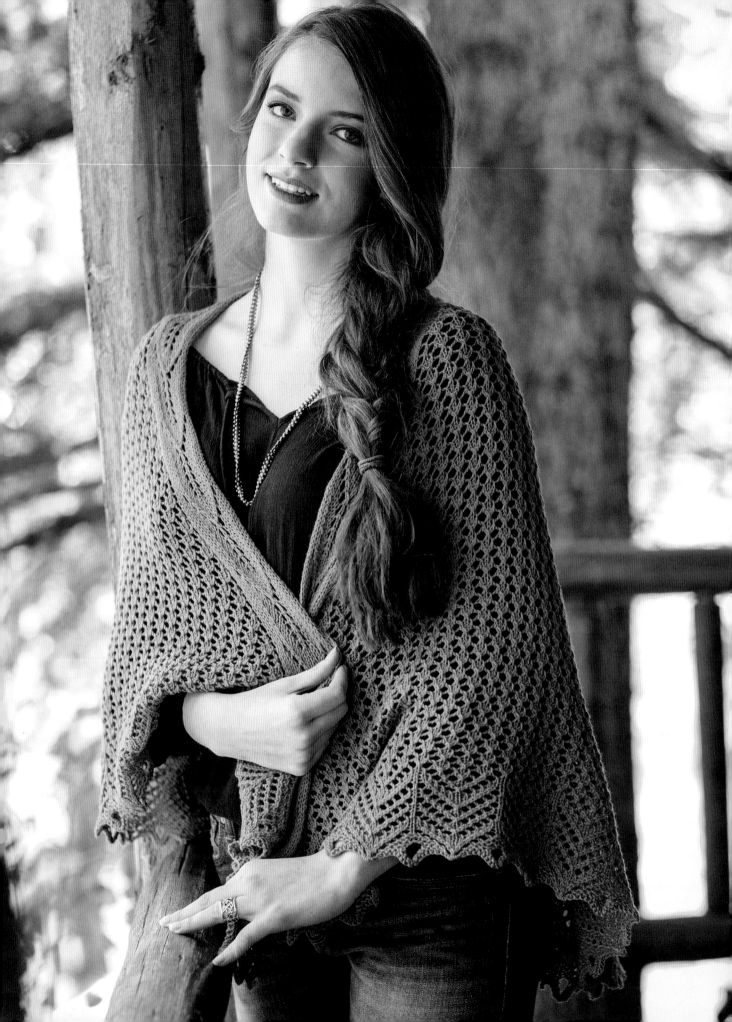

OAK FLAT ROAD
shawl

Knitted from a springy and delicious blend of merino and silk, this shawl is perfect when the temperature drops. Striking leaf panels run down two spines and around the edges to frame and enhance the simple allover lace pattern that makes up the body. The shawl is worked from the top down, beginning with a garter-stitch tab at the center neck and ending with a decorative—and very stretchy—bind-off.

FINISHED SIZE
About 65" (165 cm) wide across top edge and 30" (76 cm) long.

YARN
Fingering weight (#1 Super Fine).

Shown here: Quince & Company Tern (75% wool, 25% silk; 221 yd [202 m]/50 g): #146 kelp, 5 skeins.

NEEDLES
Size U.S. 6 (4 mm): 24" or 32" (60 or 80 cm) circular (cir) needle.

Adjust needle size if necessary to obtain the correct gauge.

NOTIONS
Stitch holder or spare cir needle (same size or smaller than main needle); markers (m); removable marker; waste yarn; size E/4 (3.5 mm) crochet hook for provisional cast-on; tapestry needle; blocking wires; T-pins.

GAUGE
16 sts and 22 rows = 4" (10 cm) in stitch pattern from Chart D.

notes

» The beginning of this shawl requires that you either break the yarn at the end of Chart A in order to start over again with Chart B, or use a separate ball of yarn for each chart. You can also wind a single skein of yarn so that both ends are available, then use one end for Chart A and the other end for Chart B. Do not break the yarn at the end of Chart A until you're certain that you won't need to rip out and start over.

» Charts D, E, and F have minor pattern repeats (outlined in green) within the main pattern repeats (outlined in red). For each of these charts, always work the main red pattern repeat box twice.

» In Chart D, each green minor repeat box has a series of numbers below it to indicate how many times to work those stitches. The series number to follow depends on how many times Chart D has already been worked. For example, the first time you work Rows 1–18 of Chart D, there will only be enough stitches to work each green box 2 times, and 2 is the first number in the series. The second time you work Chart D, there will be enough new stitches to work each green box 5 times, and 5 is the second number in the series. Continue in this manner until the sixth and final appearance of Chart D, when there will be enough stitches to work each green box 17 times, the last number in the series.

» In Charts E and F, work each green box the number of times shown below the box. Each of these charts is worked only one time, so the green boxes do not need a series of numbers.

» If you use markers to set off pattern repeats, you'll need to move each marker one stitch to the left to accommodate the double decrease before the first green minor repeat and at the end of each green minor repeat in Rows 3, 7, 11, and 15 of Chart D, and Rows 3, 7, 11, and 15 of Chart E.

» In Row 9 of Chart F, you'll need to move the marker at the start of each red major repeat one stitch to the right.

STARTING RECTANGLE

With waste yarn and crochet hook, use a provisional method (see Glossary) to CO 16 sts. Change to main yarn and purl 1 WS row.

Work Rows 1–26 of Chart A.

Place sts onto holder or spare cir needle.

Hold piece with RS facing and upside down so provisional CO runs across the top. Insert tip of working cir needle under 1 garter bump at starting edge to pick up 1 loop, then carefully remove waste yarn from provisional CO and place 15 exposed loops onto working cir needle—16 sts. With WS facing, join a second ball of yarn (or other end of the same skein; see Notes).

Transition row: (WS) K1 through back loop (tbl), p9, p2tog, p2, M1P (see Stitch Guide), [k1tbl] 2 times—still 16 sts.

Work Rows 1–26 of Chart B. Leave sts on needle and do not break the yarn attached to Chart B; yarn attached to Chart A may be cut now if the piece looks correct.

SHAWL BODY

Note: The starting rectangle created by mirror-image Charts A and B will have 2 twisted selvedge stitches along one edge and a single twisted selvedge stitch along the other. When picking up stitches, pick up along the edge with the single twisted stitch, making sure to pick up one full stitch in from the edge so that the twisted stitch is not visible from the right side.

Place removable marker in the transition row at the center of the diamond formed where Charts A and B meet.

Set-up row: (RS; Row 1 of Chart C) With working yarn attached to end of Chart B, work first 15 sts of Chart C (see page 61) over 16 Chart B sts, dec as shown—15 sts. Rotate the piece 90 degrees so the pick-up edge runs horizontally across the top. With RS still facing, work

stitch guide

M1P: Insert left needle tip from back to front under the horizontal strand between the needles, then purl the lifted strand—1 st inc'd.

Stretchy BO: K2, *return 2 sts to left needle tip, k2tog through back loop (tbl), k1; rep from * until 2 sts rem on right needle, return 2 sts to left needle tip, k2togtbl—1 st rem. Fasten off rem st.

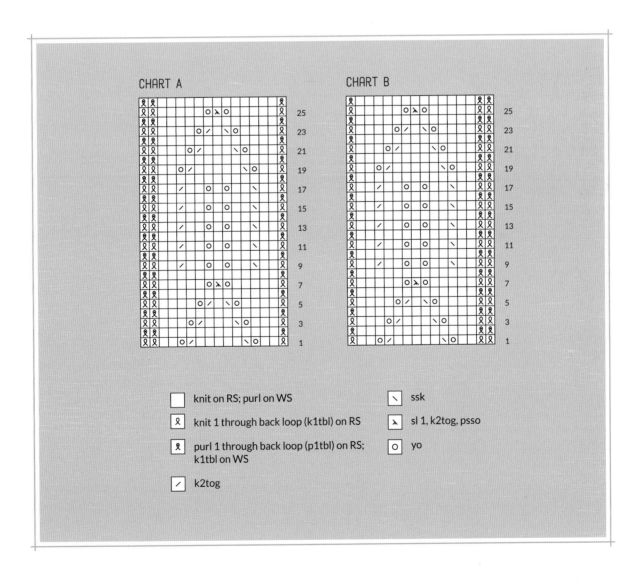

CHART A

CHART B

knit on RS; purl on WS

knit 1 through back loop (k1tbl) on RS

purl 1 through back loop (p1tbl) on RS; k1tbl on WS

k2tog

ssk

sl 1, k2tog, psso

yo

red patt rep box of Chart C twice to create 28 new sts as foll: *Yo, pick up and knit 13 sts (1 st for every 2 rows)* to end at marker in center of diamond, remove marker, rep from * to * once more—43 sts. Rotate the piece 90 degrees again so the 16 live sts of Chart A are across the top. With RS still facing, work the last 16 sts of Chart C over 16 Chart A sts—59 sts total.

Work Rows 2–18 of Chart C—101 sts.

Work Row 1 of Chart D, working each green repeat box 2 times (see Notes)—107 sts.

Work Rows 2–18 of Chart D—155 sts.

Work Rows 1–18 of Chart D 5 more times, working each green box the number of times required—425 sts.

Work Row 1 of Chart E (see pages 62 and 63), working each green box 10 times—431 sts.

Work Rows 2–18 of Chart E—491 sts.

Work Row 1 of Chart F (see pages 62 and 63), working each green box 11 times—497 sts

Work Rows 2–14 of Chart F—527 sts.

Work Rows 1–3 of Chart G (see page 62), ending with a RS row—795 sts.

With WS facing, use the stretchy method (see Stitch Guide) to BO all sts knitwise.

FINISHING

Wash in wool wash. Gently squeeze out water, then roll in towels to remove excess moisture. Insert straight blocking wires through the straight long side of damp shawl. Insert flexible blocking wires through the ends of the three sections, place on a flat surface, and pin out the points. Smooth the large yarnovers between the chevrons, and pin each with two T-pins each so that they're open but not stretched lengthwise. Allow to air-dry thoroughly before removing wires and pins.

Weave in loose ends.

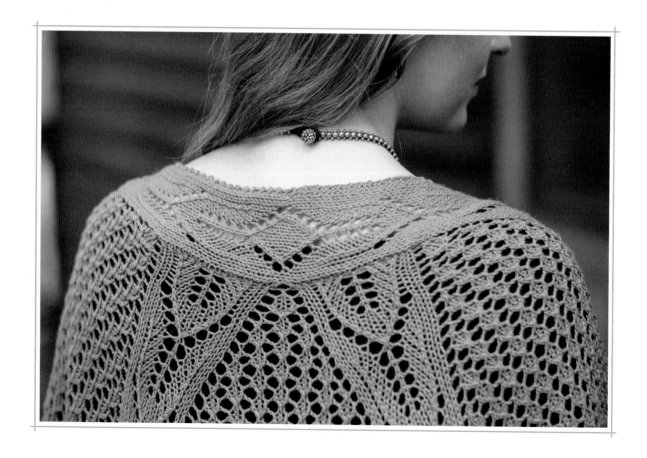

work 6 times

17 *15 13 *11 9 *7 5 *3 1

17 15 13 11 9 7 5 3 1

work 2 times
see instructions for Row 1

work 2, 5, 8, 11, 14, 17 times

work 2 times
*see Notes

work 2, 5, 8, 11, 14, 17 times

CHART C

CHART D

+ pick up and knit 1 st (see instructions)

no stitch

main pattern repeat (see Notes)

minor pattern repeat (see Notes)

\ k2tog

/ ssk

⅄ sl 1, k2tog, psso

o yo

knit on RS; purl on WS

· purl on RS; knit on WS

⋈ knit 1 through back loop (k1tbl) on RS

⋈ purl 1 through back loop (p1tbl) on RS;
k1tbl on WS

CHART E

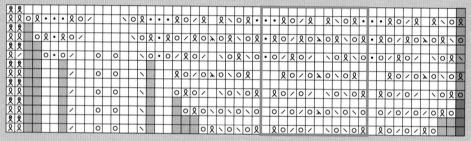

work 10 times

Note: Stitches shaded in blue are duplicated for ease of following the two halves of the chart. Work the shaded stitches only once.

CHART F

work 11 times

Note: Stitches shaded in purple are duplicated for ease of following the two halves of the chart. Work the shaded stitches only once.

CHART G

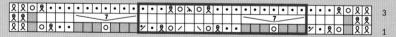

work 43 times

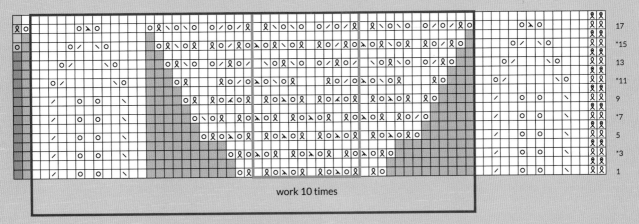

work 10 times

work 2 times
*see Notes

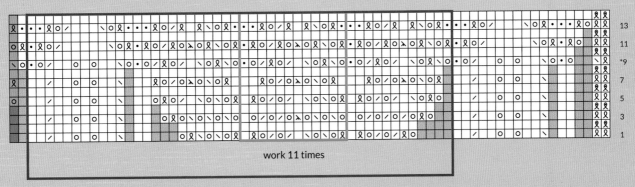

work 11 times

work 2 times
*see Notes

	knit on RS; purl on WS		∕	k2tog		○	yo
	purl on RS; knit on WS		⟍	ssk			no stitch
ℛ	knit 1 through back loop (k1tbl) on RS		⟋	p2tog			main pattern repeat (see Notes)
ℛ	purl 1 through back loop (p1tbl) on RS; k1tbl on WS		⟑	sl 1, k2tog, psso			minor pattern repeat (see Notes)
			⟑	k3tog		7	work [k1, p1] 3 times, k1 into yo

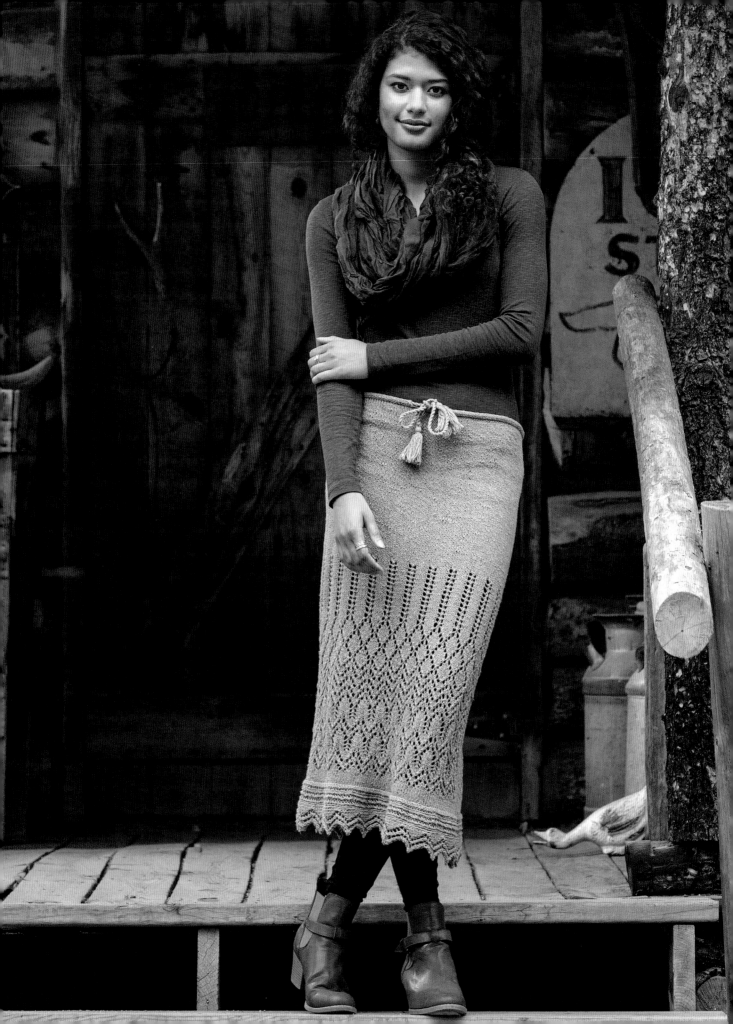

HOPE VALLEY
flounce

When I designed this lacy denim skirt, I envisioned wearing it with cowboy boots and a ruffled underskirt (I love that the yarn is made from recycled blue jeans!). The skirt combines all the elements of the leaf and trellis variants, and, as a bonus, features a great knitted-on edging that echoes the diamond motif! It's a perfect combination of skill building interspersed with relaxing rounds of simple knitting.

FINISHED SIZE
About 32 (34¼, 36¾, 39, 41½, 43¾, 46¼)" (81.5 [87, 93.5, 99, 105.5, 111, 117.5] cm) hip circumference, after washing and blocking (to be worn with negative ease; see Notes on page 66).

Skirt shown measures 32" (81.5 cm).

YARN
Sport weight (#2 Fine).

Shown here: Kollàge Riveting Sport (95% cotton, 5% other, made from recycled jeans); 350 yd [320 m]/100 g): #7901 Storm Denim, 4 (4, 4, 5, 5, 5, 6) skeins.

NEEDLES
Skirt: sizes U.S. 3 and 4 (3.25 and 3.5 mm): 24" (60 cm) circular (cir).

Edging: size U.S. 4 (3.5 mm): 2 double-pointed (dpn).

Drawstring casing: size U.S. 7 (4.5 mm): 1 dpn (see Notes on page 66).

Adjust needle size if necessary to obtain the correct gauge.

NOTIONS
Markers (m); waste yarn; size E/4 (3.5 mm) crochet hook for provisional CO; tapestry needle; blocking wires; T-pins; 3" (7.5 cm) cardboard square for making tassels.

GAUGE
27 sts and 29 rnds = 4" (10 cm) in St st on larger needles.

24 sts and 26 rnds = 4" (10 cm) in Chart B pattern on larger needles.

» Because the cotton yarn will stretch during wear, this skirt is designed to be worn with 1" to 2" (2.5 to 5 cm) negative ease. Choose a size that's at least 1" (2.5 cm) smaller than your actual hip circumference.

» To minimize the chance of twisting the stitches, one row is knitted before the stitches are joined for working in rounds. The small opening created by the first row will be concealed by the I-cord drawstring casing.

» The edging begins with a provisional cast-on and is worked perpendicular to the skirt, then the ends are grafted together. See Knitted-On Edgings on page 136.

» The loops picked up from the provisional cast-ons of the edging and skirt lie between actual stitches, so there will be one fewer than the number of stitches required. To make up the one-loop deficit, create an extra loop by slipping the needle under one leg of an edging selvedge stitch, or under the strand between the first and last skirt stitches.

» Depending on how loosely or tightly you work, you may need to adjust the size of the needle used for the I-cord drawstring casing. Choose a needle size that creates a smooth join at the waist so that the skirt fabric neither puckers nor stretches.

SKIRT

With waste yarn and smaller cir needle, use a provisional method (see Glossary) to CO 208 (224, 240, 256, 272, 288, 304) sts.

Change to working yarn and knit 1 row.

With knit side still facing, place marker (pm) and join for working in rnds, being careful not to twist sts; rnd begins at center back.

Work even in St st (knit every rnd) until piece measures 2" (5 cm) from CO.

Change to larger cir needle and work in St st until piece measures 4" (10 cm) from CO.

SHAPE HIPS

Rnd 1: K26 (28, 30, 32, 34, 36, 38), [M1 (see Stitch Guide), k52 (56, 60, 64, 68, 72, 76)] 3 times, M1, k26 (28, 30, 32, 34, 36, 38)—212 (228, 244, 260, 276, 292, 308) sts.

Rnds 2, 3, and 4: Knit.

Rnd 5: K27 (29, 31, 33, 35, 37, 39), M1, k52 (56, 60, 64, 68, 72, 76), M1, k54 (58, 62, 66, 70, 74, 78), M1, k52 (56, 60, 64, 68, 72, 76), M1, k27 (29, 31, 33, 35, 37, 39)—216 (232, 248, 264, 280, 296, 312) sts.

Work even in St st until piece measures 11 (11½, 12, 12½, 13, 13½, 14)" (28 [29, 30.5, 31.5, 33, 34.5, 35.5] cm) from CO.

LACE FLOUNCE

Work Rnds 1 and 2 of Chart A (see page 68) 12 times.

Work Rnds 1–6 of Chart B.

Remove end-of-rnd marker, k1, replace marker.

Work Rnds 7–12 of Chart B.

Work Rnds 1–12 of Chart B once more, moving marker after Rnd 6 as before.

Work Rnds 1–4 of Chart C 4 times.

Work Rnds 1–16 of Chart D 2 times.

Work Rnds 1–10 of Chart E.

Set aside. Do not cut yarn.

EDGING

With waste yarn and smaller dpn, provisionally CO 17 sts.

Turn skirt so WS is facing and use the working yarn still attached to skirt to p17 CO sts onto cir needle, taking care to tighten yarn between skirt and provisional CO.

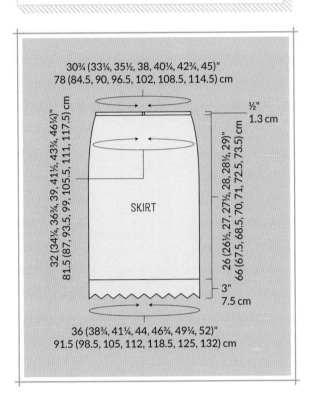

Work Rows 1–16 of Chart F 27 (29, 31, 33, 35, 37, 39) times, working last edging st tog with 1 live skirt st at end of every RS row—17 edging sts rem; all skirt sts have been joined. Break yarn, leaving a 16" (40.5 cm) tail for grafting.

Carefully remove waste yarn from edging CO and place 17 exposed sts onto empty smaller dpn (see Notes). Hold the two needles parallel with WS of lace facing tog. With grafting tail threaded on a tapestry needle, use the Kitchener st (see Glossary) to graft the two groups of sts tog, matching the tension of the lace patt, and taking care not to pull the grafting tight until you're pleased with the results. Fasten off and weave in end.

DRAWSTRING CASING

Carefully remove waste yarn from provisional CO at top of skirt and place 208 (224, 240, 256, 272, 288, 304) exposed sts onto smaller cir needle (see Notes). Sl the first 104 (112, 120, 128, 136, 144, 152) sts purlwise without working them to end at center front.

With RS facing, join yarn and use the knitted method (see Glossary) to CO 5 sts onto left needle tip. Work 5-st I-cord using larger dpn as foll: *K4, k2tog through back loop (tbl; last I-cord st tog with 1 skirt st), return 5 sts onto left needle tip; rep from * until 6 sts rem on left needle (5 I-cord sts and 1 skirt st). BO 4 sts, return last st onto left needle tip, k2togtbl—1 st rem. Fasten off last st.

Weave in ends, leaving the casing open at center front for inserting the drawstring later.

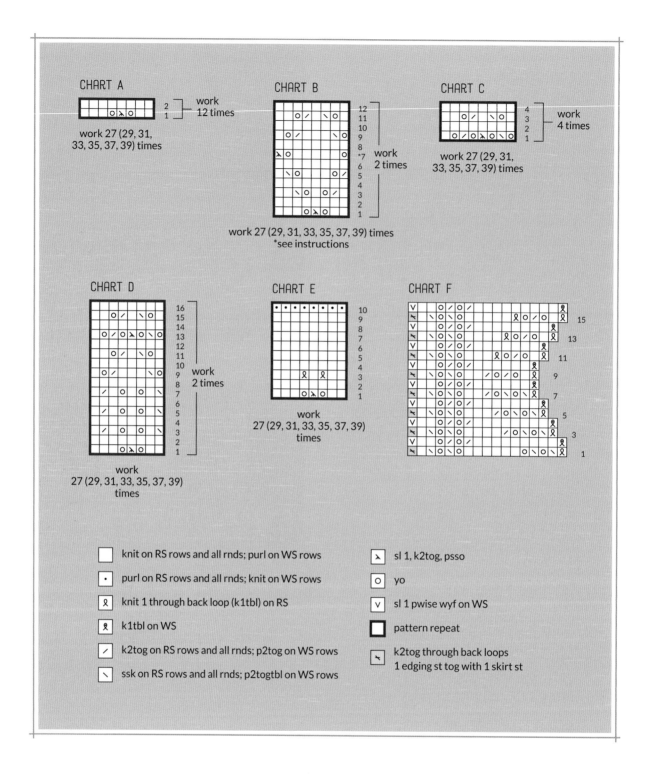

CHART A

work 27 (29, 31, 33, 35, 37, 39) times

CHART B

work 27 (29, 31, 33, 35, 37, 39) times
*see instructions

CHART C

work 27 (29, 31, 33, 35, 37, 39) times

CHART D

work 27 (29, 31, 33, 35, 37, 39) times

CHART E

work 27 (29, 31, 33, 35, 37, 39) times

CHART F

knit on RS rows and all rnds; purl on WS rows

· purl on RS rows and all rnds; knit on WS rows

knit 1 through back loop (k1tbl) on RS

k1tbl on WS

∕ k2tog on RS rows and all rnds; p2tog on WS rows

∖ ssk on RS rows and all rnds; p2togtbl on WS rows

ㅅ sl 1, k2tog, psso

o yo

v sl 1 pwise wyf on WS

pattern repeat

k2tog through back loops
1 edging st tog with 1 skirt st

FINISHING

Wash skirt, being careful to rinse thoroughly if you must use wool wash (not recommended for cotton yarn).

Gently squeeze out water, then roll in towels to remove excess moisture. Insert blocking wires inside skirt along each side, then pull tight to the correct width. Pin to a flat surface, pinning drawstring casing straight across the top. Pull skirt down to the correct length, and pin out the points of the edging so it measures about 3" (7.5 cm) at deepest point. Allow to air-dry completely before removing pins and wires.

Weave in loose ends.

DRAWSTRING

Measure 6 strands of yarn, each 7¾ (8, 8¼, 8½, 9, 9¼, 9½) yd (7 [7.25, 7.5, 7.75, 8.25, 8.5, 8.75] m) long, or about 5 times the desired finished drawstring length. Fold the strands in half to form two equal groups of 6 strands (12 strands total). Anchor the strands at the fold by looping them over a doorknob. Holding one group in each hand, twist the groups tightly in one direction until they begin to kink. Transfer both groups to the same hand, then release them, allowing the groups to twist around each other. Smooth out the twists so they're uniform along the length of the cord. Trim to 55 (57, 60, 62, 64, 67, 69)" (139.5 [145, 152.5, 157.5, 162.5, 170, 175] cm) if necessary (about 24" [61 cm] longer than waist circumference), and tie an overhand knot at each end. Thread drawstring through I-cord casing, beg and ending at center front.

TASSELS (MAKE 2)

Wrap yarn to desired thickness around a 3" (7.5 cm) cardboard square. Cut a short length of yarn, slip it under the wrapped strands at one edge of the card-board, and tie the ends tightly to secure the top of the tassel's head. Cut the yarn loops at the opposite edge of the cardboard. Cut another piece of yarn and wrap it tightly around the entire tassel bundle about ½" (1.3 cm) below the head to form the tassel's neck. Knot securely, thread the ends on a tapestry needle, and conceal in center of tassel. Trim loose ends even. Attach one tassel to each end of drawstring.

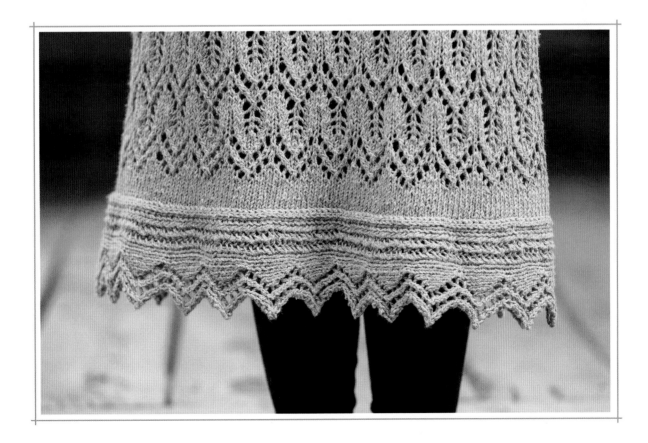

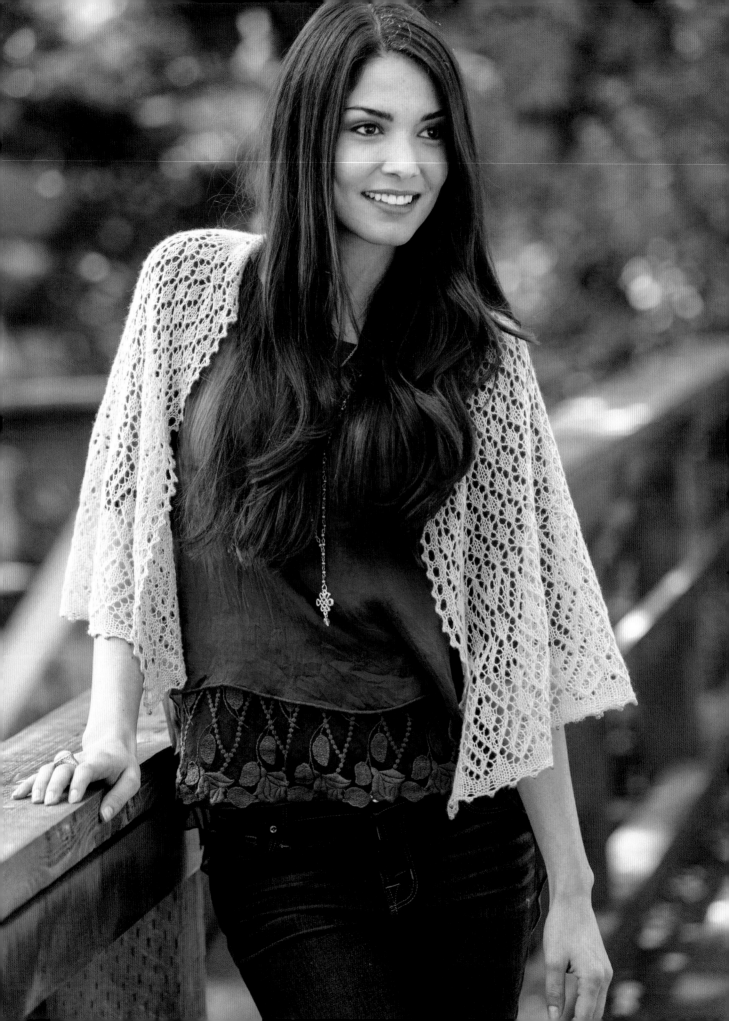

WINTER WHEAT
shawl

The diamond motif in this shawl includes a variation on a variation! The diamond—pulled from the full motif—is shown plain as well as expanded into its own variation. Knitted in a scrumptious lighter-than-air cashmere singles yarn, it begins with subtle shoulder shaping at the top and ends with a beaded bind-off that adds just the right amount of weight for lovely drape. Choose beads that blend with the yarn for a sparkly surprise with even the slightest movement.

FINISHED SIZE
About 56" (142 cm) wide and 24" (61 cm) long.

YARN
Lace weight (#0 Lace).

Shown here: Artyarns Cashmere 1 (100% cashmere; 510 yd [466 m]/50 g): #270 Maize, 1 skein.

NEEDLES
Size U.S. 4 (3.5 mm): 24" or 32" (60 or 80 cm) circular (cir).

Adjust needle size if necessary to obtain the correct gauge.

NOTIONS
Cable needle (cn); tapestry needle; waste yarn; 68 size 6/0 seed beads; size 8 (1.5 mm) steel crochet hook (or size to fit through hole in beads); flexible blocking wires; T-pins.

GAUGE
24 sts and 32 rows = 4" (10 cm) in Chart E pattern.

notes

» The loops picked up from the provisional cast-on lie between actual stitches, so there will be one fewer than the number of stitches required. To make up the one-loop deficit, create an extra loop at one side by slipping the needle under one leg of an edge stitch.

» If you use markers to set off the repeats, you'll need to move each marker one stitch to the left on odd-numbered Rows 3–17 of Chart C to accommodate the single decreases at the start of each repeat and after the last repeat.

» You'll also need to move the markers one stitch to the left to accommodate the double decrease before the first repeat and at the end of each repeat on Row 31 of Chart C, Row 5 of Chart D, Row 5 of Chart E, Row 5 of Chart F, and Rows 3 and 11 of Chart G.

stitch guide

M1: Insert left needle tip from back to front under the horizontal strand between the needles, then knit the lifted strand through the front loop to twist it—1 st inc'd.

Twist 3 inc: Sl 3 sts onto cn, twist right tip of cn toward you and then to the left so you're looking at the back side of the sts on cn, then (work [k1, yo] 2 times, k1) from cn—5 sts made from 3 sts; mimics the appearance of a left-leaning double dec while inc 2 sts.

Twist 3: Sl 3 sts onto cn; twist right tip of cn toward you and then to the left so you're looking at the back side of the sts on cn, then k3 from cn—3 sts made from 3 sts; mimics the appearance of a left-leaning double dec with no change to st count.

Place bead: Slide bead onto crochet hook, insert hook in next st, remove st from left needle, pull loop of st up through top of bead, then slide the bead down onto the st.

SHAWL

With waste yarn, use a provisional method (see Glossary) to CO 4 sts.

Change to main yarn and knit 2 rows.

Work Rows 1–7 of Chart A, ending with a RS row— 6 sts.

Next row: (WS) BO 2 sts (1 st rem on right needle after BO), k3—4 sts.

With WS still facing, rotate work 90 degrees clockwise so straight edge of tab is across the top, work [yo, pick up and knit 1 st] 4 times, yo, along straight edge—13 sts.

Carefully remove waste yarn from provisional CO, k4 exposed sts (see Notes)—17 sts.

Work Rows 1–12 of Chart B—30 sts.

Work Row 1 of Chart C—53 sts.

Work Rows 2–34 of Chart C—143 sts.

Work Row 1 of Chart D (see page 75)—187 sts.

Work Rows 2–8 of Chart D—209 sts.

Work Rows 1–8 of Chart E 6 times.

Work Row 1 of Chart F—275 sts.

Work Rows 2–8 of Chart F.

Work Rows 1–20 of Chart G (see page 76) 2 times.

Work Rows 1–6 of Chart H—273 sts.

FINISHING

BO while placing beads as foll: BO 2 sts, return st from right needle onto left needle tip, *use the knitted method (see Glossary) to CO 3 sts, k2tog through back loop (tbl), place bead (see Stitch Guide), return beaded st onto left needle tip, [k1tbl, pass first st on right needle

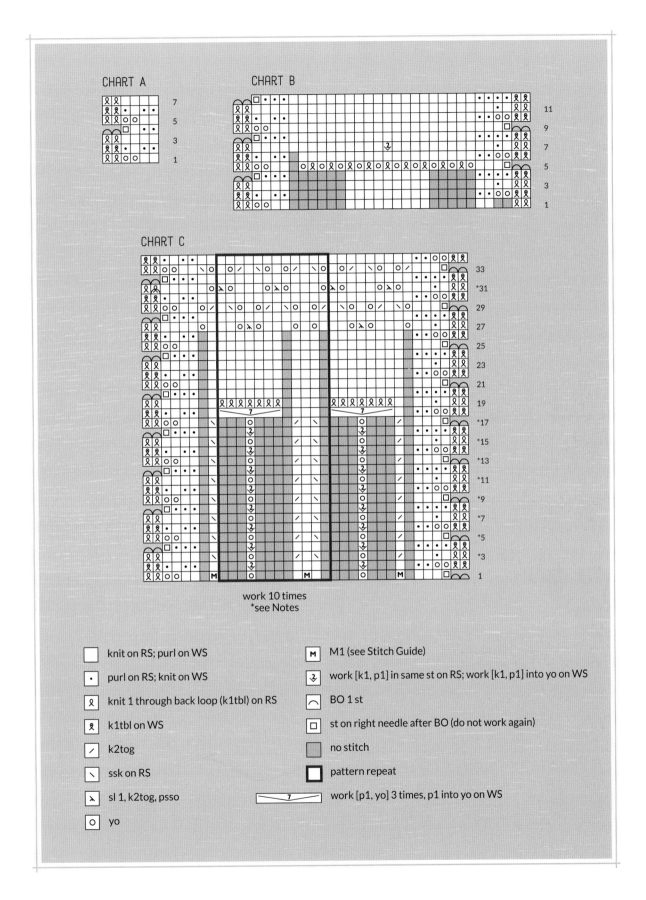

CHART A

CHART B

CHART C

work 10 times
*see Notes

	knit on RS; purl on WS		M	M1 (see Stitch Guide)
·	purl on RS; knit on WS		⅌	work [k1, p1] in same st on RS; work [k1, p1] into yo on WS
ℛ	knit 1 through back loop (k1tbl) on RS		⌒	BO 1 st
ℛ	k1tbl on WS		☐	st on right needle after BO (do not work again)
∕	k2tog			no stitch
∖	ssk on RS		☐	pattern repeat
⅄	sl 1, k2tog, psso		7	work [p1, yo] 3 times, p1 into yo on WS
o	yo			

over second st] 2 times, BO 4 sts, return st on right needle after last BO onto left needle tip; rep from * until 3 sts rem, CO 3 sts, k2togtbl, place bead, return beaded st onto left needle tip, [k1tbl, pass first st on right needle over second st] 2 times, return st on right needle onto left needle tip, k3togtbl—1 st rem. Fasten off rem st.

Wash in wool wash. Gently squeeze out water, then roll in towels to remove excess moisture. Insert flexible blocking wires through bead holes along BO edge. Insert wires through the sides of shawl from BO edge to center CO, then place on a flat surface. Pin in place. Allow to air-dry thoroughly before removing wires and pins.

Weave in loose ends.

choosing beads

The beads for this shawl were chosen to blend with the yarn color. They provide a small embellishment that adds weight to the hem and causes the featherlight fabric to hang beautifully.

When choosing beads, remember that the color of transparent or translucent beads will be affected by the yarn—they may look different when attached to the knitting than when held next to the yarn. If it's not possible to knit a swatch, string a bead on the yarn to make sure you like the effect before purchasing the beads.

Keep in mind that not all beads are created equal. Japanese seed beads are the highest quality and the most uniform, so if a small crochet hook fits through one bead, it's likely to fit through all the beads in a package. Other types of beads may not be as uniform and you should purchase extra and select the most well-matched beads.

Before you begin a project, string a few beads onto your yarn and wash the strand as you plan to wash the finished project. Some beads may tarnish, bleed, or otherwise wreak havoc on the yarn.

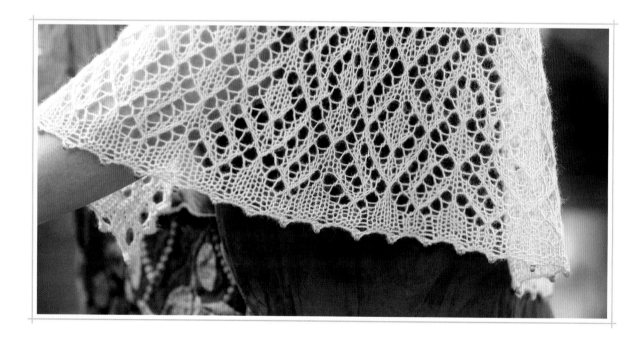

CHART D

work 10 times
*see Notes

7
*5
3
1

CHART E

work 32 times
*see Notes

7
*5
3
1

work
6 times

CHART F

work 16 times
*see Notes

7
*5
3
1

	knit on RS; purl on WS			yo
	purl on RS; knit on WS			BO 1 st
	knit 1 through back loop (k1tbl) on RS			st on right needle after BO (do not work again)
	k1tbl on WS			no stitch
	k2tog			pattern repeat
	ssk on RS			twist 3 (see Stitch Guide)
	sl 1, k2tog, psso			twist 3 inc (see Stitch Guide)

CHART G

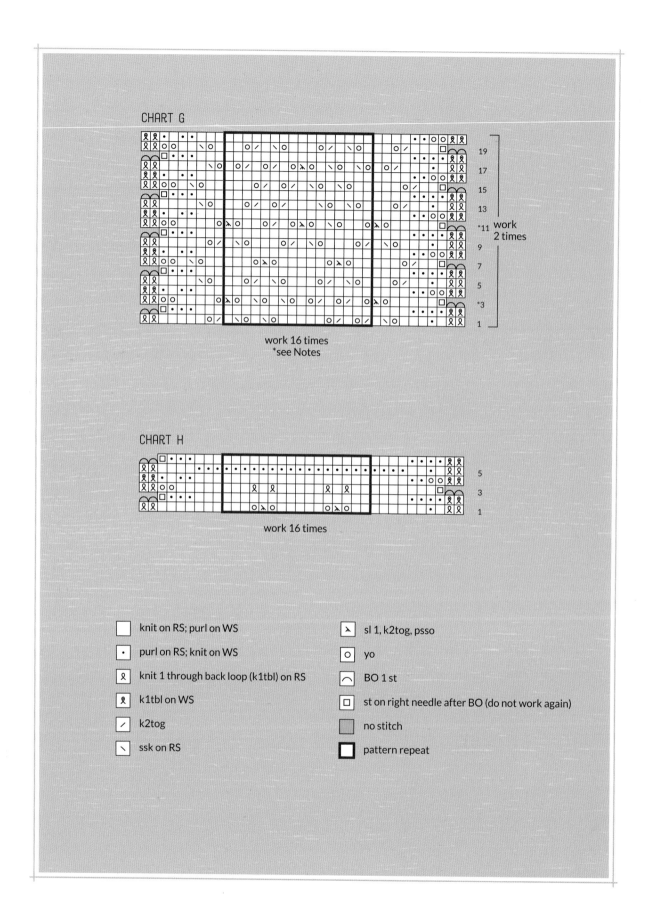

work 16 times
*see Notes

work 2 times

CHART H

work 16 times

	knit on RS; purl on WS
	purl on RS; knit on WS
	knit 1 through back loop (k1tbl) on RS
	k1tbl on WS
	k2tog
	ssk on RS

sl 1, k2tog, psso

yo

BO 1 st

st on right needle after BO (do not work again)

no stitch

pattern repeat

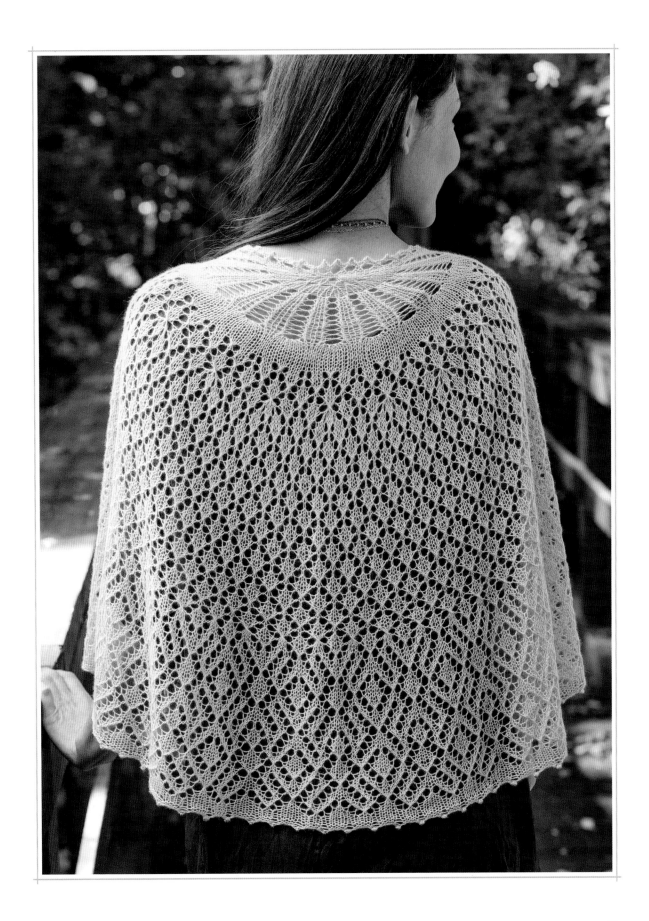

ASPENGOLD
scarf

A single diamond motif is repeated throughout this luxurious scarf. The piece begins with a provisional cast-on, continues with picots worked at each selvedge for a bit of subtle decoration along the length, then ends with an unexpected knitted fringe bind-off. Live stitches from the provisional cast-on are bound off with the same fringe technique for a symmetrical look.

FINISHED SIZE
About 9" (23 cm) wide and 70" (178 cm) long, excluding edge picots and fringe, blocked.

YARN
Fingering weight (#1 Super Fine).

Shown here: All for Love of Yarn Eloquence Fingering (70% superwash Bluefaced Leicester wool, 20% silk, 10% cashmere; 438 yd [400 m]/100 g): Glowing Umber, 1 skein.

NEEDLES
Size U.S. 5 (3.75 mm): straight or 24" (60 cm) circular (cir).

Adjust needle size if necessary to obtain the correct gauge.

NOTIONS
Tapestry needle; crochet hook for provisional CO; mercerized cotton waste yarn; blocking wires; T-pins.

GAUGE
22 sts and 20 rows = 4" (10 cm) in Chart B pattern, blocked.

notes

stitch guide

Edge Picot: Use the knitted method to CO 2 sts, k2togtbl, k1tbl, pass first st on right needle over second st—1 st rem on right needle. Continue as shown on chart.

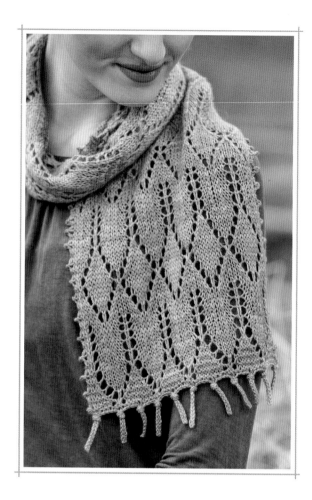

SCARF

With waste yarn and using the crochet-on method (see Glossary), provisionally CO 55 sts.

Change to working yarn and knit 1 WS row.

Work Rows 1–10 of Chart A.

Work Rows 1–52 of Chart B 6 times.

Work Rows 1–44 of Chart C (see page 82).

Work fringe BO as foll: Use the knitted method (see Glossary) to CO 15 sts, then BO 21 sts (15 newly CO sts and 6 scarf sts)—1 st on right needle. *Return last st onto left needle tip, use the knitted method to CO 15 sts, BO 14 sts knitwise while working through the back loops (tbl), k2togtbl, pass first st on right needle over second st, then BO 4 more sts; rep from * 8 more times—4 sts rem (1 st on right needle). BO 2 sts, return last st onto left needle tip, use the knitted method to CO 15 sts, BO 14 knitwise tbl, k2togtbl, pass first st on right needle over second st—1 st rem. Fasten off rem st.

twisted stitches and yarnovers

On many of the lace patterns in this book, you'll notice a twisted stitch that is worked on the next right-side row immediately above a yarnover, giving a tidy look to the twisted stitch. At the ends of this scarf, twisted stitches are used to give a crisp look to the garter-stitch triangles. However, some lace stitch patterns—such as the leaf and diamond pattern featured throughout this scarf—depend on the openness of the stitch immediately above a yarnover, and those stitches are worked as usual to add softness to the overall look of the pattern.

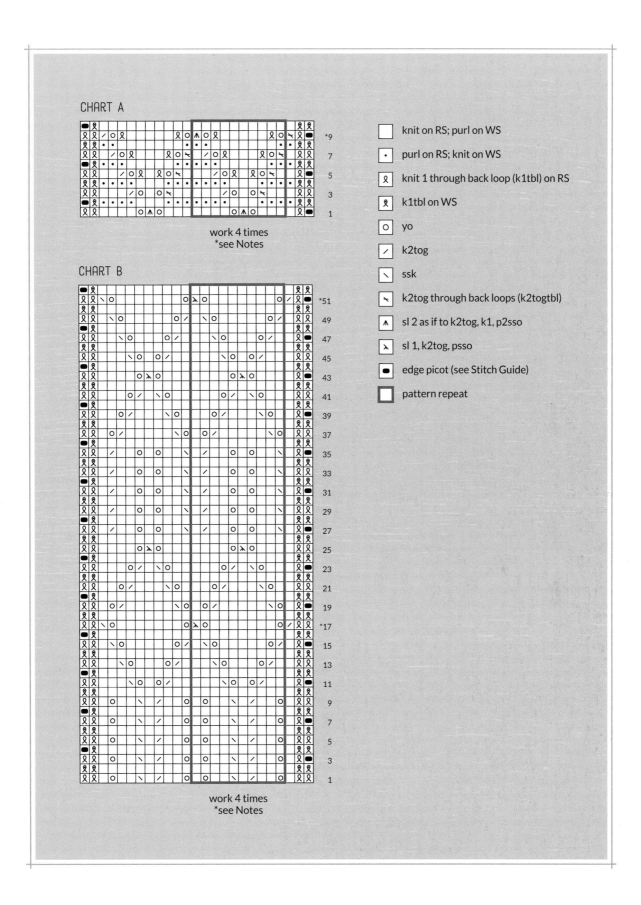

CHART A

work 4 times
*see Notes

CHART B

work 4 times
*see Notes

☐	knit on RS; purl on WS
·	purl on RS; knit on WS
ℛ	knit 1 through back loop (k1tbl) on RS
ℛ	k1tbl on WS
○	yo
╱	k2tog
╲	ssk
↖	k2tog through back loops (k2togtbl)
⋀	sl 2 as if to k2tog, k1, p2sso
⅄	sl 1, k2tog, psso
▪	edge picot (see Stitch Guide)
☐	pattern repeat

Carefully remove waste yarn from provisional cast on and place 55 exposed loops on needle.

Note: The loops picked up from a provisional cast-on lie between actual stitches, so there will be one fewer than the number of stitches required. To make up this one-loop deficit, create an extra loop at one side by slipping the needle under one leg of an edge st.

Join yarn with WS facing and knit 1 row. With RS facing, work fringe BO as before.

FINISHING

Wash in wool wash. Gently squeeze out water, then roll in towels to remove excess moisture. Insert blocking wires through picots on both long sides of damp scarf, place on a flat surface, and use T-pins to stretch to measurements. Stretch knitted fringe out straight at each end and pin in place. Allow to air-dry thoroughly before removing wires and pins.

Weave in loose ends.

Tie an overhand knot at the base of each knitted fringe unit.

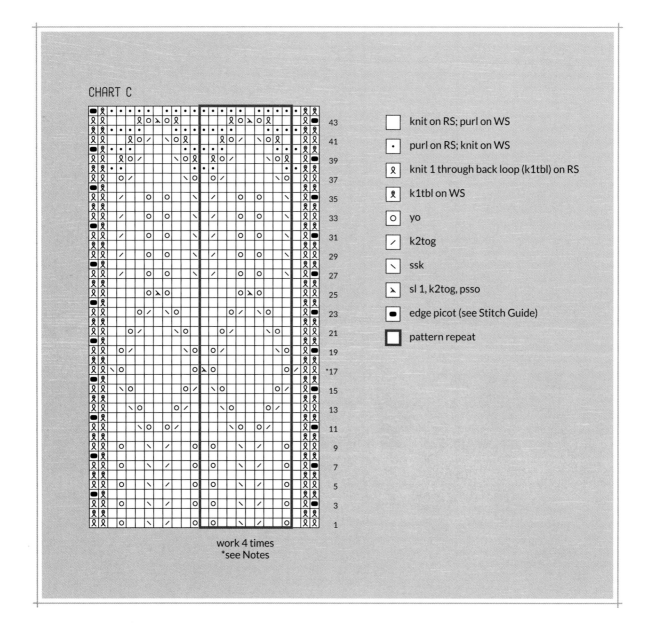

CHART C

work 4 times
*see Notes

knit on RS; purl on WS

· purl on RS; knit on WS

knit 1 through back loop (k1tbl) on RS

k1tbl on WS

o yo

∕ k2tog

∖ ssk

⋏ sl 1, k2tog, psso

■ edge picot (see Stitch Guide)

pattern repeat

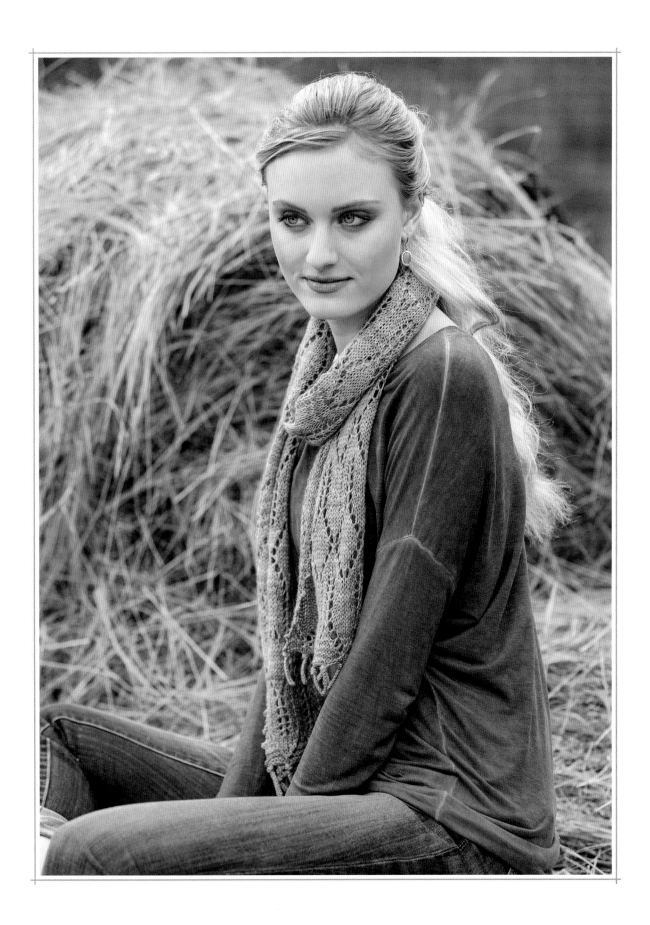

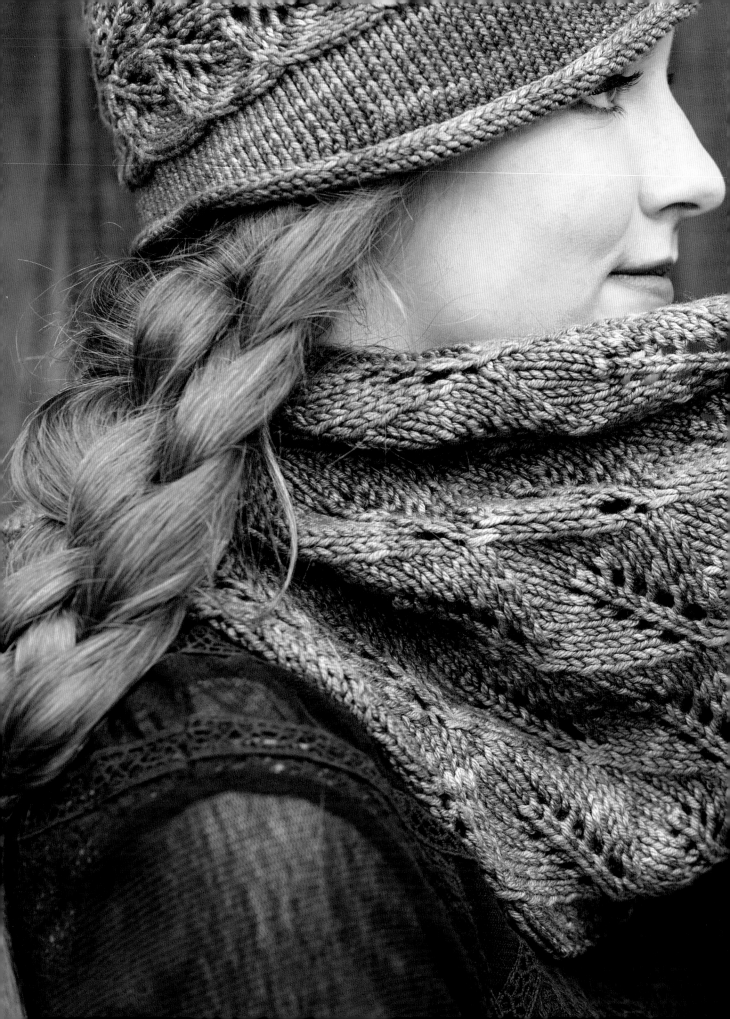

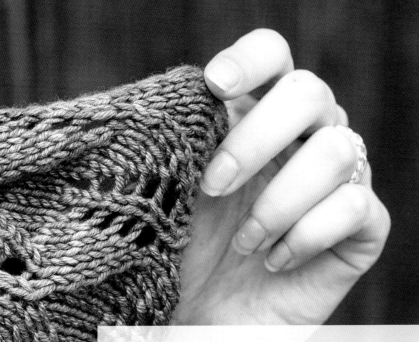

CHAPTER FOUR

TWIN *leaves*

THE LEAF MOTIF, WITH ITS MANY VARIATIONS, is one of my absolute favorites when it comes to designing and knitting lace. The patterns in this chapter feature a twin-leaf panel, used both in its original form and as a variation. The original panel travels along the sleeve of the Salt Grass Pull on page 94 and is in the Virginia City Cloche and Cowl on page 86. I used a variation of the twin-leaf panel in the Silver Birch Slouch on page 106, along with the body stitch pattern from Salt Grass Pull. Although the pieces themselves are quite different, the repeated twin-leaf motif unifies them as a collection.

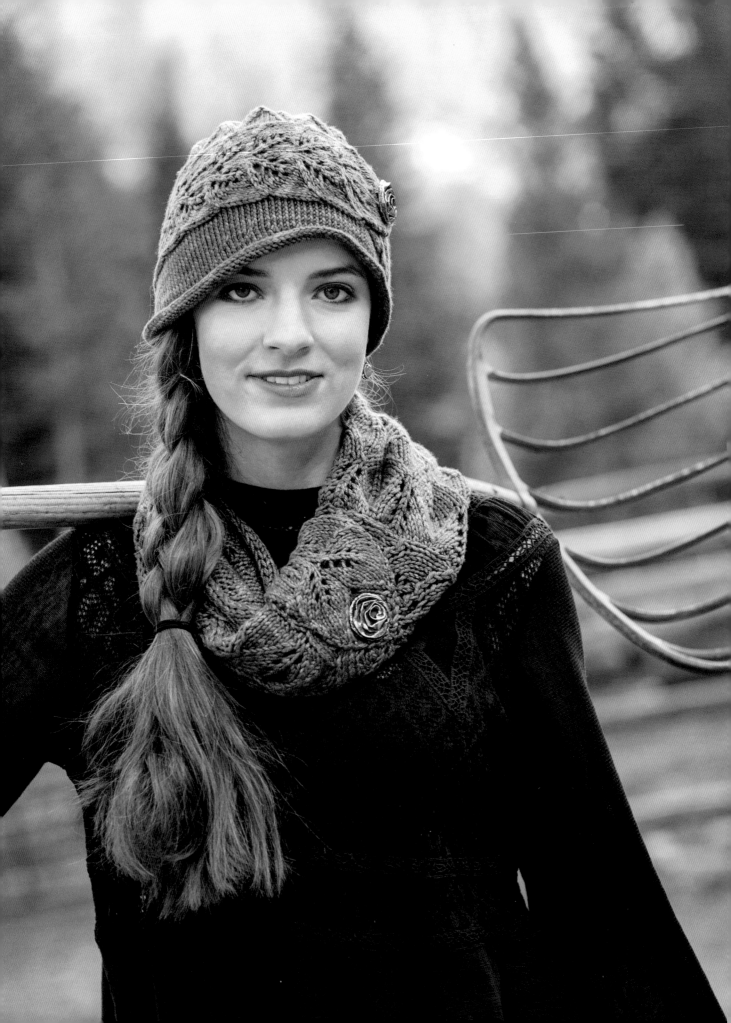

VIRGINIA CITY
cloche and cowl

For this design, the twin-leaf panel serves as the hatband for a stylish cloche, as well as the focal point for the matching cowl. Although the same yarn is used for both pieces, they're knitted at different gauges. A smaller needle is combined with twisted stitches to produce the stiff fabric necessary for the cloche to keep its shape; a larger needle is used to produce a flexible and snuggly fabric for the cowl.

FINISHED SIZE

Cloche: About 20" (51 cm) head circumference.

Cowl: About 26" (66 cm) circumference and 17½" (44.5 cm) high.

YARN

Aran weight (#4 Medium).

Shown here: SweetGeorgia Yarns Merino Silk Aran (50% fine merino wool, 50% silk; 185 yd [169 m]/100 g): Deep Olive, 3 skeins for the set.

NEEDLES

Cloche hatband and crown: size U.S. 7 (4.5 mm): 16" (40 cm) circular (cir) and set of 4 or 5 double-pointed (dpn).

Cloche brim: size U.S. 6 (4 mm):16" (40 cm) cir.

Cloche I-cord BO: 1 size U.S. 8 (5 mm) dpn.

Cowl: size U.S. 8 (5 mm): straight or 24" or 32" (60 or 80 cm) circular (cir).

Adjust needle size if necessary to obtain the correct gauge.

NOTIONS

Markers (m); coil-less safety pins; tapestry needle; balloon or other round form for blocking hat; blocking wires; T-pins; two 1½" (3.8 cm) buttons (one each for the cloche and cowl).

GAUGE

Cloche: 24 sts and 34 rnds = 4" (10 cm) in twisted St st on smallest cloche needles; 24 rows (3 patt reps) of Chart A measure about 3¾" (9.5 cm) high on middle-size cloche needles.

Cowl: 18 sts and 27 rows = 4" (10 cm) in Chart D pattern on cowl needles.

notes

» The hat brim uses the Japanese short-row method. Instead of wrapping a stitch at the turning point, a coil-less safety pin is placed around the strand of working yarn after turning. To close the short-row gaps, pull up on each pin as you come to it, lift the turning loop onto the left needle, remove the pin, then work the loop together with one of the adjacent stitches as instructed.

» Note that the left-leaning double decrease used in this pattern includes a k2togtbl rather than a k2tog so that the stitches will lie flatter in this particular lace pattern.

» If you use markers to set off each pattern repeat in the chart, you'll need to move each marker one stitch to the left in Rows 9 and 29 of Chart D to accommodate the double decrease before the first pattern repeat and at the end of each subsequent repeat.

stitch guide

M1: Insert left needle tip from back to front under the strand between the needles, then knit the lifted strand through the front loop to twist it—1 st inc'd.

FIGURE 1

FIGURE 2

FIGURE 3

FIGURE 4

CLOCHE

With middle-size 16" (40 cm) cir or 2 dpn, CO 23 sts, leaving a 20" (51 cm) tail.

HATBAND

Work Rows 1–8 of Chart A 16 times—piece measures about 20" (51 cm) from CO.

Work Rows 1–15 of Chart B once—1 st rem.

Fasten off last st, leaving a 10" (25.5 cm) tail.

Bring the ends of the band together, overlapping the Chart B point on top, and aligning the first Chart A row with the last Chart A row to form a 20" (51 cm) ring. Thread CO tail on tapestry needle and sew last Chart A row on top of the first Chart A row, leaving Chart B pointed button tab free (**Figure 1**).

CROWN

With RS facing and middle-size cir needle, pick up and knit 132 sts along one selvedge of band (about 8 sts for each patt rep, plus 4 extra sts evenly spaced), picking up 1 full st in from the edge (**Figure 2**). Place marker (pm) and join for working in rnds.

Note: Change to middle-size dpn when there are too few sts to fit around cir needle.

Work Rnds 1–18 of Chart C—44 sts rem.

Remove end-of-rnd marker, k1, replace marker.

Work Rnds 19–22 of Chart C—11 sts rem.

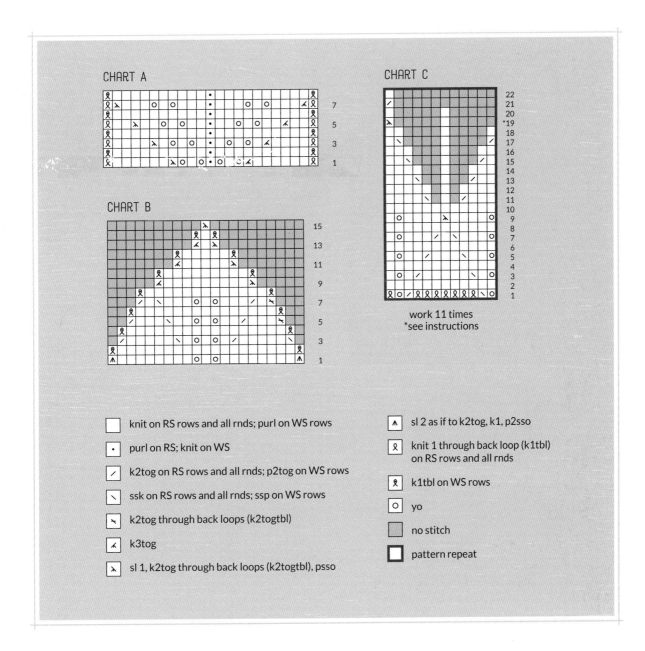

CHART A

CHART B

CHART C

work 11 times
*see instructions

☐ knit on RS rows and all rnds; purl on WS rows

• purl on RS; knit on WS

╱ k2tog on RS rows and all rnds; p2tog on WS rows

╲ ssk on RS rows and all rnds; ssp on WS rows

⅄ k2tog through back loops (k2togtbl)

⋏ k3tog

⅄ sl 1, k2tog through back loops (k2togtbl), psso

Λ sl 2 as if to k2tog, k1, p2sso

ℓ knit 1 through back loop (k1tbl) on RS rows and all rnds

ℓ k1tbl on WS rows

○ yo

▨ no stitch

☐ pattern repeat

Cut yarn, leaving a 10" (25.5 cm) tail. Thread tail on tapestry needle and draw it through rem sts 2 times. Fasten off securely on WS.

BRIM

With smallest cir needle and beg at seam joining the ends of Chart A, pick up and knit 128 sts (8 sts for each patt rep) along other selvedge of hatband, picking up 1 full st in from the edge (**Figure 3**). Place marker (pm) and join for working in rnds.

Knitting each st through the back loop (tbl), knit 7 rnds in twisted St st.

Work Japanese short-rows as foll (see Notes).

Short-Row 1: (RS) K105tbl, turn work and place safety pin around working yarn—23 sts rem unworked at end of rnd.

Short-Row 2: (WS) P16tbl, turn work and place safety pin around working yarn—16 sts between turning pins.

Short-Row 3: K16tbl, slip next st purlwise tbl then return it to left needle tip in twisted orientation, pull safety pin to lift yarn loop onto left needle tip, remove pin, knit lifted loop tog with twisted st, k3tbl, turn work and place safety pin around working yarn.

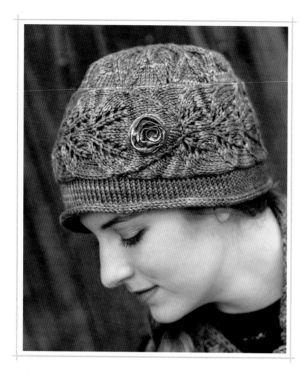

pin to lift yarn loop onto left needle tip, remove pin, knit lifted loop tog with twisted st, k3tbl, turn work and place safety pin around working yarn.

Short-Row 10: P44tbl, pull safety pin to lift yarn loop onto left needle tip, remove pin, purl lifted loop tog with next st, p3tbl, turn work and place safety pin around working yarn—48 sts between turning pins.

Short-Row 11: K48tbl, slip next st purlwise tbl, then return to left needle tip in twisted orientation, pull safety pin to lift yarn loop onto left needle tip, remove pin, knit lifted loop tog with twisted st, k3tbl, turn work and place safety pin around working yarn.

Short-Row 12: P52tbl, pull safety pin to lift yarn loop onto left needle tip, remove pin, purl lifted loop tog with next st, p3tbl, turn work and place safety pin around working yarn—56 sts between turning pins.

Next row: (RS) K56tbl, slip next st purlwise tbl, then return to left needle tip in twisted orientation, pull safety pin to lift yarn loop onto left needle tip, remove pin, knit lifted loop tog with twisted st, knit each st tbl to end-of-rnd marker.

Note: As you work the following round, slip the stitch before each safety pin purlwise, pull safety pin to lift yarn loop onto left needle, return the slipped stitch to the left needle, then work the stitch and lifted loop after it as k2togtbl; this counts as a k1tbl.

Next rnd: Working safety-pin loops as described, k4tbl, M1 (see Stitch Guide), [k8tbl, M1] 15 times, k4tbl—144 sts.

Work I-cord BO as foll: Use the knitted method (see Glossary) to CO 3 sts onto left needle tip. Using single dpn in largest size to work I-cord, knit first 2 new CO sts, k2togtbl (last CO st tog with next st after it). Keeping the same side of work facing throughout, cont as foll: *With yarn in back, return 3 sts onto left needle tip, bring working yarn around behind the left needle, k2, k2togtbl; rep from * until 3 I-cord sts rem—all brim sts have been joined.

Cut yarn, leaving a 10" (25.5 cm) tail. Thread tail on a tapestry needle and use the Kitchener stitch (see Glossary) to graft live I-cord sts to base of CO I-cord sts.

Weave in loose ends.

Short-Row 4: P20tbl, pull safety pin to lift yarn loop onto left needle tip, remove pin, purl lifted loop tog with next st, p3tbl, turn work and place safety pin around working yarn—24 sts between turning pins.

Short-Row 5: K24tbl, slip next st purlwise tbl, then return to left needle tip in twisted orientation, pull safety pin to lift yarn loop onto left needle tip, remove pin, knit lifted loop tog with twisted st, k3tbl, turn work and place safety pin around working yarn.

Short-Row 6: P28tbl, pull safety pin to lift yarn loop onto left needle tip, remove pin, purl lifted loop tog with next st, p3tbl, turn work and place safety pin around working yarn—32 sts between turning pins.

Short-Row 7: K32tbl, slip next st purlwise tbl, then return to left needle tip in twisted orientation, pull safety pin to lift yarn loop onto left needle tip, remove pin, knit lifted loop tog with twisted st, k3tbl, turn work and place safety pin around working yarn.

Short-Row 8: P36tbl, pull safety pin to lift yarn loop onto left needle tip, remove pin, purl lifted loop tog with next st, p3tbl, turn work and place safety pin around working yarn—40 sts between turning pins.

Short-Row 9: K40tbl, slip next st purlwise tbl, then return to left needle tip in twisted orientation, pull safety

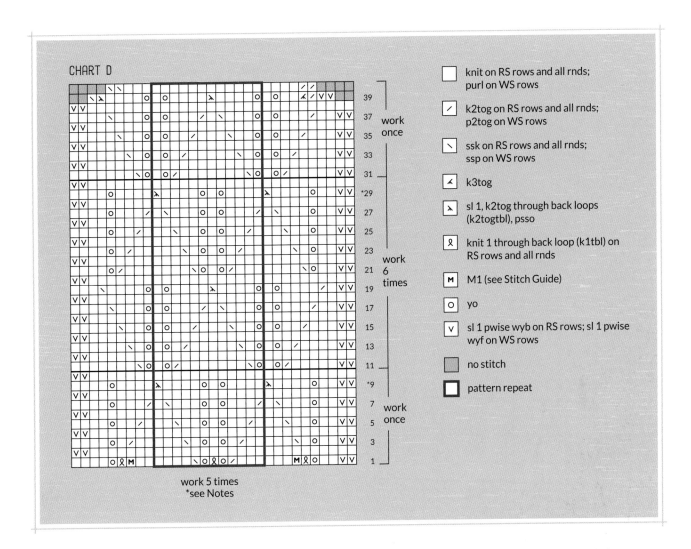

CHART D

Legend:

☐	knit on RS rows and all rnds; purl on WS rows
╱	k2tog on RS rows and all rnds; p2tog on WS rows
╲	ssk on RS rows and all rnds; ssp on WS rows
⅄	k3tog
⅄	sl 1, k2tog through back loops (k2togtbl), psso
ℓ	knit 1 through back loop (k1tbl) on RS rows and all rnds
M	M1 (see Stitch Guide)
O	yo
V	sl 1 pwise wyb on RS rows; sl 1 pwise wyf on WS rows
▨	no stitch
☐	pattern repeat

Chart row numbers: 39, 37, 35, 33, 31, *29, 27, 25, 23, 21, 19, 17, 15, 13, 11, *9, 7, 5, 3, 1

work once

work 6 times

work once

work 5 times
*see Notes

FINISHING

Wash in wool wash. Gently squeeze out water, then roll in towels to remove excess moisture. Block hat on balloon inflated to desired circumference (using tape to shape the balloon into an oblong, if desired) or similar hat form. Allow to air-dry thoroughly before removing balloon.

With yarn threaded on a tapestry needle, sew button to center of Chart B pointed tab (**Figure 4**; see page 88), sewing through both layers. Thread tail at tip of Chart B point on tapestry needle and tack point to band.

COWL

With cowl needles, CO 23 sts.

CENTER FRONT BAND

Work Rows 1–8 of Chart A (see page 89) 8 times.

Use coil-less safety pins to mark each side of last row completed.

Work Rows 1–8 of Chart A 2 more times—10 reps total.

Work Rows 1–15 of Chart B once—1 st rem.

Fasten off last st.

BODY

With RS facing and beg at CO edge of center front band, pick up and knit 71 sts along selvedge of band (about 9 sts for each Chart A rep), picking up 1 full st in from the edge and ending at safety pin marker; do not pick up sts along last 2 repeats of Chart A or along edge of Chart B. Leave safety pin markers in place until finishing.

Set-up row: (WS) [K1f&b (see Glossary)] 2 times, purl 67 sts through the back loop (tbl), [k1f&b] 2 times— 75 sts.

FIGURE 1

FIGURE 2

FIGURE 3

Work Row 1 of Chart D (see page 91)—79 sts.

Work Rows 2–10 of Chart D once.

Work Rows 11–30 of Chart D 6 times.

Work Rows 31–40 of Chart D once—71 sts rem; 140 chart rows completed.

Note: The following bind-off creates a naturally stretchy edge, so there's no need to work it especially loosely.

BO as foll: K2, *return 2 sts onto left needle tip, k2togtbl, k1; rep from * until 2 sts rem on right needle, return 2 sts onto left needle tip, k2togtbl—1 st rem. Fasten off rem st.

FINISHING

Wash in wool wash. Gently squeeze out water, then roll in towels to remove excess moisture. Insert blocking wires along straight edges of damp center front band and body, and place on a flat surface. Use T-pins to pin out piece so center front band measures 5" (12.5 cm) wide and 17" (43 cm) long from CO to point, and body measures 17½" (44.5 cm) wide and 21" (53.5 cm) long from pick-up row to BO.

Allow to air-dry thoroughly before removing wires and pins.

With yarn threaded on tapestry needle, sew BO edge of body to center front band between CO edge and marked row (**Figure 1**) to create a ring, sewing 1 full st in from the edge of the band. Fold point of Chart B to the WS, up through the center of the ring, then down over the top of the ring (**Figure 2**), overlapping about halfway down to gather the ring. With yarn threaded on a tapestry needle, sew button to center of the Chart B point, sewing through all layers (**Figure 3**). Using yarn threaded on a tapestry needle, sew the two tapered sides of the Chart B point to the top layer of front band.

Weave in loose ends.

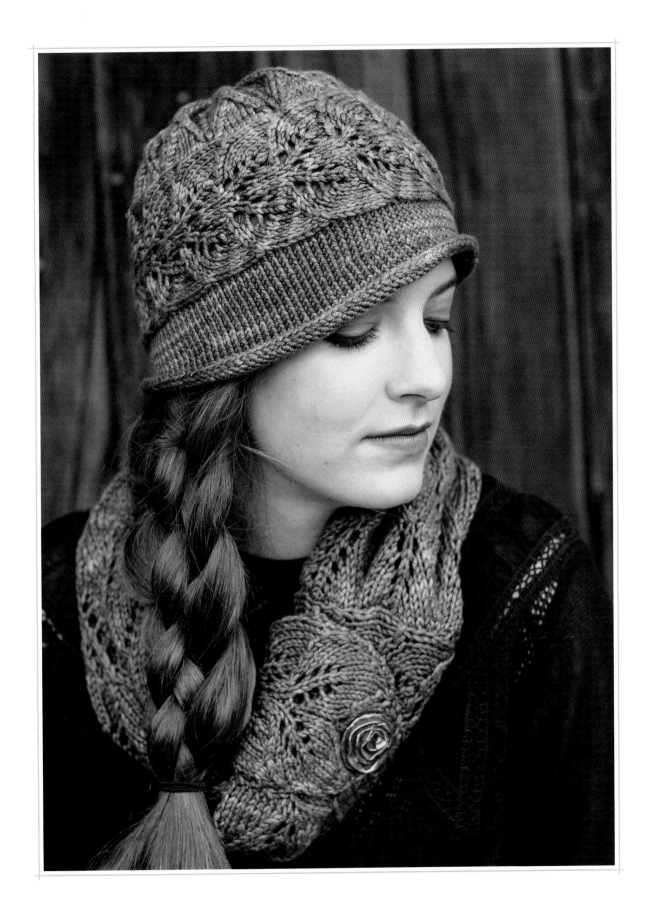

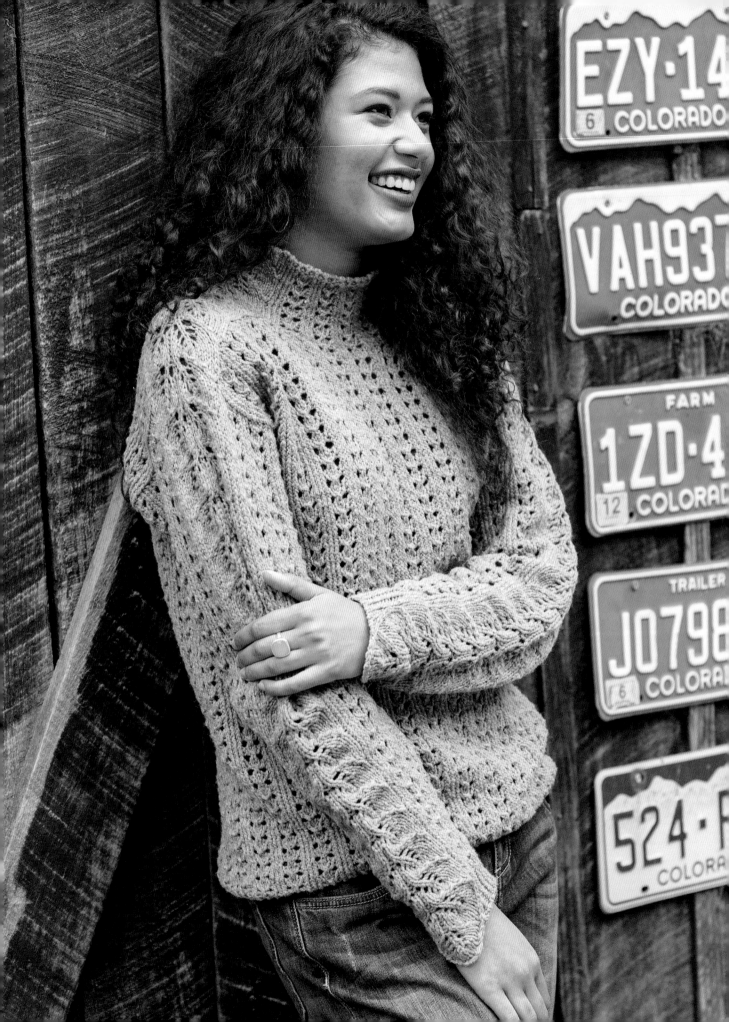

SALT GRASS
pull

Perfect for relaxing in style, this pullover is modeled on the traditional gansey shape, with its drop shoulders and comfortable lines. The twin-leaf motif begins at the top of the mock turtleneck, then travels down each sleeve to end in a point. An allover simple openwork pattern further dresses up the sweater. Knitted in a beautiful light-as-a-feather wool, it's as comfortable as a favorite sweatshirt!

FINISHED SIZE
About 32 (36½, 41¼, 45¾, 50¼)" (81.5 [92.5, 105, 116, 127.5] cm) bust circumference.

Sweater shown measures 36½" (92.5 cm).

YARN
Worsted weight (#4 Medium).

Shown here: Brooklyn Tweed Shelter (100% wool; 140 yd [128 m]/50 g): Foothills, 8 (9, 10, 11, 12) skeins.

NEEDLES
Body, sleeves, and shoulder straps: size U.S. 7 (4.5 mm): 16" (40 cm) and 24" or 32" (60 or 80 cm) circular (cir).

Neck and sleeve cuffs: sizes U.S. 5 and 6 (3.75 and 4 mm) set of 5 double-pointed (dpn).

Body ribbing: size U.S. 5 (3.75 mm): 24" or 32" (60 or 80 cm) cir.

Adjust needle size if necessary to obtain the correct gauge.

NOTIONS
Markers (m); smooth cotton waste yarn; coil-less safety pins; cable needle (cn); tapestry needle; sweater-blocking frame (optional but strongly recommended; see Notes on page 96).

GAUGE
21 sts and 30 rows = 4" (10 cm) in Chart D pattern on largest needles.

21-st leaf panel from Chart A measures 4" (10 cm) wide on largest needles.

notes

» The sweater is worked from the top down, beginning with a super-stretchy provisional cast-on that provides a nicely finished edge.

» This sweater is worked in a lofty woolen-spun yarn with minimal memory, or as I like to say: minimal "sproing." After blocking, it holds its shape beautifully. If you substitute a more elastic yarn with more "bounce-back" (for example, a worsted-spun merino), the neckline and leaf points at the wrists may curl. As always, please swatch when substituting.

» When picking up stitches along the shoulder strap edges for the upper body and along the armhole edges for the sleeves, make sure to pick up one full stitch in from the edge so that the twisted garter selvedge stitch is not visible from the right side.

» A traditional sweater-blocking frame—also known as a blocking horse or woolly board—was used to block the sweater shown. Although more commonly associated with blocking Fair Isle or gansey style sweaters, it's also an excellent tool for blocking lace fabrics. It will open up the body pattern beautifully to produce an incomparable finished look. I recommend one for blocking this sweater!

stitch guide

Slip, slip, return, k2tog: [Slip 1 st purlwise through the back loop (tbl)] 2 times, return slipped sts onto left needle, and work them tog as k2tog—1 st dec'd.

Japanese Short-Rows

Japanese short-rows are used to shape the neckline. Instead of wrapping a stitch at the turning point, a coil-less safety pin is placed around the strand of working yarn after turning. To close the short-row gaps, pull up on each pin to lift the turning loop onto the left needle and work it together with an adjacent stitch as follows:

On right-side rows within a twisted 3-stitch panel: Slip the stitch after the turning gap purlwise through the back loop (tbl), return slipped stitch onto needle in its twisted orientation, pull safety pin to lift yarn loop onto left needle, remove pin, and work lifted loop together with twisted stitch after it as k2tog.

On wrong-side rows within a twisted 3-stitch panel: At turning gap, pull safety pin to lift yarn loop onto left needle, remove pin, and work lifted loop together with next stitch as p2togtbl.

On right-side rows within an openwork 3-stitch panel: At turning gap, pull safety pin to lift yarn loop onto left needle, remove pin, and work lifted loop together with next stitch as k2tog.

On wrong-side rows within an openwork 3-stitch panel: At turning gap, pull safety pin to lift yarn loop onto left needle, remove pin, slip 2 stitches knitwise, return slipped stitches to left needle in their twisted orientation, and work lifted loop together with next stitch as p2togtbl.

All rows: The stitches worked together with a lifted loop are shaded in gold on the charts, and do not represent a decrease in the stitch count.

NECK

With smallest dpn and waste yarn, use the crochet-on method (see Glossary) to provisionally CO 48 (48, 52, 56, 60) sts onto a single dpn. Change to main yarn.

Set-up rnd: *K1, yo; rep from * to end, dividing sts evenly onto 4 dpn as you work—96 (96, 104, 112, 120) sts.

Place marker (pm) and join for working in rnds.

Rnd 1: *Sl 1 knit st purlwise with yarn in back (wyb), purl into yo; rep from *.

Rnd 2: *K1, sl 1 purlwise with yarn in front (wyf); rep from *.

Rnd 3: Rep Rnd 1.

Note: Chart A (see page 100) has minor pattern repeats (outlined in green) within the main pattern repeat (outlined in red). Each green minor repeat box has numbers below indicating how many times to work it. After working to the end of the chart once, repeat the entire chart a second time as indicated by the main red repeat box.

Work Rnds 1–16 of Chart A.

Change to middle-size dpn.

Work Rnds 17–26 of Chart A—piece measures about 3" (7.5 cm) from CO.

Note: Waste yarn may be removed from provisional CO now or during finishing; the starting edge of the rib will not ravel.

SHOULDER STRAPS

Cut yarn, sl first 3 sts of rnd without working them, then rejoin yarn at beg of leaf panel and place marker (pm). Change to longer cir needle in largest size.

Work Row 1 of Chart B as foll: (RS) Use the knitted method (see Glossary) to CO 1 st onto left needle, work new st as k1 through back loop (k1tbl), work first patt rep box 0 (0, 1, 2, 3) time(s), work next 21 chart sts, work second patt rep box 0 (0, 1, 2, 3) time(s), CO 1 st as before and work new st as k1tbl—23 (23, 27, 31, 35) shoulder strap sts.

Place next 27 sts for all sizes onto waste-yarn holder, place next 21 (21, 25, 29, 33) sts onto separate holder, then place rem 27 sts for all sizes (including 3 sts slipped before Row 1) onto a third holder—23 (23, 27, 31, 35) shoulder strap sts rem on needle.

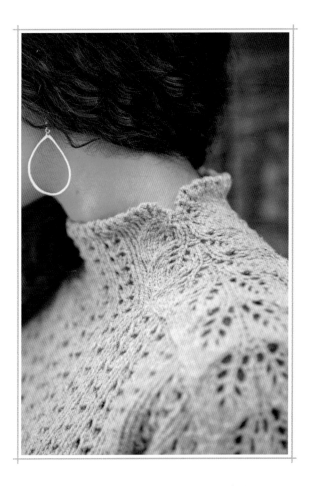

Working back and forth in rows on shoulder strap sts, work Rows 2–8 of Chart B once.

Work Rows 9–16 of Chart B 2 (3, 3, 4, 5) times.

Work 3 (1, 5, 7, 3) more row(s) of Chart B to end with RS Row 19 (17, 21, 23, 19)—27 (33, 37, 47, 51) total Chart B rows; strap measures 3½ (4½, 5, 6¼, 6¾)" (9 [11.5, 12.5, 16, 17] cm) from end of neck.

Place sts onto waste-yarn holder.

With RS facing, skip the next held group of 27 sts and place the foll group of 21 (21, 25, 29, 33) sts onto largest dpn. Rejoin yarn with RS facing, ready to work a RS row.

Work Row 1 of Chart B as for first shoulder strap—23 (23, 27, 31, 35) strap sts.

Complete as for first shoulder strap—strap measures 3½ (4½, 5, 6¼, 6¾)" (9 [11.5, 12.5, 16, 17] cm) from end of neck. Place sts onto waste-yarn holder, but do not break yarn.

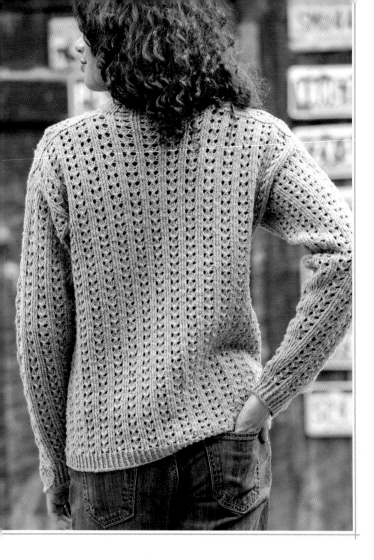

UPPER BACK

With RS of second shoulder strap still facing, rotate piece 90 degrees so selvedge at end of RS strap rows is at the top. With longer cir needle in largest size and yarn attached to last strap row, pick up and knit 25 (31, 37, 43, 49) sts evenly spaced along strap selvedge; work next 27 sts from holder as ([k1tbl 3 times, yo, sl 1, k2tog, psso, yo] 4 times, k1tbl 3 times), then with RS still facing, pick up and knit 25 (31, 37, 43, 49) sts evenly spaced along selvedge of first shoulder strap—77 (89, 101, 113, 125) sts total.

Next row: (WS) K1tbl, *[p1tbl] 3 times, p3; rep from * to last 4 sts, [p1tbl] 3 times, k1tbl.

SHAPE BACK NECK

Work Row 1 of Chart C-1 as foll: (RS) Work as shown over first 51 (57, 63, 69, 75) sts, place safety pin around working yarn as indicated on chart (turning loop symbol does not count as a st)—26 (32, 38, 44, 50) sts rem unworked at end of row. Turn work.

Work Row 2 of Chart C-1 as foll: (WS) Work as shown over 25 sts for all sizes, place safety pin around working yarn as indicated—26 (32, 38, 44, 50) sts rem unworked at end of row. Turn work.

tricks for even stitches

All knitters have quirks that make certain patterns look a little uneven. Although most irregularities in lace are easy to block out, I've discovered a few little tricks to help produce a more even fabric.

The leaf panels of the Salt Grass Pull use the "slip 1, k2tog, psso" left-leaning double decrease, but I sometimes prefer to substitute "slip 1, k2togtbl, psso." I think the extra twist from knitting the stitches together through their back loops helps the decrease to lie flatter and produces a cleaner line.

To prevent a yarnover right before a purl stitch from appearing too large in the leaf panels, I omitted the yarnover in the chart row where it appears, then picked up the running strand between the needles at the yarnover's location on the following row or round and worked it.

To make the knit stitches on either side of the leaf motif's center purl stitch neater, I wrapped the yarn backward around the needle (from the bottom instead of the top for the middle purl stitch). Doing so creates a stitch with a reversed stitch mount. To correct the mount and work the stitch without twisting it, insert the right needle tip from back to the front when purling the center stitch on the following round, or from front to the back when knitting the stitch on the following row.

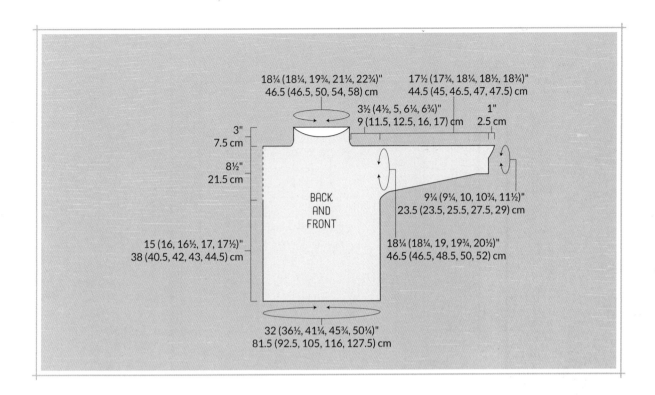

18¼ (18¼, 19¾, 21¼, 22¾)"
46.5 (46.5, 50, 54, 58) cm

17½ (17¾, 18¼, 18½, 18¾)"
44.5 (45, 46.5, 47, 47.5) cm

3½ (4½, 5, 6¼, 6¾)"
9 (11.5, 12.5, 16, 17) cm

1"
2.5 cm

3"
7.5 cm

8½"
21.5 cm

BACK
AND
FRONT

9¼ (9¼, 10, 10¾, 11½)"
23.5 (23.5, 25.5, 27.5, 29) cm

15 (16, 16½, 17, 17½)"
38 (40.5, 42, 43, 44.5) cm

18¼ (18¼, 19, 19¾, 20½)"
46.5 (46.5, 48.5, 50, 52) cm

32 (36½, 41¼, 45¾, 50¼)"
81.5 (92.5, 105, 116, 127.5) cm

Work Rows 3 and 4 of Chart C-1 to end, working the lifted loop at each turning gap together with an adjacent st (see Notes).

Work Rows 1–4 of Chart D (see page 102) 11 times—50 rows in center (including pick-up row) and 48 rows at each side—piece measures 6½" (16.5 cm) from pick-up at each side (armhole edges). Place sts onto waste yarn.

UPPER FRONT

Hold piece with RS facing so rem strap selvedges are at the top with 27 held sts between them. Join work to end of last RS row of the right-hand strap. With longer cir needle in largest size, pick up and knit 25 (31, 37, 43, 49) sts evenly spaced along strap selvedge (see Notes), work next 27 sts from holder as ([k1tbl 3 times, yo, sl 1, k2tog, psso, yo] 4 times, k1tbl 3 times), then with RS still facing, pick up and knit 25 (31, 37, 43, 49) sts evenly spaced along selvedge of other shoulder strap—77 (89, 101, 113, 125) sts total.

Next row: (WS) K1tbl, *[p1tbl] 3 times, p3; rep from * to last 4 sts, [p1tbl] 3 times, k1tbl.

SHAPE FRONT NECK

Work Row 1 of Chart C-2 (see page 101) as foll: (RS) Work as shown over first 26 (32, 38, 44, 50) sts,

place safety pin around working yarn as indicated on chart—51 (57, 63, 69, 75) sts rem unworked at end of row. Turn work.

Work Rows 2–10 of Chart C-2, working the lifted loop at each turning gap together with an adjacent st.

Work Row 11 of Chart C-2 across all sts, working rem lifted loop as before.

Work Row 12 of Chart C-2 as foll: (WS) Work as shown over first 26 (32, 38, 44, 50) sts, place safety pin around working yarn as indicated on chart, turn work—51 (57, 63, 69, 75) sts rem unworked at end of row.

Work Rows 13–21 of Chart C-2.

Work Rows 22–24 of Chart C-2 across all sts, working rem lifted loop as before when you come to it in Row 22.

Work Rows 1–4 of Chart D 8 times—48 front rows at each side (including pick-up row), 38 front rows in center; piece measures 6½" (16.5 cm) from pick-up at each side (armhole edges) and 1½" (3.8 cm) less at center front. Leave sts on needle, and do not break yarn.

CHART A

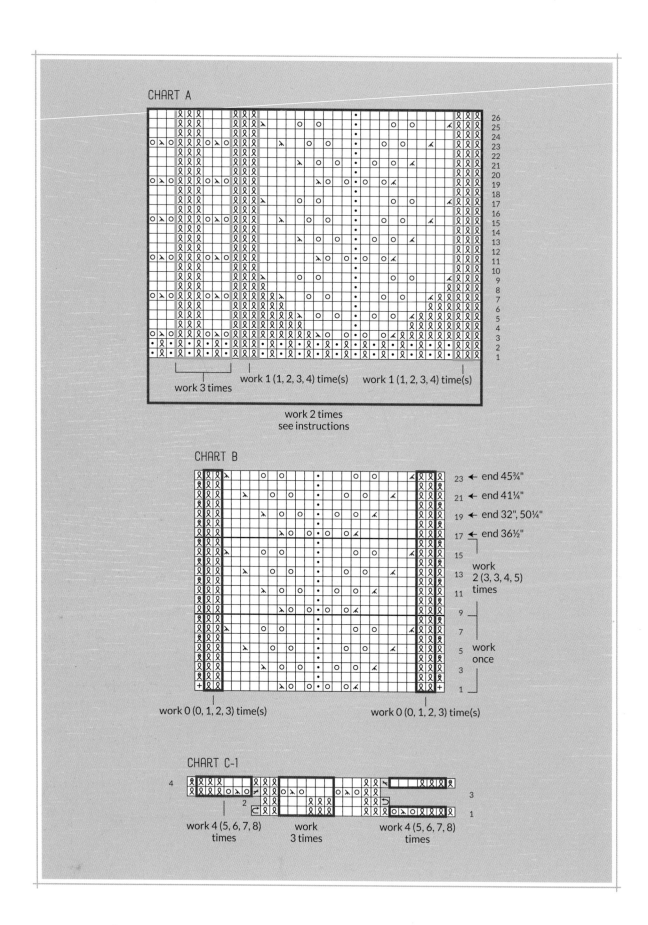

work 3 times

work 1 (1, 2, 3, 4) time(s) work 1 (1, 2, 3, 4) time(s)

work 2 times
see instructions

CHART B

23 ← end 45¾"
21 ← end 41¼"
19 ← end 32", 50¼"
17 ← end 36½"

work
2 (3, 3, 4, 5)
times

work
once

work 0 (0, 1, 2, 3) time(s) work 0 (0, 1, 2, 3) time(s)

CHART C-1

work 4 (5, 6, 7, 8)
times

work
3 times

work 4 (5, 6, 7, 8)
times

LOWER BODY

With RS facing, place 77 (89, 101, 113, 125) held back sts onto end of needle holding front sts so that front sts with working yarn attached will be worked first—154 (178, 202, 226, 250) sts total.

Join for working in rnds. Slip the first front st pwise wyb, then pm for end-of-rnd

Work Rnd 1 of Chart E (see page 102) as foll: Work 3 sts, work 6-st patt rep 12 (14, 16, 18, 20) times, work 1 st, use the backward-loop method (see Glossary) to CO 7 sts onto right needle, work 4 sts, work 6-st patt

rep 12 (14, 16, 18, 20) times, work 1 st, CO 7 sts onto right needle as before, work 1 st (slipped st from beg of rnd)—168 (192, 216, 240, 264) sts.

Work Rnds 2–6 of Chart E.

Work Rnds 1–4 of Chart F until piece measures 14 (15, 15½, 16, 16½)" (35.5 [38, 39.5, 40.5, 42] cm) from underarm joining rnd, ending with Row 4 of chart.

Work Rnds 1–4 of Chart G once.

Change to cir needle in smallest size.

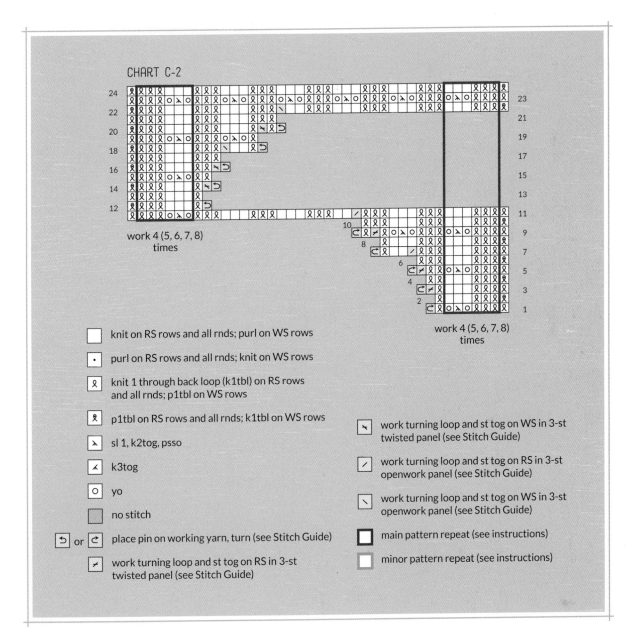

CHART C-2

work 4 (5, 6, 7, 8) times

work 4 (5, 6, 7, 8) times

☐ knit on RS rows and all rnds; purl on WS rows

· purl on RS rows and all rnds; knit on WS rows

Ջ knit 1 through back loop (k1tbl) on RS rows and all rnds; p1tbl on WS rows

Ջ p1tbl on RS rows and all rnds; k1tbl on WS rows

⅄ sl 1, k2tog, psso

⅄ k3tog

○ yo

☐ no stitch

� or ↻ place pin on working yarn, turn (see Stitch Guide)

↗ work turning loop and st tog on RS in 3-st twisted panel (see Stitch Guide)

↖ work turning loop and st tog on WS in 3-st twisted panel (see Stitch Guide)

╱ work turning loop and st tog on RS in 3-st openwork panel (see Stitch Guide)

╲ work turning loop and st tog on WS in 3-st openwork panel (see Stitch Guide)

☐ main pattern repeat (see instructions)

☐ minor pattern repeat (see instructions)

Rep Rnds 3 and 4 of Chart G 4 more times—piece measures 15 (16, 16½, 17, 17½)" (38 [40.5, 42, 43, 44.5] cm) from underarm.

Cut yarn, leaving a tail 2½ to 3 times the lower body circumference. Thread tail on a tapestry needle, then use the tubular k1, p1 rib method (see Glossary) to BO all sts.

SLEEVES

With shorter cir needle in largest size, RS facing, and beg at 3-st column of k1tbl sts in center of underarm, pick up and knit 2 sts in top of last 2 k1tbl sts, 3 sts in top of 3-st lace column, and 33 sts (about 3 sts for every 4 rows; see Notes) along armhole selvedge, pm, work 23 (23, 27, 31, 35) held shoulder strap sts while dec 2 sts as [k2tog, k9 (9, 11, 13, 15), p1, k9 (9, 11, 13, 15), ssk], pm, pick up and knit 33 sts along other armhole selvedge as before, 3 sts

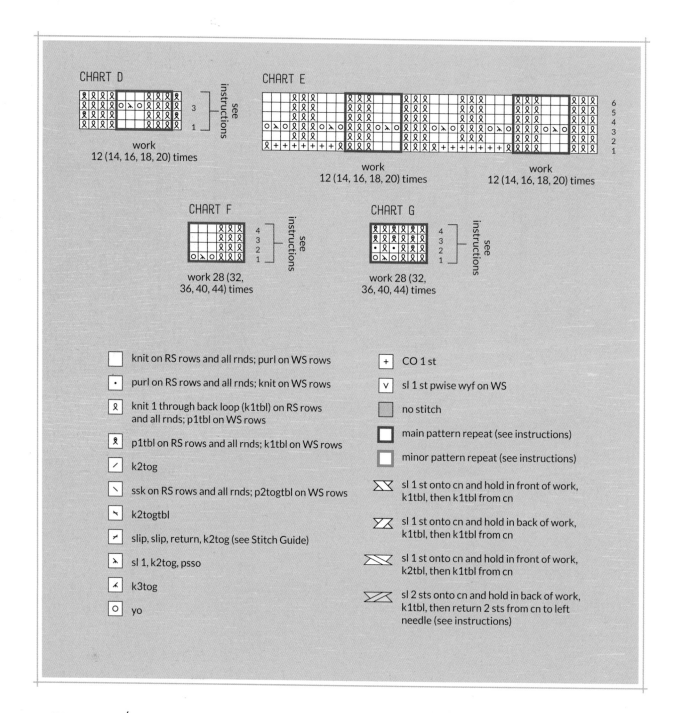

CHART D
work 12 (14, 16, 18, 20) times

CHART E
work 12 (14, 16, 18, 20) times work 12 (14, 16, 18, 20) times

CHART F
work 28 (32, 36, 40, 44) times

CHART G
work 28 (32, 36, 40, 44) times

	knit on RS rows and all rnds; purl on WS rows
·	purl on RS rows and all rnds; knit on WS rows
ℛ	knit 1 through back loop (k1tbl) on RS rows and all rnds; p1tbl on WS rows
ℛ	p1tbl on RS rows and all rnds; k1tbl on WS rows
/	k2tog
\	ssk on RS rows and all rnds; p2togtbl on WS rows
↖	k2togtbl
↗	slip, slip, return, k2tog (see Stitch Guide)
⋏	sl 1, k2tog, psso
↙	k3tog
O	yo

+	CO 1 st
v	sl 1 st pwise wyf on WS
	no stitch
	main pattern repeat (see instructions)
	minor pattern repeat (see instructions)
	sl 1 st onto cn and hold in front of work, k1tbl, then k1tbl from cn
	sl 1 st onto cn and hold in back of work, k1tbl, then k1tbl from cn
	sl 1 st onto cn and hold in front of work, k2tbl, then k1tbl from cn
	sl 2 sts onto cn and hold in back of work, k1tbl, then return 2 sts from cn to left needle (see instructions)

CHART H

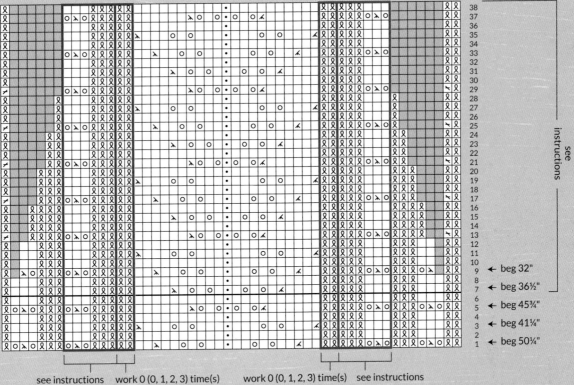

see instructions | work 0 (0, 1, 2, 3) time(s) work 0 (0, 1, 2, 3) time(s) | see instructions

see instructions

← beg 32"
← beg 36½"
← beg 45¾"
← beg 41¼"
← beg 50¼"

CHART I

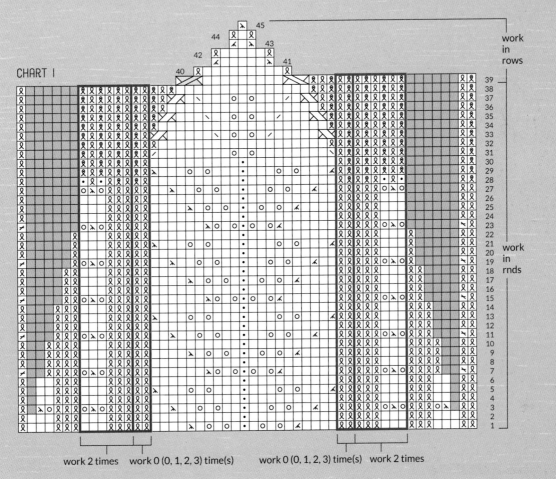

work in rows

work in rnds

work 2 times | work 0 (0, 1, 2, 3) time(s) work 0 (0, 1, 2, 3) time(s) | work 2 times

in top of 3-st lace column, and 1 st from top of rem k1tbl st in center of underarm—96 (96, 100, 104, 108) sts total.

Pm and join for working in rnds.

Beg with Rnd 9 (7, 3, 5, 1), work through Rnd 38 of Chart H (see page 103), working each 6-st red patt rep box 5 times—84 (84, 88, 92, 96) sts rem.

Work Rnds 7–38 of Chart H (do not work Rnds 1–6 again), working each 6-st patt rep 4 times—72 (72, 76, 80, 84) sts rem.

Work Rnds 7–38 of Chart H, working each 6-st patt rep 3 times—60 (60, 64, 68, 72) sts rem.

Work Rnds 1–32 of Chart I—48 (48, 52, 56, 60) sts rem.

Change to smallest dpn.

Work Rnds 33–38 of Chart I.

Change to working Chart I back and forth in rows to shape the pointed tip of the leaf panel. These are not Japanese short-rows; simply turn and work back at the end of each row, without marking any turning loops.

Row 39: (RS) work first 29 (29, 31, 33, 35) sts, sl 2 sts onto cn and hold in back of work, k1tbl, return 2 sts on cn to left needle, turn work—sleeve measures about 17½ (17¾, 18¼, 18½, 18¾)" (44.5 [45, 46.5, 47, 47.5] cm) from pick-up rnd.

Row 40: P1tbl, p9, p1tbl—11 leaf tip sts.

Rows 41–45: Work back and forth in rows on leaf tip sts only—1 leaf tip st rem; 38 (38, 42, 46, 50) sts total; with RS facing, 19 (19, 21, 23, 25) sts before leaf tip, and 18 (18, 20, 22, 24) sts after it.

Cut yarn and fasten off leaf tip st.

With WS facing, slide all sts to beg of needle and rejoin yarn at start of row, aligned with the sleeve "seam" of the original end-of-rnd.

Row 46: (WS) [P1tbl, k1tbl] 8 (8, 9, 10, 11) times, then work 2 returned cable sts from end of Row 39, as [p1tbl] 2 times.

Cut yarn, leaving a tail 2½ to 3 times the circumference of the sleeve opening. Thread tail on a tapestry needle, and turn work so RS is facing. Work a modified tubular k1, p1 rib BO as foll:

Insert tapestry needle knitwise into first st on needle (a purl st with RS facing) and pull yarn through, leaving st on left needle.

Insert tapestry needle purlwise into edge st of leaf point to the right of the purl st on needle, then into the first knit st on left needle, leaving st on needle.

Beg with Step 5, cont as for tubular k1, p1 rib BO described in Glossary until 1 st rem before leaf point; treat the last 2 sts before the leaf point from the cable in Row 39 as (k1tbl, p1tbl).

Insert tapestry needle knitwise into last purl st, then purlwise into a knit st just slipped off needle and then into edge st of leaf point, leaving st on needle.

Insert tapestry needle purlwise into last purl st, and slip both sts off left needle.

Pull yarn through, and fasten off on WS.

FINISHING

Wash in wool wash. Gently squeeze out water, then roll in towels to remove excess moisture. Place damp pullover on sweater blocking frame and stretch tight to open lace pattern. To prevent neckline from stretching, thread smooth cotton waste yarn on a tapestry needle and draw through CO neck sts, drawstring-fashion to gather neck opening to a measurement smaller than desired circumference, then tie waste yarn in an over-hand knot to secure. Allow to air-dry thoroughly before removing from blocking frame. Remove waste yarn.

Weave in loose ends.

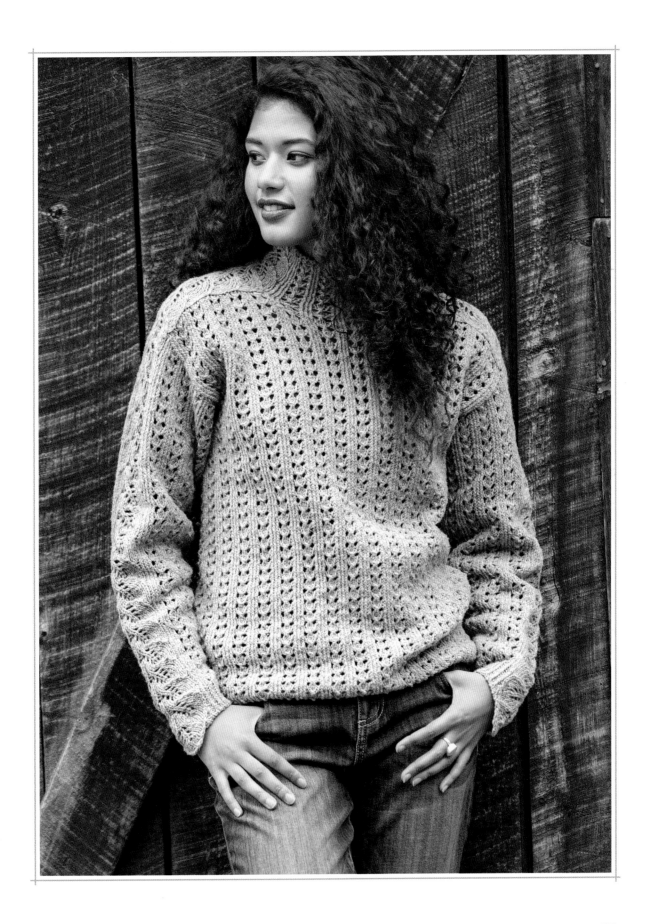

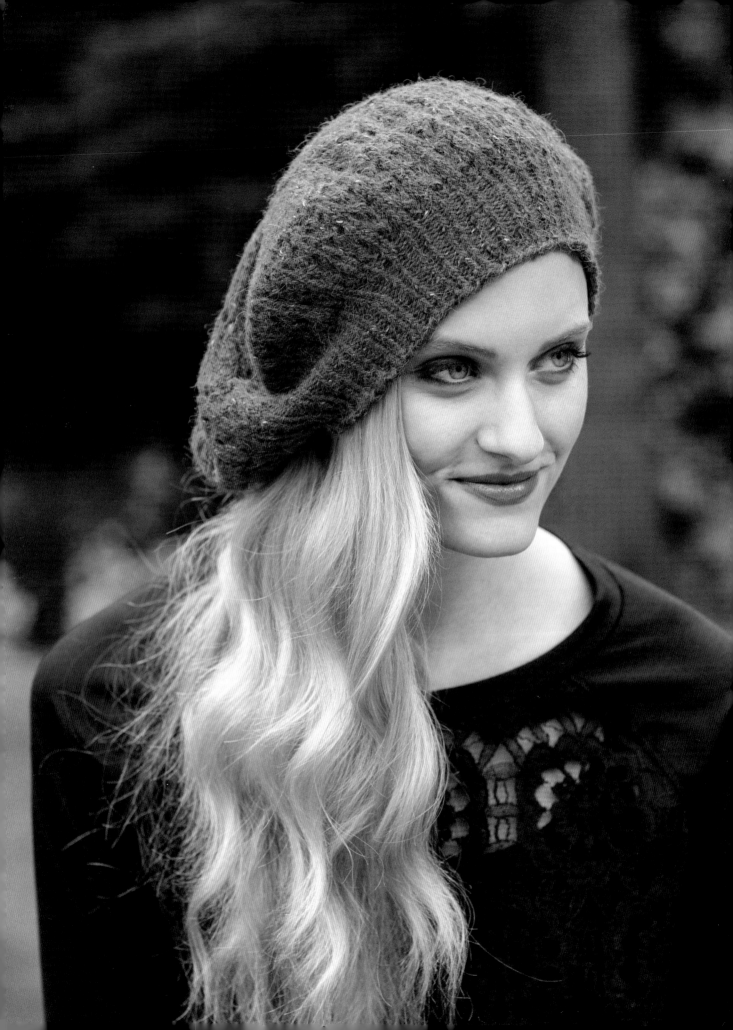

SILVER BIRCH
slouch

The leaf pattern in this slouchy hat is a variation of the twin-leaf lace panel featured in the Virginia City Cloche and Cowl on page 86, as well as the Salt Grass Pull on page 94. There's another lace pattern from Salt Grass. Can you spot it? With just a few tweaks, the lace patterns put on a whole different personality! There's an unlined version for spring and fall, and a cozy version lined with mohair for winter, both based on traditional round doily construction.

FINISHED SIZE
About 24" (61 cm) circumference at band.

YARN
DK weight (#3 Light).

Shown here:

Unlined version with pom-pom: The Fibre Company Acadia (60% merino, 20% silk, 20% alpaca; 145 yd [132 m]/50 g): Driftwood (light taupe), 2 skeins.

Lined Ginger or Gilt version: Rowan Felted Tweed DK (50% wool, 25% alpaca, 25% viscose; 191 yd [175 m]/50 g): #154 Ginger (orange) or #160 Gilt (gold), 1 ball.

Lining: Rowan Kidsilk Haze (70% super kid mohair, 30% silk; 229 yd [210 m]/25 g): #590 Pearl (silver; used with #154 Ginger) or #644 Ember (gold; used with #160 Gilt), 1 ball.

NEEDLES
Sizes U.S. 3 and 4 (3.25 and 3.5 mm): 16" (40 cm) circular (cir) and set of 4 or 5 double-pointed (dpn).

Adjust needle size if necessary to obtain the correct gauge.

NOTIONS
Markers (m); tapestry needle; waste yarn; dinner or pie plate for blocking.

GAUGE
28 sts and 32 rnds = 4" (10 cm) in Chart A patt with DK yarn on larger needles.

HAT

CO for your style as foll.

Gilt/Ember version with I-cord topknot

With DK yarn, smaller dpn, and using Emily Ocker's method (see Glossary), CO 4 sts. Work 4-st I-cord (see Glossary) until piece measures 3½" (9 cm).

Distribute sts evenly on 4 dpn (1 st per needle).

Set-up rnd: *K1, yo; rep from *—8 sts; 2 sts on each needle.

Place marker (pm) and join for working in rnds.

Other versions

With DK yarn and smaller dpn, CO 8 sts. Distribute sts evenly on 4 dpn (2 sts per needle), place marker (pm), and join for working in rnds.

All versions

Knit 1 rnd.

Work Rnds 1–4 of Chart A—24 sts.

note

» This hat is knitted from the top down.

Remove end-of-rnd m, k1, replace m.

Work Rnds 5 and 6 of Chart A—32 sts.

Change to larger dpn.

Work Rnds 7–28 of Chart A, changing to larger cir needle when necessary—144 sts.

Work Rnds 1–6 of Chart B (see page 110)—264 sts.

Remove end-of-rnd m, k1, replace m.

Work Rnds 7–16 of Chart B—240 sts.

Work Rnds 1–4 of Chart C 2 times, then work Rnds 1 and 2 once more—piece measures about 7" (18 cm) from CO.

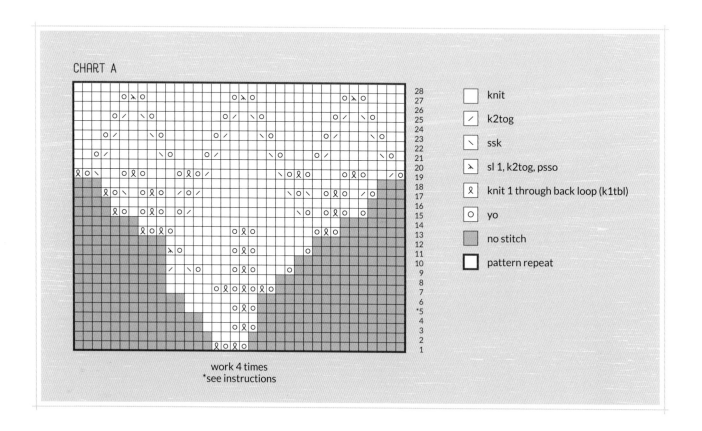

CHART A

work 4 times
*see instructions

	knit
∕	k2tog
╲	ssk
⅄	sl 1, k2tog, psso
ℓ	knit 1 through back loop (k1tbl)
o	yo
	no stitch
	pattern repeat

Lined version only

Keeping sts on needle, thread waste yarn on tapestry needle and draw through all sts, leaving waste yarn tails hanging out at each end; this marks where to pick up sts later for the lining. Cont with working yarn as foll.

All versions

Work Rnds 1–5 of Chart D once, then work Rnd 6 a total of 15 times—120 sts.

Optional: Knit 2 rnds for rolled edge (shown on unlined version).

Work stretchy BO as foll: K2, *return 2 sts to left needle tip, k2tog through back loop (tbl), k1; rep from * until 2 sts rem on right needle, return 2 sts to left needle tip, k2togtbl—1 st rem. Fasten off rem st.

OPTIONAL LINING

Turn hat inside out. With smaller cir needle and lining yarn, pick up and knit 240 sts from purl bumps directly below waste-yarn strand. Pm and join for working in rnds.

Change to larger cir needle.

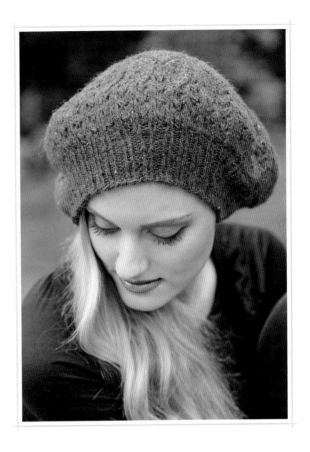

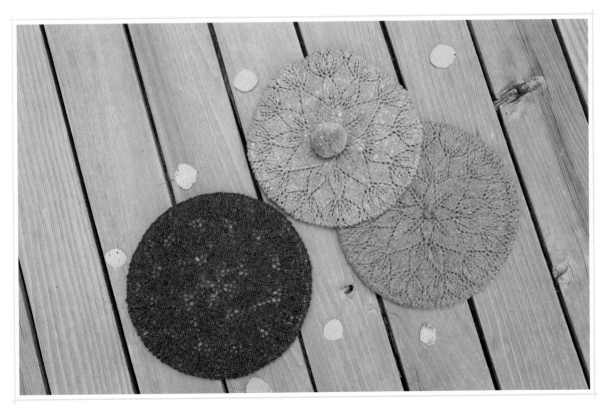

From left to right: Lined Ginger/Pearl, unlined Driftwood with pom-pom, lined Gilt/Ember with topknot.

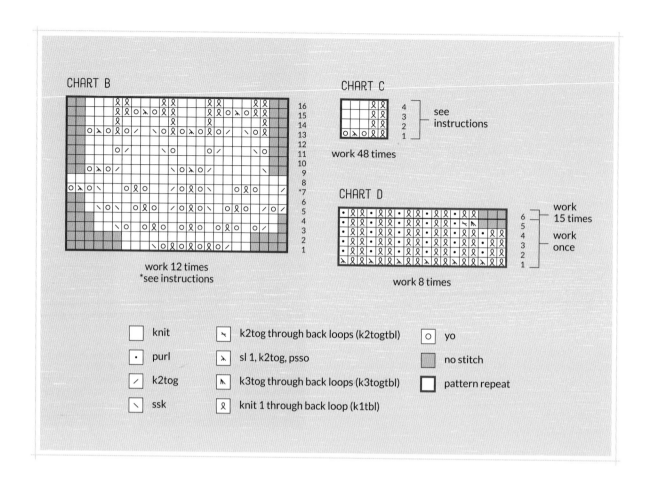

CHART B

work 12 times
*see instructions

CHART C

work 48 times

see instructions

CHART D

work 15 times
work once
work 8 times

	knit		k2tog through back loops (k2togtbl)		yo
	purl		sl 1, k2tog, psso		no stitch
	k2tog		k3tog through back loops (k3togtbl)		pattern repeat
	ssk		knit 1 through back loop (k1tbl)		

Rnds 3–40: Purl.

Rnd 41: *P2tog; rep from *—120 sts rem.

Rnds 42–46: Purl.

Rnd 47: *P2tog; rep from *—60 sts rem.

Rnds 48–56: Purl.

Cut yarn, leaving a 7" (18 cm) tail. Thread tail on tapestry needle, draw through live sts 3 times, and pull tight to close hole. Use tail to tack top center of lining securely to WS of hat.

FINISHING

Use starting CO tail to close hole at top of hat. Wash in wool wash. Gently squeeze out water, then roll in towels to remove excess moisture. Insert pie or dinner plate into crown of damp hat, smoothing lace patt into shape, and pulling band in toward center of plate. Allow to air-dry thoroughly before removing plate.

Weave in loose ends.

Optional pom-pom: With DK yarn, make a 2½" (6.5 cm) pom-pom (see Glossary) and secure to top of hat.

Optional topknot: Tie starting I-cord in an overhand knot.

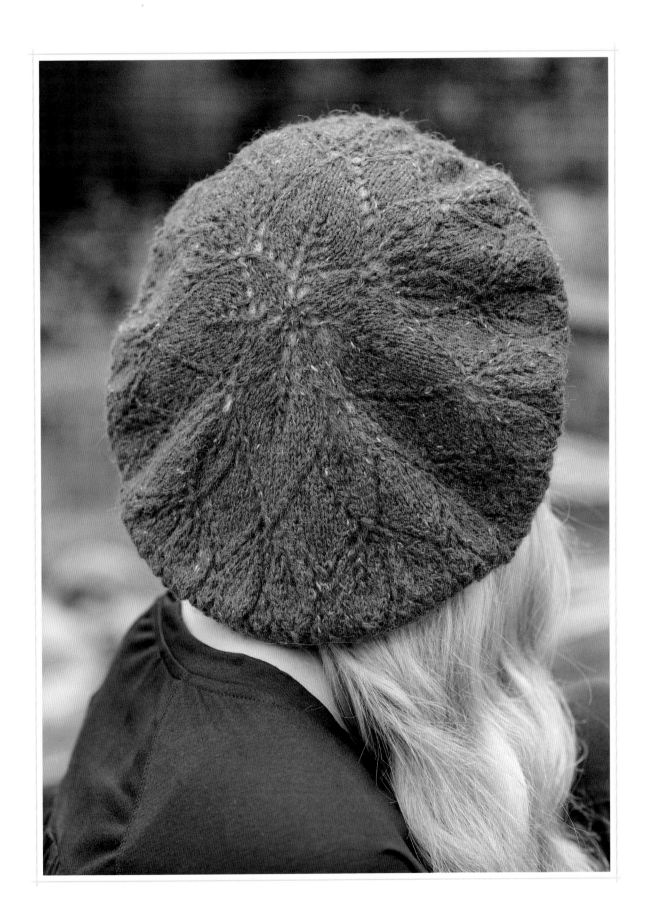

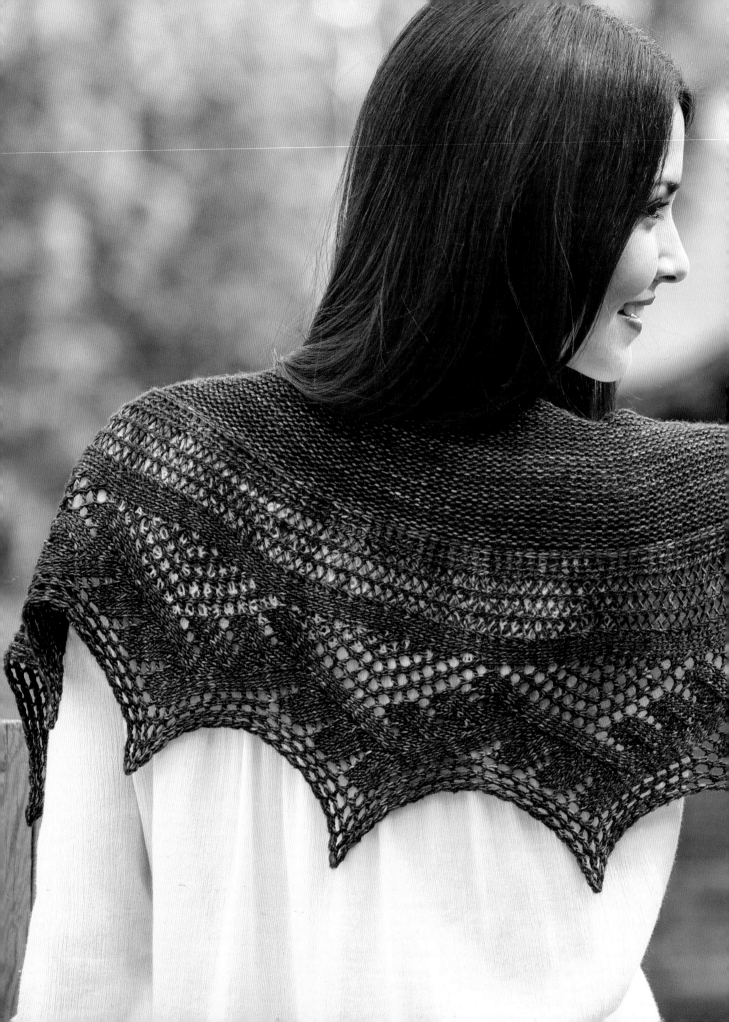

CHAPTER FIVE

WIND *and* SHORE

A STUNNING LACE PANEL FOUND IN ABUNDANCE in Shetland and Estonian lace is the cornerstone of the designs in this chapter. One of my all-time favorites, the panel reminds me of water lapping along the shore in a gentle breeze. For the following designs, I've used the pattern in its basic and "elaborated" versions as an edging and also as a lace panel in the Williwaw Cardigan on page 118. The elaborated edging is combined with a lacy insert in the Crystal Bay Shawl on page 114, where it adds a beautiful accent to a simple garter-stitch top. The basic edging is used for the Secret Cove Cowl on page 133—a perfect, warm and cozy little knit on which to practice your lace skills.

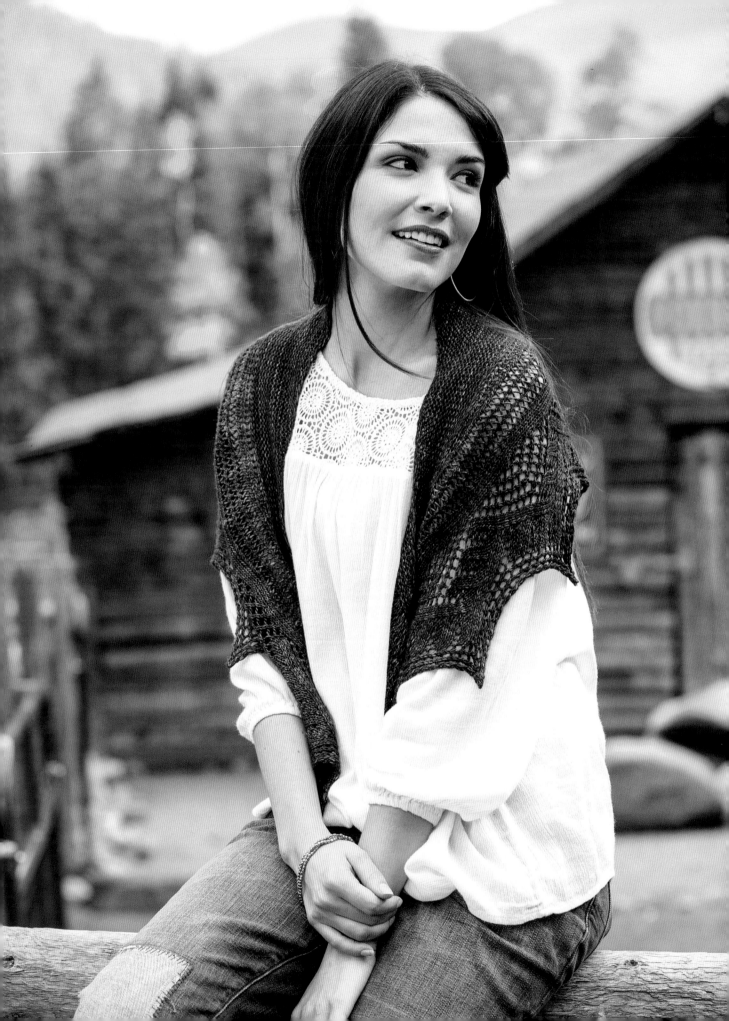

CRYSTAL BAY
shawl

Ultimately adjustable and beautifully simple, this lovely shawl looks amazing in any size and any weight yarn. The "elaborated" Print o' the Wave edging from traditional Shetland lace knitting contrasts nicely with the squishy garter-stitch top to create a wrap that can be worn casually in a heavier-weight yarn or dressed up in a lighter-weight yarn, such as the Zen Yarn Garden yarn shown here (in Mystic Ocean colorway).

FINISHED SIZE
Shawl A (laceweight yarn): About 74" (188 cm) wide and 17" (43 cm) tall.

Shawls B and C (fingering-weight singles yarn): About 60 (81)" (152.5 [206] cm) wide and 14 (16½)" (35.5 [42] cm) tall.

Shawl D (fingering-weight singles yarn): About 66" (167.5 cm) wide and 18" (45.5 cm) tall.

Shawl E (fingering-weight 2-ply yarn): About 65" (165 cm) wide and 16" (40.5 cm) tall.

YARN
Shawl A: Lace weight (#0 Lace): Zen Yarn Garden Serenity Silk+ (75% superwash merino, 15% cashmere, 10% silk; 500 yd [457 m]/100 g): Romi's Garden, 1 skein.

Shawls B and C: Fingering weight (#1 Super Fine): Zen Yarn Garden Serenity Silk Singles (75% superwash merino, 15% cashmere, 10% silk; 430 yd [393 m]/100 g): 1 (2) skeins. Shown in Mystic Ocean (B) and Silver Moon (C).

Shawl D: Fingering weight (#1 Super Fine): Royale Hare Carneros (80% superwash merino, 10% cashmere, 10% nylon; 496 yd [453 m]/4 oz): Forest Green, 2 skeins.

Shawl E: Fingering weight (#1 Super Fine): Baah La Jolla (100% superwash merino; 400 yd [365 m]/100 g): Night Sky, 2 skeins.

Note: Shawls D and E shown were worked with a single skein each with very little yarn leftover.

NEEDLES
Shawl A: Size U.S. 5 (3.75 mm): 24" or 32" (60 or 80 cm) circular (cir) and 1 double-pointed (dpn) for edging.

Shawls B, C, and D: Size U.S. 4 (3.5 mm): 24" or 32" (60 or 80 cm) circular (cir) and 1 double-pointed (dpn) for edging.

Shawl E: Size U.S. 5 (3.75 mm): 24" or 32" (60 or 80 cm) circular (cir) and 1 double-pointed (dpn) for edging.

Shawl F: Size U.S. 8 (5 mm): 24" or 32" (60 or 80 cm) circular (cir) and 1 double-pointed (dpn) for edging.

Adjust needle size if necessary to obtain the correct gauge.

NOTIONS
Removable markers; tapestry needle; flexible blocking wires; T-pins.

GAUGE
Shawl A: 18 sts and 40 rows = 4" (10 cm) in garter st, after blocking.

Shawls B and C: 17 sts and 46 rows = 4" (10 cm) in garter st, after blocking.

Shawl D: 16 sts and 36 rows = 4" (10 cm) in garter st, after blocking.

Shawl E: 15 sts and 36 rows = 4" (10 cm) in garter st, after blocking.

Shawl F: 13 sts and 28 rows = 4" (10 cm) in garter st, after blocking.

» Be sure to work the selvedge stitches loosely to keep the edges stretchy.

» Instructions are provided for 5 options as A (B, C, D, E).

» The edging is worked perpendicularly to the shawl body. See Knitted-On Edgings on page 136.

» In the Edging chart, the gold-shaded symbols always direct you to join 1 edging stitch to 1 shawl stitch as k2togtbl, for a joining rate of 1 shawl stitch for every 2 edging rows.

» The first 3 times and the last 3 times you work Rows 3–38 of the Edging chart, the joining rate is different: only 2 shawl stitches are joined for every 6 edging rows. In these repeats, each pink-shaded symbol indicates joining a second edging stitch to a shawl stitch that was already joined. Work the pink symbol as follows: Slip the last edging stitch, insert the left needle tip from front to back into the shawl stitch joined in the previous right-side row, lift the shawl stitch onto the left needle, return the edging stitch to the left needle, then work it together with the lifted shawl stitch as k2togtbl—a second edging stitch has been joined to 1 shawl stitch.

» For the middle repeats of Rows 3–38, work each pink-shaded symbol as k2togtbl to join 1 shawl stitch to 1 edging stitch, the same as the gold symbol.

SHAWL

With needles specified for your yarn and using the knitted method (see Glossary), CO 6 sts.

Row 1: Yo, k1 through back loop (k1tbl), k1f&b (see Glossary), knit to last 2 sts, k1f&b, k1tbl—3 sts inc'd.

Rep this row 70 (52, 76, 70, 52) more times—219 (165, 237, 219, 165) sts.

EDGING

Without working any sts, place removable markers (pm) as foll: Count 2 sts, pm, [count 12 sts, pm] 3 times, [count 18 sts, pm] 8 (5, 9, 8, 5) times, [count 12 sts, pm] 3 times—1 st left after last marker.

With working yarn, use the knitted method to CO 38 edging sts onto left needle tip. With dpn, work the edging as foll:

Work Row 1 of Edging chart over 38 new CO sts, then work k2togtbl over the first 2 shawl sts (counts as last edging st), remove marker, turn work—2 shawl sts removed; 39 edging sts.

Work Row 2 of Edging chart.

Work Rows 3–38 of Edging chart 3 times, joining each pink shaded edging st to a previously joined shawl st (see Notes), and removing marker after each 12-st group—36 more shawl sts joined, 12 sts for each 36-row rep.

Work Rows 3–38 of Edging chart 8 (5, 9, 8, 5) times, working both pink- and gold-shaded symbols as k2togtbl to join 1 shawl st to 1 edging st, and removing m at the end of each 18-st group—144 (90, 162, 144, 90) more shawl sts joined, 18 sts for each 36-row rep.

Work Rows 3–38 of Edging chart 3 more times, joining each pink-shaded st to a previously joined shawl st as before, and removing marker after each 12-st group—36 more shawl sts joined, 12 sts for each 36-row rep; 40 edging sts and 1 shawl st rem.

Work Row 39 of Edging chart—40 edging sts rem; all shawl sts have been joined.

Using the stretchy method (see Stitch Guide), BO all sts.

FINISHING

Wash in wool wash. Gently squeeze out water, then roll in towels to remove excess moisture. Insert a flexible blocking wire through upper edge of damp shawl, place on a flat surface, and pin securely into a gentle curve. Insert flexible blocking wires through edging points and pin securely. Allow to air-dry thoroughly before removing wires and pins.

Weave in loose ends.

stitch guide

Stretchy BO: K2, *return 2 sts onto left needle tip, k2tog through back loop (tbl), k1; rep from * until 2 sts rem on right needle, return 2 sts onto left needle tip, k2togtbl— 1 st rem. Fasten off rem st.

From left to right: Mystic Ocean (B), Forest Green (D), Night Sky (E), Silver Moon (C), Romi's Garden (A).

EDGING

work once — 39

work 14 (11, 15, 14, 11, 14) times

work once — 1

- knit on RS; purl on WS
- · purl on RS; knit on WS
- ℛ knit 1 through back loop (k1tbl) on RS
- ℛ p1tbl on RS; k1tbl on WS
- ╱ k2tog on RS; p2tog on WS
- ╲ ssk on RS; ssp on WS
- ⟍ k2tog through back loops (k2togtbl)
- ⟑ sl 1, k2togtbl, psso
- ○ yo
- ⟱ k1f&b on WS
- V sl 1 pwise wyf on WS
- ⟍ k2togtbl 1 edging st tog with 1 shawl st
- ▨ work according to directions and Notes

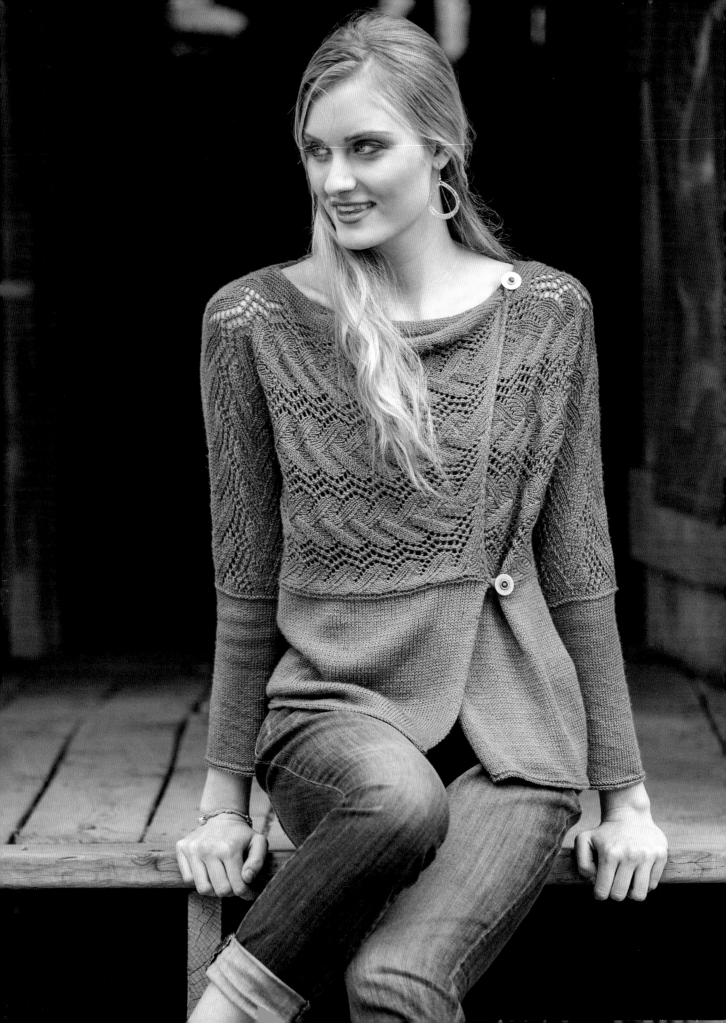

WILLIWAW
cardigan

This cardigan features an interesting twist on construction—the upper section is worked from side to side; then, from that section, stitches for the lower section are picked up and worked downward. As a result, the lace panels appear in horizontal bands across the upper body and sleeves. Knitted in a high-twist yarn with beautiful silken drape, the relaxed asymmetrical closure adds an elegant finish.

FINISHED SIZE
About 37 (42, 47, 52, 58)" (94 [106.5, 119.5, 132, 147.5] cm) bust circumference with fronts overlapped so side seams align with side folds.

Sweater shown measures 37" (94 cm).

YARN
Fingering weight (#1 Super Fine).

Shown here: Shibui Staccato (70% superwash merino, 30% silk; 191 yd [174 m]/50 g): #2002 Graphite, 7 (8, 10, 11, 13) skeins.

NEEDLES
Body and sleeves: size U.S. 4 (3.5 mm): 16" (40 cm) and 24" or 32" (60 or 80) circular (cir).

Lower body and lower sleeves: size U.S. 3 (3.25 mm): 16" and 24" or 32" (40 and 60 or 80) cir.

Edgings and button loops: size U.S. 3 (3.25 mm) set of 2 double-pointed (dpn).

Bind-off: size U.S. 2 (2.75 mm) straight, cir, or dpn.

Adjust needle size if necessary to obtain the correct gauge.

NOTIONS
Markers (m); waste yarn; cable needle (cn); tapestry needle; blocking wires, T-pins; three ½" (1.3 cm) clear buttons; two ⅞" (2.2 cm) buttons.

GAUGE
24 sts and 32 rows/rnds = 4" (10 cm) in St st on largest needles, after blocking.

20½ sts and 36½ rows = 4" (10 cm) in lace patt from repeated section of Chart A-4 on largest needles, after blocking.

notes

» It's extremely important to swatch for this sweater because the lace will relax substantially after washing and blocking, and there will be large differences in pre- and post-blocking measurements.

» Make sure to work the slipped edge stitches of Charts A-1 through A-3 and Charts F-1 through F-3 loosely, so they can be stretched firmly to create straight edges during blocking.

» If you use markers to set off individual pattern repeats, you may need to move each marker one stitch to accommodate a decrease that falls at the start or end of an outlined pattern repeat, before the first repeat, or after the last repeat.

» The loops picked up from the provisional cast-on lie between actual stitches, so there will be one fewer than the number of stitches required. To make up the one-loop deficit, create an extra loop at one side by slipping the needle under one leg of a garter selvedge stitch from the first row.

stitch guide

3 Edge Sts: *RS rows:* K3, return 3 sts just worked onto left needle with yarn in back (wyb), and work them again as k3. *WS rows:* P3, return 3 sts just worked onto left needle with yarn in front (wyf), and work them again as p3.

M1: Insert left needle tip from back to front under the horizontal strand between the needles, then knit the lifted strand through the front loop to twist it—1 st inc'd.

Stretchy BO: K2, *return 2 sts onto left needle tip, k2tog through back loop (tbl), k1; rep from * until 2 sts rem on right needle, return 2 sts onto left needle tip, k2togtbl—1 st rem. Fasten off rem st.

RIGHT FRONT

Note: The right front is worked from the point of the asymmetrical front closure out to the right side of the neck opening.

With waste yarn and longer cir needle in largest size, use a provisional method (see Glossary) to CO 6 (6, 8, 8, 6) sts, leaving a 36" (91.5 cm) tail for working button loop and grafting later.

Change to working yarn and knit 1 RS row.

Next row: (WS) P3, yo, purl to end—7 (7, 9, 9, 7) sts.

Work Rows 1–36 of Chart A-1 (see page 122)—49 (49, 51, 51, 49) sts.

Work Rows 1–12 of Chart A-2 (see page 123), working the 17-st repeat box once —66 (66, 68, 68, 66) sts.

Size 58" (147.5 cm) only

Work Rows 1–12 of Chart A-2 once more, working the 17-st repeat box 2 times—83 sts.

All sizes

Work Rows 1–10 of Chart A-3—79 (79, 81, 81, 96) sts; 60 (60, 60, 60, 72) rows completed (including 2 rows before first chart); piece measures about 6½ (6½, 6½, 6½, 8)" (16.5 [16.5, 16.5, 16.5, 20.5] cm) from CO, after blocking.

Work Row 11 of Chart A-3 to last 3 sts, place rem 3 edge sts onto waste-yarn holder—76 (76, 78, 78, 93) sts.

Work Rows 12–18 of Chart A-3.

Work Rows 1–6 of Chart A-4 once.

Work Rows 7–18 of Chart A-4 three times.

Work Rows 19 and 20 of Chart A-4 once, ending at right side of neck opening—piece measures about 12¼ (12¼, 12¼, 12¼, 13¾)" (31 [31, 31, 31, 35] cm) from CO, after blocking.

With RS facing, place 3 neck edge sts at beg of row onto waste yarn; place rem 73 (73, 75, 75, 90) sts onto spare cir needle or waste yarn. Cut yarn, leaving a 12" (30.5 cm) tail for grafting neck edge sts to back later.

RIGHT BACK

Note: The right back is worked from center out to the right side of the neck opening.

With waste yarn and longer cir needle in largest size, use a provisional method to CO 76 (76, 78, 78, 93) sts.

Change to working yarn and purl 1 WS row.

Work Rows 1–16 of Chart B (see page 124) once.

Work Rows 17–28 of Chart B 2 times.

Work Rows 29 and 30 of Chart B once, ending at right side of neck opening—43 rows completed (including first WS row); piece measures about 4¾" (12 cm) from CO, after blocking.

With RS facing, place 3 neck edge sts at end of row onto waste yarn—73 (73, 75, 75, 90) sts rem on needle.

RIGHT SHOULDER AND SLEEVE

Work Row 1 of Chart C (see page 124) to join right back and front as foll: Work first 72 (72, 74, 74, 89) chart sts across back sts on needle, temporarily slip last back st onto right needle tip; place 73 (73, 75, 75, 90) held right front sts onto left needle with RS facing, slip last back st onto cn and hold in front, knit the first front st, then knit

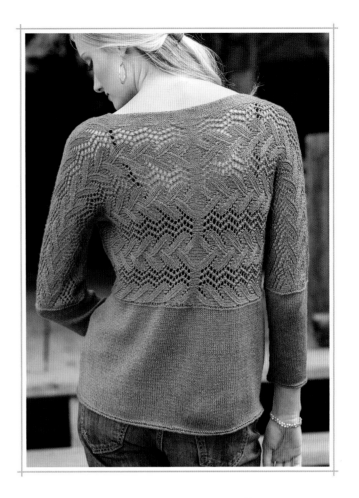

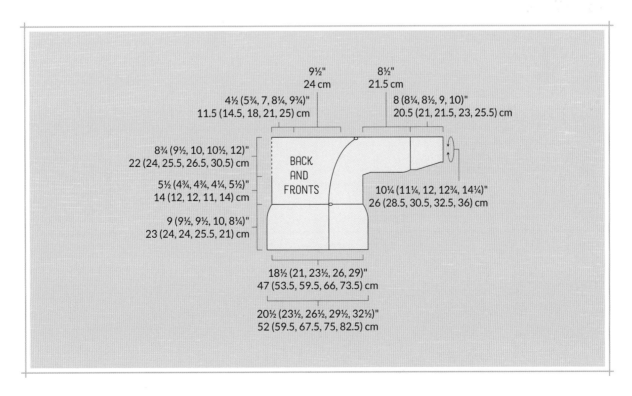

last back st from cn; work rem 72 (72, 74, 74, 89) chart sts across 72 (72, 74, 74, 89) right front sts—146 (146, 150, 150, 180) sts.

Work Row 2 of Chart C.

Work Row 3 of Chart C, dec 2 sts in center as shown—144 (144, 148, 148, 178) sts rem.

Work Rows 4–10 of Chart C once.

Work Rows 11–22 of Chart C 2 (3, 4, 5, 6) times—34 (46, 58, 70, 82) rows completed from end of right neck opening.

Notes: Use Chart D (see pages 126–127) for sizes 37 (58)" (94 [147.5] cm); use Chart D-1 for sizes 42 (47, 52)" (106.5 [119.5, 132] cm). When working Chart D-1 for sizes 42 (47)" (106.5 [119.5] cm), work the green-shaded edge stitches and everything between them, omitting the pink-shaded stitches. When working Chart D-1 for size 52" (132 cm), work the entire chart, including the pink-shaded stitches and working the green-shaded stitches that apply to the other two sizes in stockinette.

Work Rows 1–6 of chart for your size—40 (52, 64, 76, 88) total shoulder rows from end of right neck opening; shoulder measures about 4½ (5¾, 7, 8¼, 9¾)" (11.5 [14.5, 18, 21, 25] cm), after blocking.

BO for sides of body on next 2 rows as foll:

Row 7: (RS) BO 28 (25, 25, 22, 28) sts, work to end—116 (119, 123, 126, 150) sts.

Row 8: (WS) BO 28 (25, 25, 22, 28) sts, work to end—88 (94, 98, 104, 122) sts rem.

Work Rows 9–36 of chart, dec as shown—76 (82, 86, 92, 110) sts rem.

Work Rows 25–36 of chart 4 times—78 rows completed from start of side BO rows; sleeve measures about 8½" (21.5 cm) from side BO, after blocking.

Place sts onto holder; do not cut yarn.

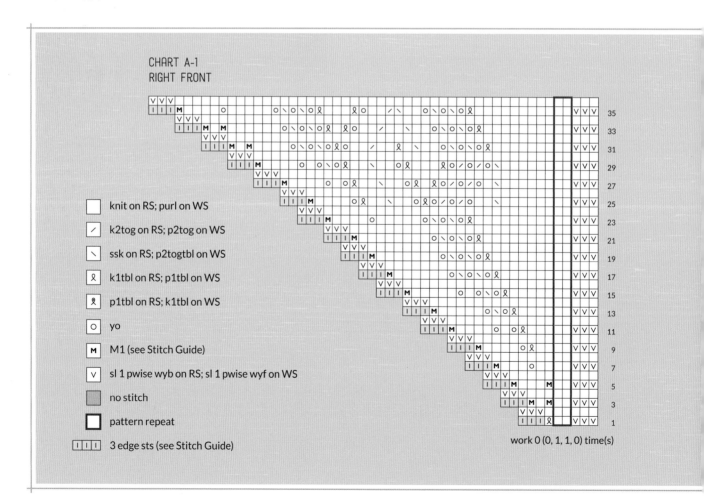

CHART A-1
RIGHT FRONT

knit on RS; purl on WS

k2tog on RS; p2tog on WS

ssk on RS; p2togtbl on WS

k1tbl on RS; p1tbl on WS

p1tbl on RS; k1tbl on WS

yo

M1 (see Stitch Guide)

sl 1 pwise wyb on RS; sl 1 pwise wyf on WS

no stitch

pattern repeat

3 edge sts (see Stitch Guide)

work 0 (0, 1, 1, 0) time(s)

CHART A-2
RIGHT FRONT

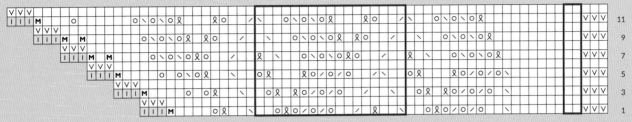

see instructions

work 0 (0, 1, 1, 0) time(s)

CHART A-3
RIGHT FRONT

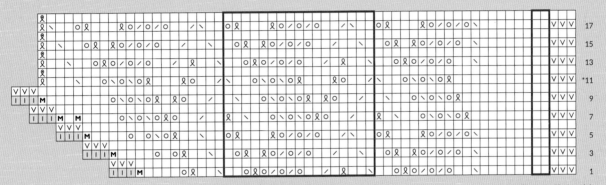

work 2 (2, 2, 2, 3) times

work 0 (0, 1, 1, 0) time(s)
*see instructions for Row 11

CHART A-4
RIGHT FRONT

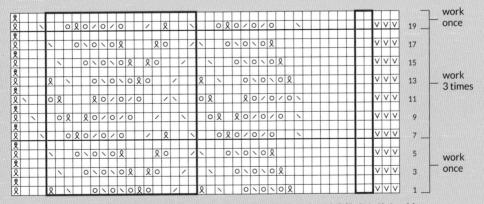

work 3 (3, 3, 3, 4) times

work 0 (0, 1, 1, 0) time(s)

work once

work 3 times

work once

Legend

- knit on RS; purl on WS
- k2tog on RS; p2tog on WS
- ssk on RS; p2togtbl on WS
- k1tbl on RS; p1tbl on WS
- p1tbl on RS; k1tbl on WS
- yo
- sl 1 pwise wyb on RS; sl 1 pwise wyf on WS
- no stitch
- pattern repeat

CHART B
RIGHT BACK

work once
work 2 times
work once

Row numbers: 29, 27, 25, 23, 21, 19, 17, 15, 13, 11, 9, 7, 5, 3, 1

work 3 (3, 3, 4) times

work 0 (0, 1, 1, 0) time(s)

CHART C
SHOULDER

work 2 (3, 4, 5, 6) times
work once

Row numbers: 21, 19, 17, 15, 13, 11, 9, 7, 5, 3, 1

work 3 (3, 3, 4) times

work 0 (0, 1, 1, 0) time(s)

work 0 (0, 1, 1, 0) time(s)

work 3 (3, 3, 4) times

LEFT BACK

Note: The left back is worked from center out to the left side of the neck opening.

Carefully remove provisional CO from right back sts and place 76 (76, 78, 78, 93) sts onto longer cir needle in largest size (see Notes).

Work Rows 1–16 of Chart E (see page 129) once.

Work Rows 17–28 of Chart E 2 times.

Work Rows 29 and 30 of Chart E once, ending at left side of neck opening—42 rows completed (including first WS row); piece measures about 4¾" (12 cm) from CO, after blocking.

With RS facing, place 3 neck edge sts at beg of row onto waste yarn; place rem 73 (73, 75, 75, 90) sts onto spare cir needle or waste yarn. Cut yarn, leaving a 12" (30.5 cm) tail for grafting neck edge sts to front later.

LEFT FRONT

Note: The left front is worked from the point of the front closure underlayer out to the left side of the neck opening.

With waste yarn and longer cir needle in largest size, use a provisional method to CO 6 (6, 8, 8, 6) sts, leaving a 36" (91.5 cm) tail for working button loop and grafting later.

Change to working yarn and knit 1 RS row.

Next row: (WS) P3 (3, 5, 5, 3), yo, purl to end—7 (7, 9, 9, 7) sts.

Work Rows 1–36 of Chart F-1 (see page 130)—49 (49, 51, 51, 49) sts.

Work Rows 1–12 of Chart F2, working the 17-st repeat box once—66 (66, 68, 68, 66) sts.

Size 58" (147.5 cm) only

Work Rows 1–12 of Chart F-2 once more, working the 17-st repeat box 2 times—83 sts.

All sizes

Work Rows 1–10 of Chart F-3—79 (79, 81, 81, 96) sts; 60 (60, 60, 60, 72) rows completed (including 2 rows before first chart); piece measures about 6½ (6½, 6½, 6½, 8)" (16.5 [16.5, 16.5, 16.5, 20.5] cm) from CO, after blocking.

Work Row 11 of Chart F-3 by placing 3 edge sts at beg of row onto waste-yarn holder, then work in patt to end—76 (76, 78, 78, 93) sts rem.

Work Rows 12–18 of Chart F-3.

Work Rows 1–6 of Chart F-4 (see page 131) once.

Work Rows 7–18 of Chart F-4 two times; this is deliberately 1 less repeat than for the right front.

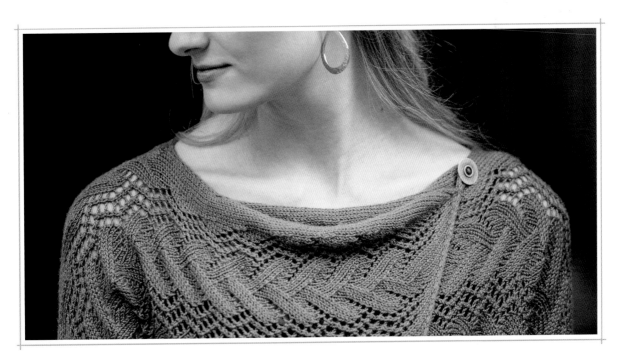

Legend

- □ knit on RS; purl on WS
- ╱ k2tog on RS; p2tog on WS
- ╲ ssk on RS; p2togtbl on WS
- ℟ k1tbl on RS; p1tbl on WS
- ℟ p1tbl on RS; k1tbl on WS
- ○ yo
- ⌒ BO 1 st
- □ st on right needle after BO (do not work again)
- ▢ pattern repeat

CHART D
SLEEVE: SIZES 37 (58)"

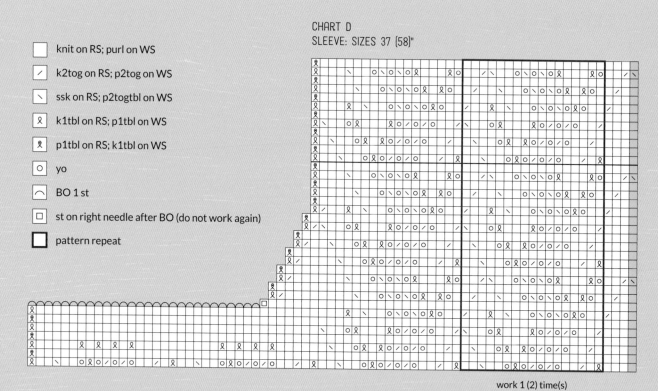

work 1 (2) time(s)

CHART D-1
SLEEVE: SIZES 42 (47, 52)"

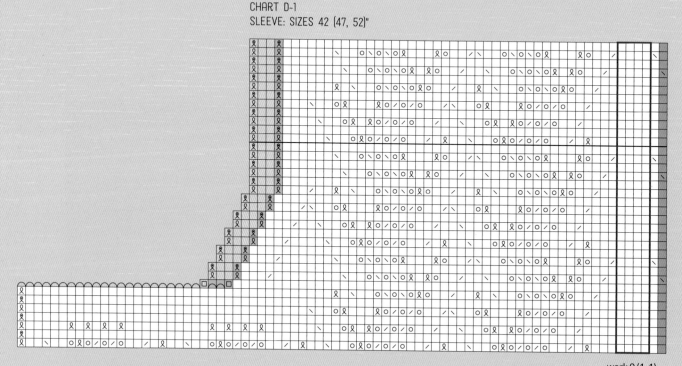

work 0 (1, 1) time(s)

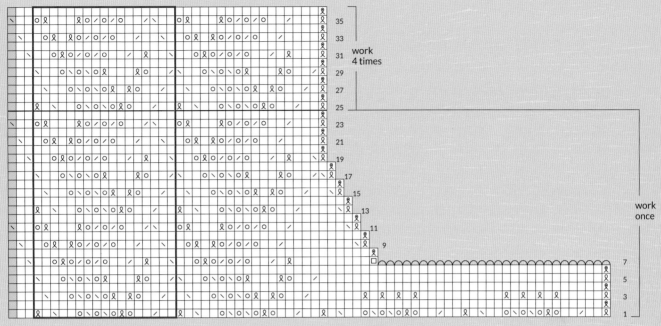

work 1 (2) time(s)

Note: Stitches shaded in blue are duplicated for ease of following the two halves of the chart. Work the shaded stitches only once.

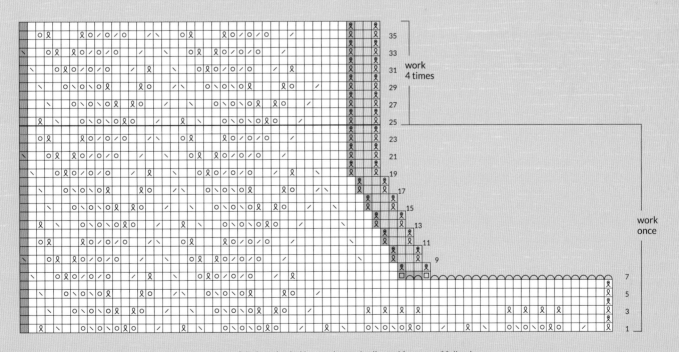

Note: Stitches shaded in purple are duplicated for ease of following the two halves of the chart. Work the shaded stitches only once.

Work Rows 19 and 20 of Chart F-4 once, ending at left side of neck opening—piece measures about 11 (11, 11, 11, 12½)" (28 [28, 28, 28, 31.5] cm) from CO, after blocking.

With RS facing, place 3 neck edge sts at end of row onto waste yarn—73 (73, 75, 75, 90) sts rem on needle.

LEFT SHOULDER AND SLEEVE

Work Row 1 of Chart C (see page 124) to join left front and back as foll: Work first 72 (72, 74, 74, 89) chart sts across front sts on needle, temporarily slip last front st onto right needle tip; place 73 (73, 75, 75, 90) held left back sts onto left needle with RS facing, slip last front st onto cn and hold in front of work, knit the first back st, then knit last front st from cn; work rem 72 (72, 74, 74, 89) chart sts across 72 (72, 74, 74, 89) left back sts—146 (146, 150, 150, 180) sts.

Complete as for right shoulder and sleeve—76 (82, 86, 92, 110) sts rem; sleeve will measure about 8½" (21.5 cm) from side BO, after blocking. Place sts onto holder; do not cut yarn.

NECK EDGING AND BUTTON LOOP

Remove waste yarn from 3 held back sts and 3 held front sts at shoulder, then place sts onto separate dpn in middle size. With yarn tail threaded on a tapestry needle, use the Kitchener st (see Glossary) to graft edge sts tog so I-cord (see Glossary) edging appears continuous as it crosses the shoulder line. Use the tail to tidy the join on the WS, if necessary.

Rep for second shoulder.

Remove waste yarn from right front provisional CO, place first 3 (3, 4, 4, 3) sts onto dpn in middle size, then place rem 3 (3, 4, 4, 3) sts onto holder. Rejoin yarn with RS facing. Work 3 (4)-st I-cord until piece is long enough to form a loop that snugly fits a ⅞" (2.2 cm) button. Bring live I-cord sts and held sts tog so the loop is twisted at its base, and use the Kitchener stitch to graft loop closed. Sew through all layers at twisted base of loop to stabilize.

Remove waste yarn from left front provisional CO and place 3 (3, 4, 4, 3) sts each onto separate dpn in middle size. With yarn tail threaded on a tapestry needle, use the Kitchener st to graft edge sts tog so I-cord edging

☐	knit on RS; purl on WS
╱	k2tog on RS; p2tog on WS
╲	ssk on RS; p2togtbl on WS
℞	k1tbl on RS; p1tbl on WS
℞	p1tbl on RS; k1tbl on WS
○	yo
∨	sl 1 pwise wyb on RS; sl 1 pwise wyf on WS
☐	pattern repeat

appears continuous as it rounds the corner, then use the tail to tidy the join on the WS, if necessary.

LOWER SLEEVES

Taking care not to get the balls of yarn attached to the sleeves wet, block front and back lace sections to measurements. Allow to dry completely before continuing.

Place 76 (82, 86, 92, 110) held sleeve sts onto 16" (40 cm) cir needle in largest size. With yarn attached to sleeve sts, knit to last st, working each st that lies directly above a yo from the final chart row as k1tbl. Bring ends of row tog and work last st tog with first st as k2togtbl to join in the rnd—75 (81, 85, 91, 109) sts. Pm for beg of rnd.

Next rnd: Purl to last 2 sts, p2tog—74 (80, 84, 90, 108) sts rem.

Knit 9 rnds even.

Dec rnd: K1, ssk, knit to last 3 sts, k2tog, k1—2 sts dec'd.

Rep the last 10 rnds 5 (5, 5, 6, 0) more times—62 (68, 72, 76, 106) sts rem; sleeve measures about 7¾ (7¾, 7¾, 9, 1½)" (19.5 [19.5, 19.5, 23, 3.8] cm) from last row of lace chart.

Size 58" (147.5 cm) only

Knit 7 rnds even.

Dec rnd: K1, ssk, knit to last 3 sts, k2tog, k1—2 sts dec'd.

Rep the last 8 rnds 7 more times—90 sts rem.

Change to 16" (40 cm) cir needle in middle size.

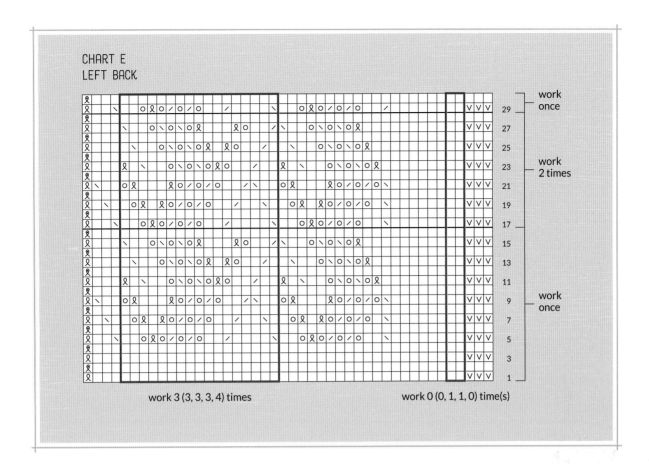

CHART E
LEFT BACK

work once
work 2 times
work once

work 3 (3, 3, 3, 4) times work 0 (0, 1, 1, 0) time(s)

[Rep dec rnd, then work 1 rnd even] 2 times—86 sts rem.

All sizes

Work even in St st, if necessary, until sleeve measures 7¾ (8, 8¼, 8¾, 10)" (19.5 [20.5, 21, 22, 25.5] cm) from last row of lace chart.

Purl 1 rnd, then knit 2 rnds—sleeve measures 8 (8¼, 8½, 9, 10)" (20.5 [21, 21.5, 23, 25.5] cm) from last row of lace chart.

Working with the smallest size needles, use the stretchy method (see Stitch Guide) to BO all sts.

LOWER BODY

With yarn threaded on a tapestry needle, sew body side seams, sewing 1 full st in from the edge so the garter selvedge sts do not show on RS.

Hold body upside down. Remove waste yarn from 3 held sts of left front corner (the ones put onto holder in Row 11 of Chart F-3), and place sts onto longer cir

needle in largest size. Join yarn with RS facing.

K3, return 3 sts just worked to left needle wyb, and work them again as k3.

Note: When picking up stitches, make sure to pick up one full stitch in from the edge so that the twisted garter selvedge stitch is not visible from the right side.

Cont with yarn attached to 3 edge sts, pick up and knit 60 (69, 78, 87, 96) sts across bottom edge of left front, 123 (141, 159, 177, 195) sts across back, and 70 (79, 88, 97, 106) sts across right front; then place 3 held sts of right front corner (the ones put onto holder in Row 11 of Chart A-3) onto left needle, k3, return 3 sts just worked onto left needle wyb, and work them again as k3—259 (295, 331, 367, 403) sts total.

Allowing rem sts to rest on needle, work 3-st I-cord on last 3 sts only until piece is the same length as previous button loop. Twist the I-cord and turn the work; this second button loop will be sewn closed later.

CHART F-1
LEFT FRONT

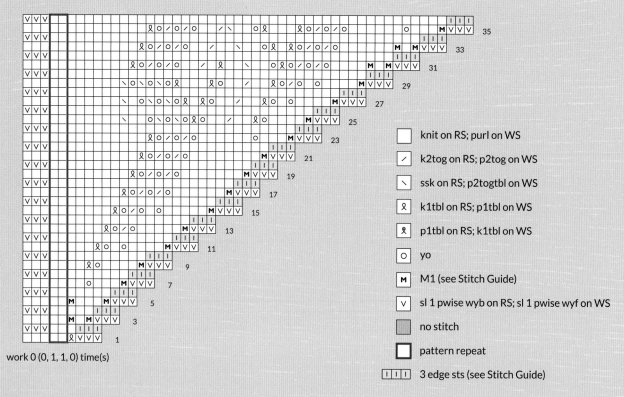

work 0 (0, 1, 1, 0) time(s)

Legend:

☐	knit on RS; purl on WS
╱	k2tog on RS; p2tog on WS
╲	ssk on RS; p2togtbl on WS
♉	k1tbl on RS; p1tbl on WS
♈	p1tbl on RS; k1tbl on WS
o	yo
M	M1 (see Stitch Guide)
V	sl 1 pwise wyb on RS; sl 1 pwise wyf on WS
▨	no stitch
☐	pattern repeat
IIII	3 edge sts (see Stitch Guide)

CHART F-2
LEFT FRONT

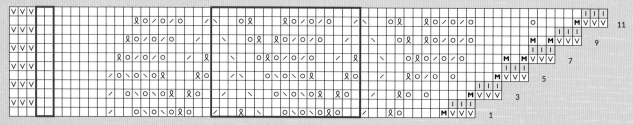

work 0 (0, 1, 1, 0) time(s) see instructions

CHART F-3
LEFT FRONT

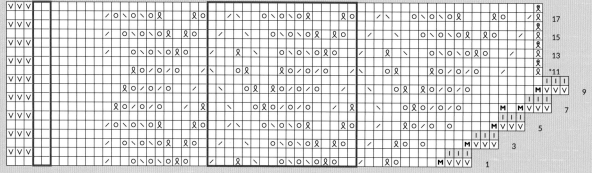

work 0 (0, 1, 1, 0) time(s)
*see instructions for Row 11

work 2 (2, 2, 2, 3) times

Next row: (WS) Sl 1 st wyf, p2, *k1tbl; rep from * to last 3 sts, p3.

Next row: (RS) Sl 3 sts wyb, knit to end.

Next row: Sl 3 sts wyf, purl to end.

Rep the last 2 rows until piece measures 8¾ (9¼, 9¼, 9¾, 8)" (22 [23.5, 23.5, 25, 20.5] cm) from pick-up row, ending with a RS row.

Note: The largest size has a deeper upper body, so its lower body is shorter to prevent the overall length from becoming too long.

Change to longer cir needle in middle size.

Row 1: (WS) Sl 3 wyf, knit to last 3 sts, p3.

Row 2: (RS) Sl 3 wyb, knit to end.

Row 3: Sl 2 wyf, purl to end—piece measures 9 (9½, 9½, 10, 8¼)" (23 [24, 24, 25.5, 21] cm) from pick-up row.

With RS facing, use the stretchy method to BO all sts.

FINISHING

Sew I-cord button loop onto right front at lower body pick-up row, twisting its base to match the other button loop. Sew through all layers at twisted base of loop to stabilize.

Dip lower body and sleeve into wool wash and remove excess water; it's not necessary to block the lace sections again. Block lower edge into a straight line by weaving blocking wires in and out of the pick-up and CO edges of the lower body while the piece is damp, then pinning to measurements. Block the lower sleeves as flat and straight as possible. Allow to air-dry thoroughly before removing wires and pins.

BUTTONS

Try on sweater with side seams hanging vertically and aligned with the sides of your body. Overlap the right front on top of the left front, with neck edges and lower body pick-up row even, and adjust the amount of overlap to the point at which the best fit is achieved. Mark where the button loops touch the RS of the left front at neckline and pick-up row, and where the upper left front corner touches the WS of the right front. Sew one small clear button to WS of right front at neck edge; the first yo in the left front corner will serve as its buttonhole. Place one large button at the marked neckline position on RS of left front, then place a small clear button directly under it on the WS to serve as a backing button, and sew buttons to one another, sandwiching the fabric. Place the second large button and remaining backing button at marked pick-up row position on RS of left front, and sew buttons together.

Weave in loose ends.

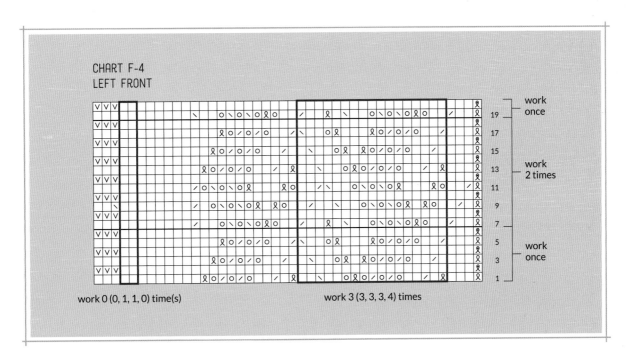

CHART F-4
LEFT FRONT

work 0 (0, 1, 1, 0) time(s) work 3 (3, 3, 3, 4) times

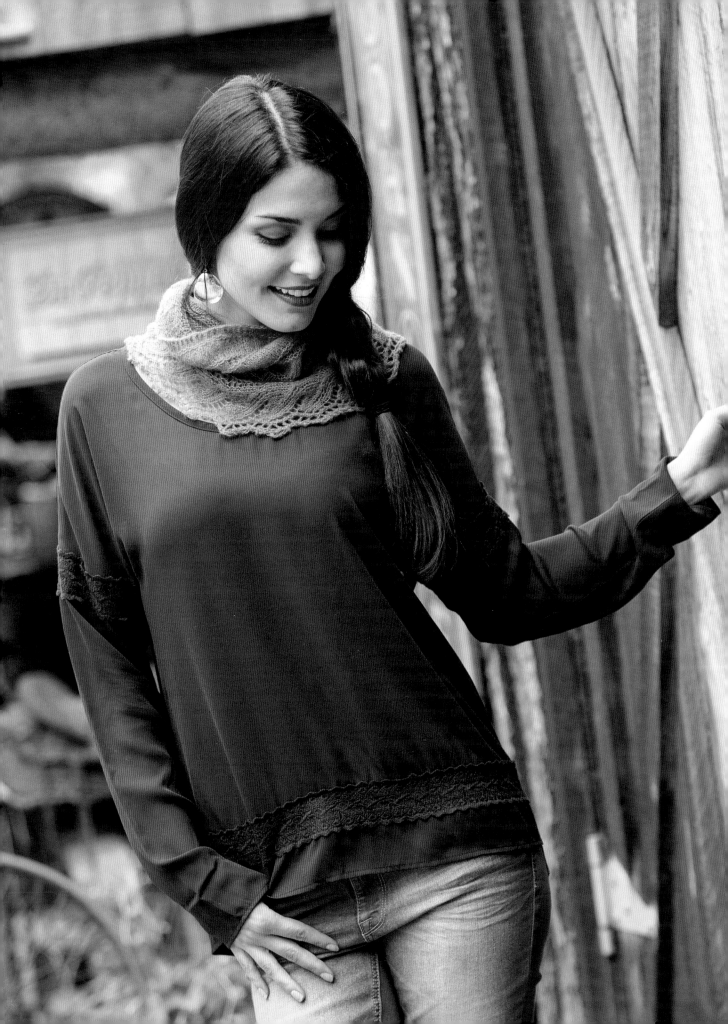

SECRET COVE
cowl

Knitted from the top down in a cashmere/silk blend, this lovely cowl has ruching at the top that will trap warm air against your neck in even the chilliest weather. Subtle short-rows at the lower edge add enough fabric for full neck coverage. A lace edging is knitted onto the live stitches of the cowl, then the ends are grafted together at the back. You can use this cowl format to knit wearable swatches while practicing the other lace patterns in this book.

FINISHED SIZE
About 16" (40.5 cm) circumference at top edge, 26" (66 cm) circumference at lower edge, 15" (38 cm) tall at center back, and 1¼" (3.2 cm) shorter at center front.

YARN
Lace weight (#0 Super Fine).

Shown here: Filatura di Crosa Superior (70% cashmere, 25% silk, 5% extra fine merino; 328 yd [300 m]/ 25 g): #56 Olive, 1 ball.

NEEDLES
Size U.S. 5 (3.75 mm): 16" (40 cm) circular (cir) and set of 4 or 5 double-pointed (dpn).

Adjust needle size if necessary to obtain the correct gauge.

NOTIONS
Markers (m); coil-less safety pins; tapestry needle; T-pins; size F/5 (3.75 mm) crochet hook for provisional CO; cotton waste yarn

GAUGE
24 sts and 29 rows = 4" (10 cm) in St st after blocking.

36 rows (3 patt reps) of lace edging measure about 5" (12.5 cm) high after blocking.

notes

» To minimize the chance of twisting the stitches, one row is knitted before joining to work in the round. The cast-on tail is used to sew the small opening created by the first row during finishing.

» This pattern uses both the Japanese and the wrap-and-turn (w&t) short-row methods. For the Japanese method, instead of wrapping a stitch at the turning point, a coil-less safety pin is placed around the strand of working yarn after turning. To close the short-row gaps, pull up on each pin as you come to it, lift the turning loop onto the left needle, remove the pin, then work the loop together with the adjacent stitch as instructed. For this project, the Japanese method is used in the stockinette areas. The w&t method is used at each end of the short-row section; it's not necessary to work the wrap together with the wrapped stitch on the purled garter ridge row because the wrap will not show.

» The Edging chart begins with 13 stitches, increases to a maximum of 16 stitches, then decreases back to 13 stitches again.

» The join where the ends of the lace edging are grafted together will not look exactly perfect because the abutting ends will be offset by half a stitch, but grafting is much less noticeable than a three-needle bind-off or seam. If you do not wish to graft, a three-needle bind-off is the next best choice; take care to bind-off loosely.

stitch guide

Ruching Pattern
Rnds 1 and 2: Purl.

Rnd 3: *K1f&b (see Glossary); rep from *— number of sts has doubled.

Rnds 4–9: Knit.

Rnd 10: *K2tog; rep from *—number of sts has been restored to original count.

Rnds 11 and 12: Purl.

Rnds 13–15: Knit.

Rep Rnds 1–15 for patt.

COWL

With cir needle, use the knitted method (see Glossary) to CO 96 sts. Do not join to work in round (see Notes). Knit 1 RS row. With RS still facing, place marker (pm) and join for working in rnds, being careful not to twist sts.

Knit 5 rounds.

Work Rnds 1–15 of ruching patt (see Stitch Guide) 5 times.

Purl 1 rnd.

SHAPE BACK NECK

Work short-rows (see Glossary) as foll.

Short-Row 1: (RS) P72, wrap next st, turn work, pm.

Short-Row 2: (WS) [P1f&b (see Glossary)] 48 times, wrap next st, turn work, pm—96 sts between markers for short-row section; 24 sts at each side; 1 wrapped st outside each short-row marker.

Short-Row 3: K84, turn work and place safety pin around yarn strand (see Notes).

Short-Row 4: P72, turn work and place safety pin around yarn strand.

Short-Row 5: K60, turn work and place safety pin around yarn strand.

Short-Row 6: P48, turn work and place safety pin around yarn strand.

Short-Row 7: K36, turn work and place safety pin around yarn strand.

Short-Row 8: P24, turn work and place safety pin around yarn strand.

Short-Row 9: Knit to m at end of short-row section, lifting each safety-pinned yarn loop onto left needle tip and knitting the loop tog with next st when you come to it (see Notes), slip short-row section marker (sl m), then purl to end-of-rnd m without purling wrapped st tog with its wrap.

Resume working in rnds as foll.

Rnd 1: Knit to 1 st before short-row m, knit rem wrapped st tog with its wrap, remove marker, *[k2tog] 5 times, sl 2 tog, lift safety-pinned yarn loop onto left needle tip, remove pin, knit loop, pass 2 slipped sts over; rep from * 2 more times, [k2tog] 30 times, remove marker at end of short-row section, knit to end of rnd—96 sts.

Rnds 2 and 3: Purl.

Set aside. Do not cut yarn.

EDGING

With dpn and waste yarn, use the crochet-on method (see Glossary) to provisionally CO 13 sts.

Turn cowl so WS is facing and use the working yarn still attached to cowl to k13 CO sts, taking care to tighten yarn between cowl and provisional CO.

Work Rows 1–12 of Edging Chart 16 times, working last edging st tog with 1 live cowl st at end of every RS row (see Notes)—13 edging sts rem; all cowl sts have been joined.

Cut yarn, leaving a 16" (40.5 cm) tail for grafting.

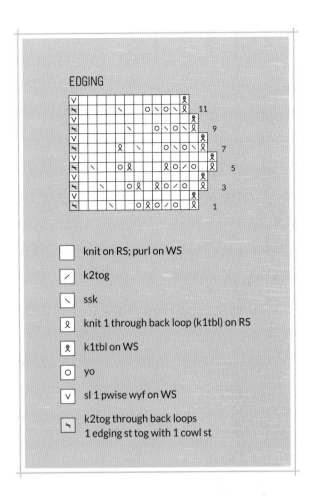

EDGING

Legend:

- ☐ knit on RS; purl on WS
- ╱ k2tog
- ╲ ssk
- ℛ knit 1 through back loop (k1tbl) on RS
- ℛ k1tbl on WS
- ○ yo
- V sl 1 pwise wyf on WS
- ⤡ k2tog through back loops 1 edging st tog with 1 cowl st

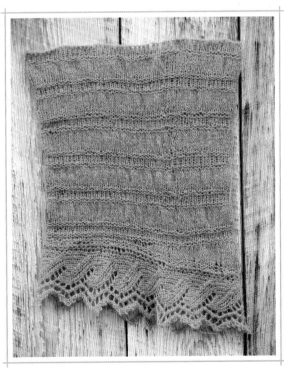

FINISHING

Carefully remove waste yarn from edging CO and place 13 exposed sts onto spare dpn. Hold the two needles parallel with WS of lace facing tog. With yarn threaded on a tapestry needle, use the Kitchener st (see Glossary) to graft the two groups of sts tog. With CO tail threaded on a tapestry needle, sew edges of first row tog.

Wash in wool wash. Gently squeeze out water, then roll in towels to remove excess moisture. Place damp cowl on flat surface and smooth to measurements, patting lace edging into shape. Allow to air-dry thoroughly.

Weave in loose ends.

knitted-on edgings

Knitted-on edgings are lovely and provide enough stretch for the lace to block out to its full potential. Although it's possible to work the edging using the two tips of the main circular needle, it can be cumbersome. Using a double-pointed needle makes it easier and much more pleasurable to work the edging perpendicular to the main piece.

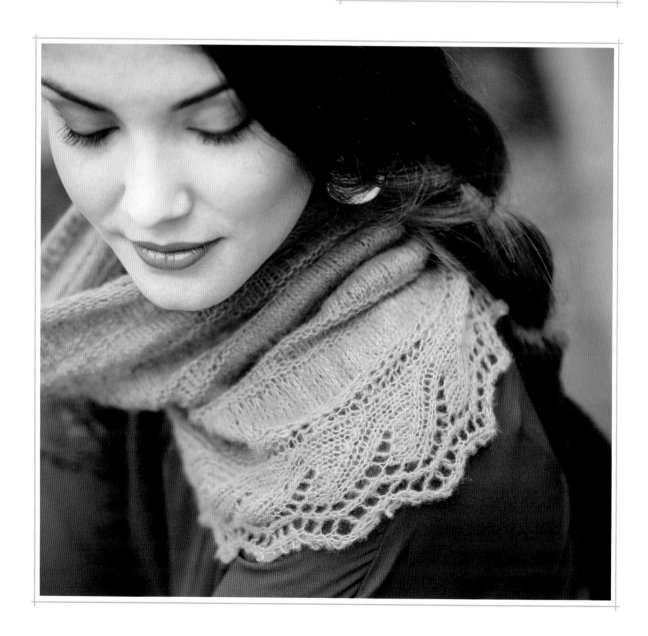

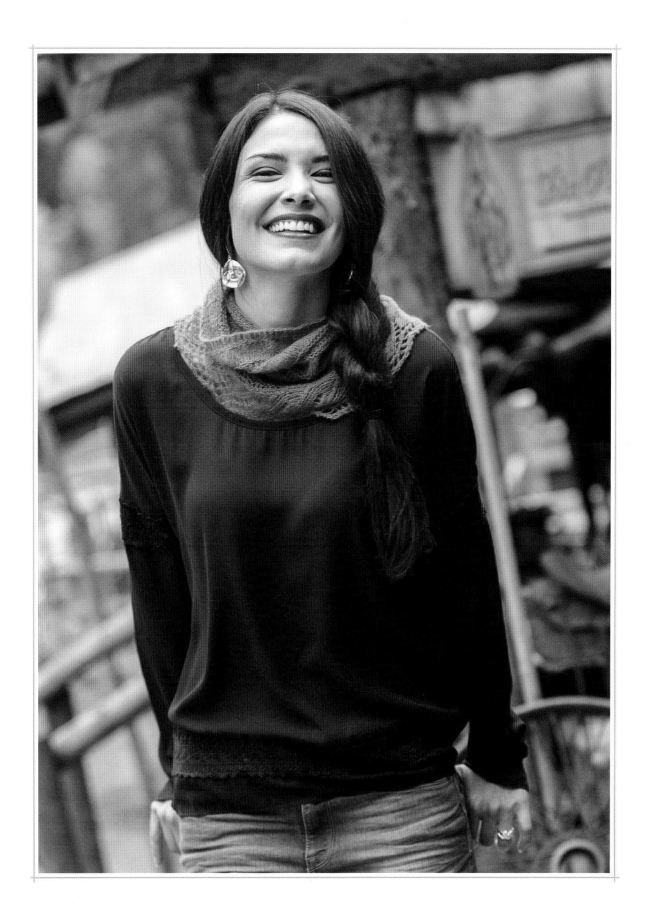

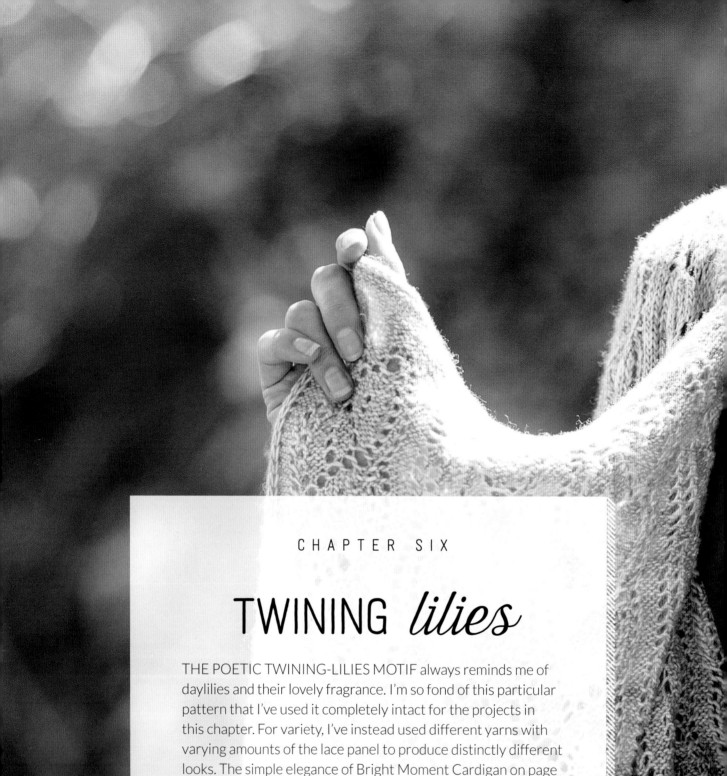

CHAPTER SIX

TWINING *lilies*

THE POETIC TWINING-LILIES MOTIF always reminds me of daylilies and their lovely fragrance. I'm so fond of this particular pattern that I've used it completely intact for the projects in this chapter. For variety, I've instead used different yarns with varying amounts of the lace panel to produce distinctly different looks. The simple elegance of Bright Moment Cardigan on page 140 comes from mere repetition of the panel with no other adornment whatsoever. The Chinquapin Wrap on page 148 relies on heavier yarn and added texture for a completely different look. Finally, the lace panel is used as a small ornament along just the neckline of the Little City Tee on page 152.

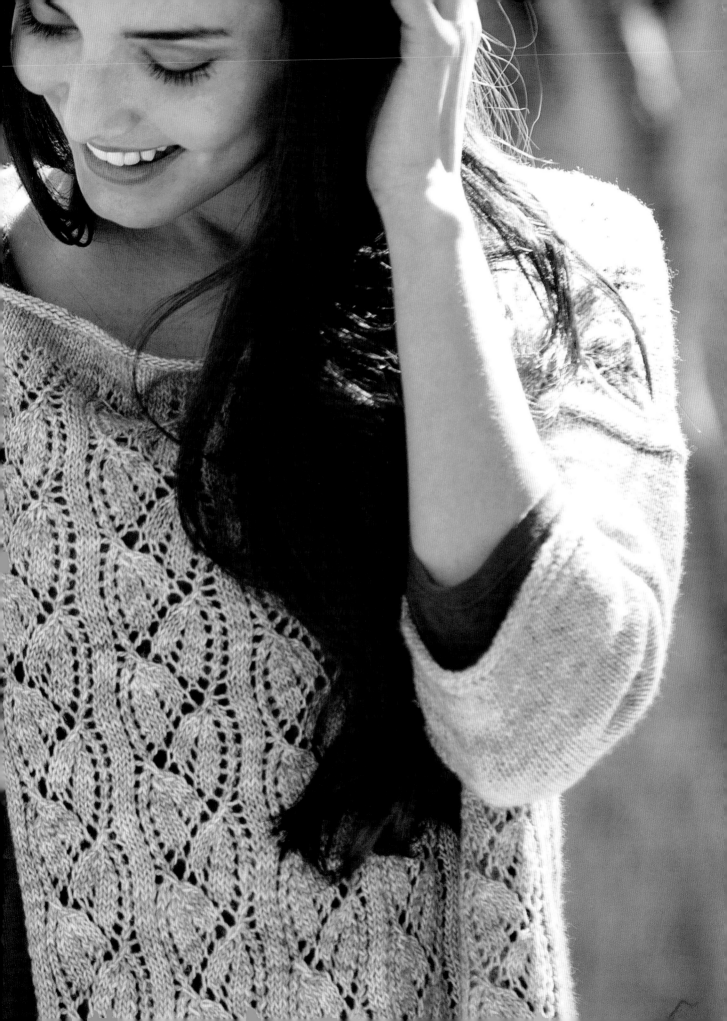

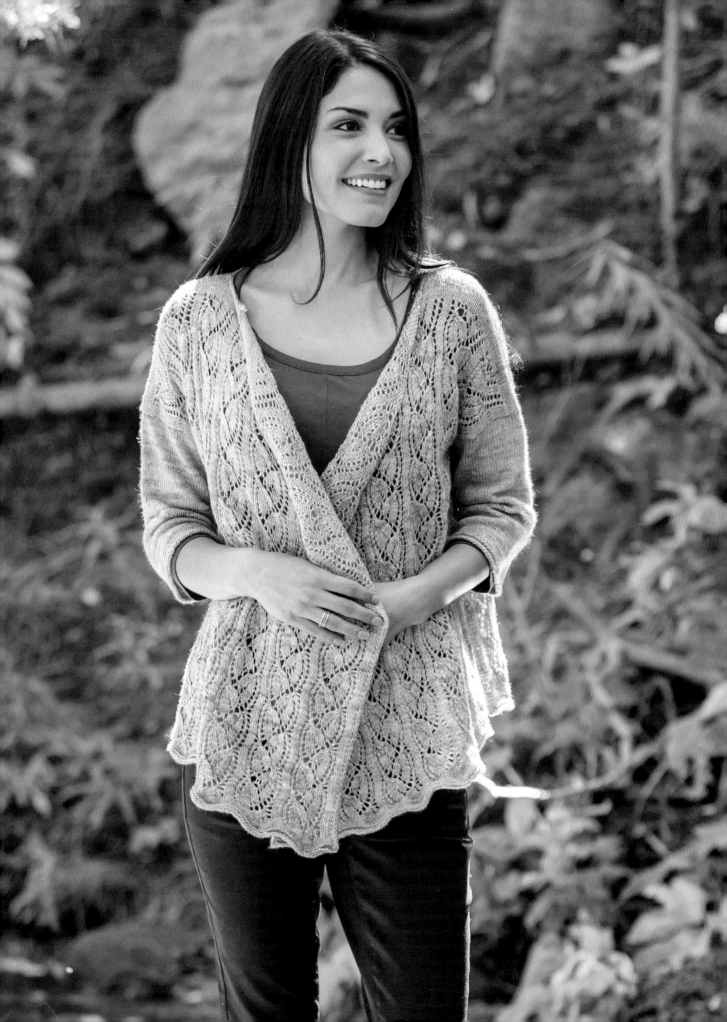

BRIGHT MOMENT
cardigan

One of my favorite lace patterns makes up the body of this lovely piece. Ultimately simple to knit and assemble, this cardigan is fashioned to showcase the beautiful lace motif. Knitted in a linen/wool singles yarn, the sweater has wonderful drape and appealing body. For casual elegance, side vents with I-cord self-facing keep the width from flaring out at the hips.

FINISHED SIZE
About 44½ (50, 55½, 60½, 66)" (113 [127, 141, 153.5, 167.5] cm) bust circumference, with fronts overlapped so side seams align with side folds. Front overlap can be adjusted to accommodate bust measurements up to 58 (65½, 73, 80½, 88)" (147.5 [166.5, 185.5, 204.5, 223.5] cm).

Sweater shown measures 44½" (113 cm).

YARN
Fingering weight (#1 Super Fine).

Shown here: Madelinetosh Dandelion (90% superwash merino, 10% linen; 325 yd [297 m]/85 g): Dusk (pale gold), 5 (6, 7, 9, 10) skeins.

NEEDLES
Size U.S. 4 (3.5 mm): straight or 24" or 32" (60 or 80 cm) circular (cir).

Adjust needle size if necessary to obtain the correct gauge.

NOTIONS
Markers (m); stitch holders or waste yarn; blocking wires, T-pins; tapestry needle; two spare cir needles same size or smaller than main needle; one ½" (1.3 cm) clear button.

GAUGE
24 sts and 36 rows = 4" (10 cm) in St st.

27 sts and 36 rows = 4" (10 cm) in Chart A patt; one pattern repeat (15 to 18 sts; see Notes) measures about 2½" (6.5 cm) wide.

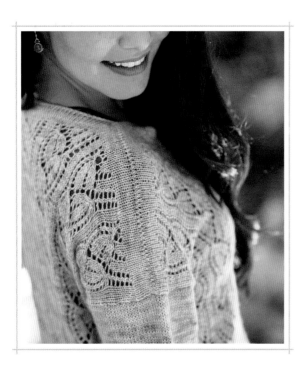

BACK

CO 155 (173, 191, 209, 227) sts.

Work Rows 1–10 of Chart A once.

Work Rows 11–26 of Chart A 2 (2, 3, 3, 3) times.

Work Rows 27–41 of Chart A once.

Work Row 42 of Chart A as foll: P3 and place sts just worked onto waste-yarn holder, M1 (see Stitch Guide), purl to last 3 sts, M1, place rem 3 sts onto waste-yarn holder—151 (169, 187, 205, 223) sts rem; piece measures 6½ (6½, 8¼, 8¼, 8¼)" (16.5 [16.5, 21, 21, 21] cm) with lower edge unrolled.

Work Rows 43–58 of Chart A 8 (9, 9, 10, 11) times.

Work Rows 59–66 of Chart A once—194 (210, 226, 242, 258) rows completed; piece measures about 21½ (23¼, 25, 27, 28¾)" (54.5 [59, 63.5, 68.5, 73] cm) from CO.

Cut yarn, leaving a 12" (30.5 cm) tail.

Place sts onto length of waste yarn at least twice the width of the final blocked back measurement.

LEFT FRONT

CO 137 (155, 173, 191, 209) sts.

Work Rows 1–10 of Chart B (see page 144) once.

Work Rows 11–26 of Chart B 2 (2, 3, 3, 3) times.

Work Rows 27–41 of Chart B once.

Work Row 42 of Chart B as foll: Purl to last 3 sts, M1, place rem 3 sts onto waste-yarn holder—135 (153, 171, 189, 207) sts rem; piece measures 6½ (6½, 8¼, 8¼, 8¼)" (16.5 [16.5, 21, 21, 21] cm) with lower edge unrolled.

Work Rows 43–58 of Chart B 8 (9, 9, 10, 11) times.

Work Rows 59–66 of Chart B once—194 (210, 226, 242, 258) rows completed; piece measures about 21½ (23¼, 25, 27, 28¾)" (54.5 [59, 63.5, 68.5, 73] cm) from CO.

Cut yarn, leaving a 12" (30.5 cm) tail.

Place sts onto length of waste yarn at least twice the width of the final blocked back measurement.

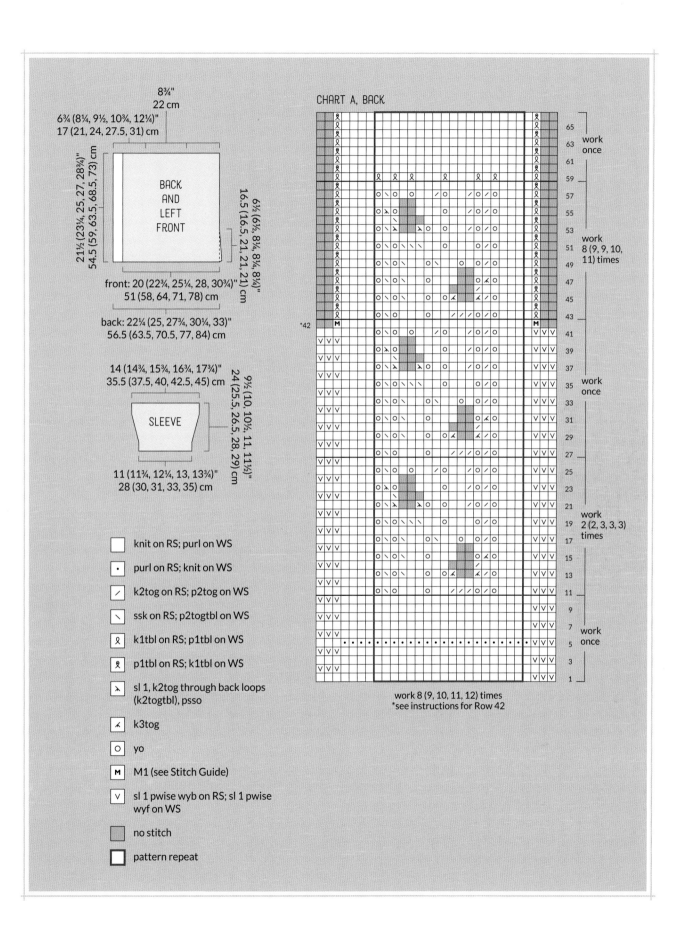

CHART A, BACK

8¾"
22 cm

6¾ (8¼, 9½, 10¾, 12¼)"
17 (21, 24, 27.5, 31) cm

BACK
AND
LEFT
FRONT

21½ (23¾, 25, 27, 28¾)"
54.5 (59, 63.5, 68.5, 73) cm

6¼ (6½, 8¼, 8¼, 8¼)"
16.5 (16.5, 21, 21, 21) cm

front: 20 (22¾, 25¼, 28, 30¾)"
51 (58, 64, 71, 78) cm

back: 22¼ (25, 27¾, 30¼, 33)"
56.5 (63.5, 70.5, 77, 84) cm

14 (14¾, 15¾, 16¾, 17¾)"
35.5 (37.5, 40, 42.5, 45) cm

SLEEVE

9½ (10, 10½, 11, 11½)"
24 (25.5, 26.5, 28, 29) cm

11 (11¾, 12¼, 13, 13¾)"
28 (30, 31, 33, 35) cm

work once
work 8 (9, 9, 10, 11) times
work once
work 2 (2, 3, 3, 3) times
work once

*42

work 8 (9, 10, 11, 12) times
*see instructions for Row 42

	knit on RS; purl on WS
·	purl on RS; knit on WS
/	k2tog on RS; p2tog on WS
\	ssk on RS; p2togtbl on WS
ℛ	k1tbl on RS; p1tbl on WS
℘	p1tbl on RS; k1tbl on WS
⋏	sl 1, k2tog through back loops (k2togtbl), psso
⋌	k3tog
o	yo
M	M1 (see Stitch Guide)
v	sl 1 pwise wyb on RS; sl 1 pwise wyf on WS
	no stitch
	pattern repeat

RIGHT FRONT

CO 137 (155, 173, 191, 209) sts.

Work Rows 1–10 of Chart C once.

Work Rows 11–26 of Chart C 2 (2, 3, 3, 3) times.

Work Rows 27–41 of Chart C once.

Work Row 42 of Chart C as foll: P3 and place sts just worked onto waste-yarn holder, M1, purl to end—135 (153, 171, 189, 207) sts rem; piece measures 6½ (6½, 8¼, 8¼, 8¼)" (16.5 [16.5, 21, 21, 21] cm) with lower edge unrolled.

Work Rows 43–58 of Chart C 8 (9, 9, 10, 11) times.

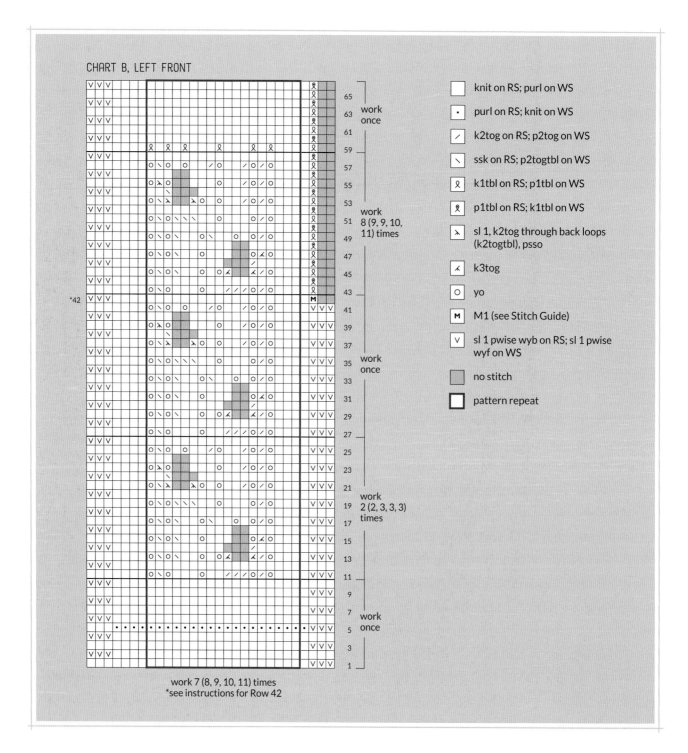

CHART B, LEFT FRONT

knit on RS; purl on WS

· purl on RS; knit on WS

∕ k2tog on RS; p2tog on WS

∖ ssk on RS; p2togtbl on WS

ℓ k1tbl on RS; p1tbl on WS

ℓ p1tbl on RS; k1tbl on WS

⋏ sl 1, k2tog through back loops (k2togtbl), psso

⋏ k3tog

○ yo

M M1 (see Stitch Guide)

V sl 1 pwise wyb on RS; sl 1 pwise wyf on WS

no stitch

pattern repeat

work once

work 8 (9, 9, 10, 11) times

work once

work 2 (2, 3, 3, 3) times

work once

*42

work 7 (8, 9, 10, 11) times
*see instructions for Row 42

Work Rows 59–66 of Chart C once—194 (210, 226, 242, 258) rows completed; piece measures about 21½ (23¼, 25, 27, 28¾)" (54.5 [59, 63.5, 68.5, 73] cm) from CO.

Cut yarn, leaving a 12" (30.5 cm) tail.

Place sts onto length of waste yarn at least twice the width of the final blocked back measurement.

SLEEVES

CO 66 (70, 74, 78, 82) sts.

Work 4 rows in St st (knit RS rows; purl WS rows), ending with a WS row.

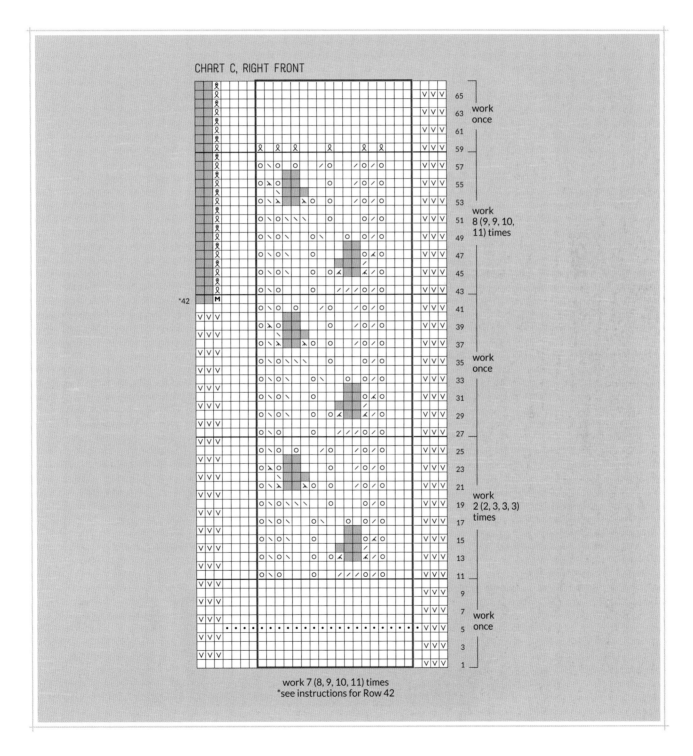

CHART C, RIGHT FRONT

work once

work 8 (9, 9, 10, 11) times

work once

work 2 (2, 3, 3, 3) times

work once

work 7 (8, 9, 10, 11) times
*see instructions for Row 42

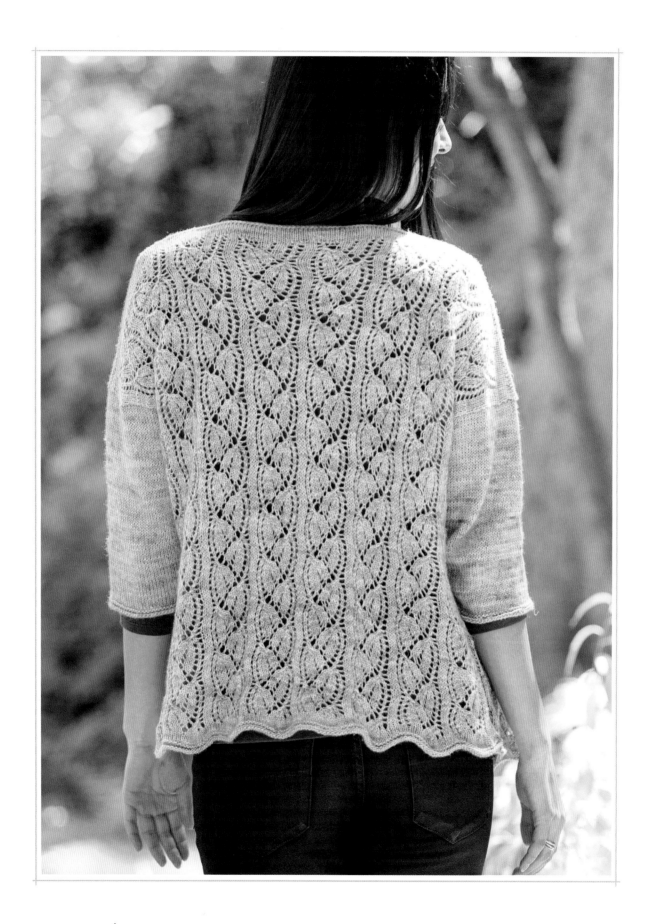

Purl 1 RS row, then work 11 more rows in St st, ending with a WS row—piece measures 1¾" (4.5 cm) with lower edge unrolled.

Inc row: (RS) K2, M1, knit to last 2 sts, M1, k2— 2 sts inc'd.

[Work 5 rows even, then rep inc row] 8 (8, 9, 10, 11) times—84 (88, 94, 100, 106) sts.

Work even in St st until piece measures 9½ (10, 10½, 11, 11½)" (24 [25.5, 26.5, 28, 29] cm) from CO, ending with a WS row.

Using the stretchy method (see Stitch Guide), BO all sts.

FINISHING

Soak all pieces in wool wash. Squeeze out water, then roll in towels to remove excess moisture. Insert blocking wires along edges of damp pieces, place on a flat surface, then pin to measurements.

Allow to air-dry thoroughly before removing wires and pins.

SHOULDERS

When pieces are completely dry, remove waste yarn from fronts and back and place live sts onto separate cir needles. Mark center 59 back neck sts for all sizes— 46 (55, 64, 73, 82) sts at each side. Hold needles of back and one front tog and parallel with RS touching and WS facing out. Working from the sleeve edge (the front selvedge without slipped sts) inward, join shoulder using three-needle stretchy BO as foll: [K2tog (1 st from each needle)] 2 times, *return 2 sts onto left needle tip, k2togtbl, k2tog (1 st from each needle); rep from * to m at start of back neck sts—1 st rem on right needle after last BO. Remove marker and place st on right needle onto left needle with back neck sts.

Join the second shoulder in the same manner, returning its 1 rem st onto needle holding back neck sts. Place all sts onto one cir needle in this order: 89 (98, 107, 116, 125) right front sts, 1 returned st from shoulder join, 59 back sts, 1 returned st, 89 (98, 107, 116, 125) left front sts—239 (257, 275, 293, 311) sts total.

NECK EDGING

With RS facing, join yarn to 3 right front edge sts. Using tip of main needle, work 3-st I-cord BO as foll: *k2, k2togtbl (last I-cord st tog with next st), return 3 sts onto left needle tip; rep from * until 6 sts rem on left needle—3 I-cord sts and 3 left front edge sts.

Work 2 unattached I-cord rows to create an inconspicuous buttonhole at top left corner as foll: *K3, return 3 sts onto left needle tip; rep from * once more.

Break yarn, leaving a 10" (25.5 cm) tail. Place 3 sts each onto separate needles. With tail threaded on a tapestry needle, use the Kitchener stitch (see Glossary) to join live I-cord BO sts to left front sts.

SEAMS

Measure down 7 (7½, 7¾, 8¼, 8¾)" (18 [19, 19.5, 21, 22] cm) from shoulder joins at each side. With yarn threaded on a tapestry needle, sew tops of sleeves between markers. Sew sleeve seams. Sew side seams from underarm to top of side slits.

For the top of each side slit, place 3 held sts from each side onto separate needles, then use the Kitchener stitch to graft them together and close the top of the slit.

Lay garment flat with side seams aligned, right front overlapped on top of left front, and neck edges straight across. Mark where the buttonhole at left front upper corner touches WS of the right front, and sew small button to WS of right front at this position.

Steam all seams and edges to relax yarn.

Weave in loose ends.

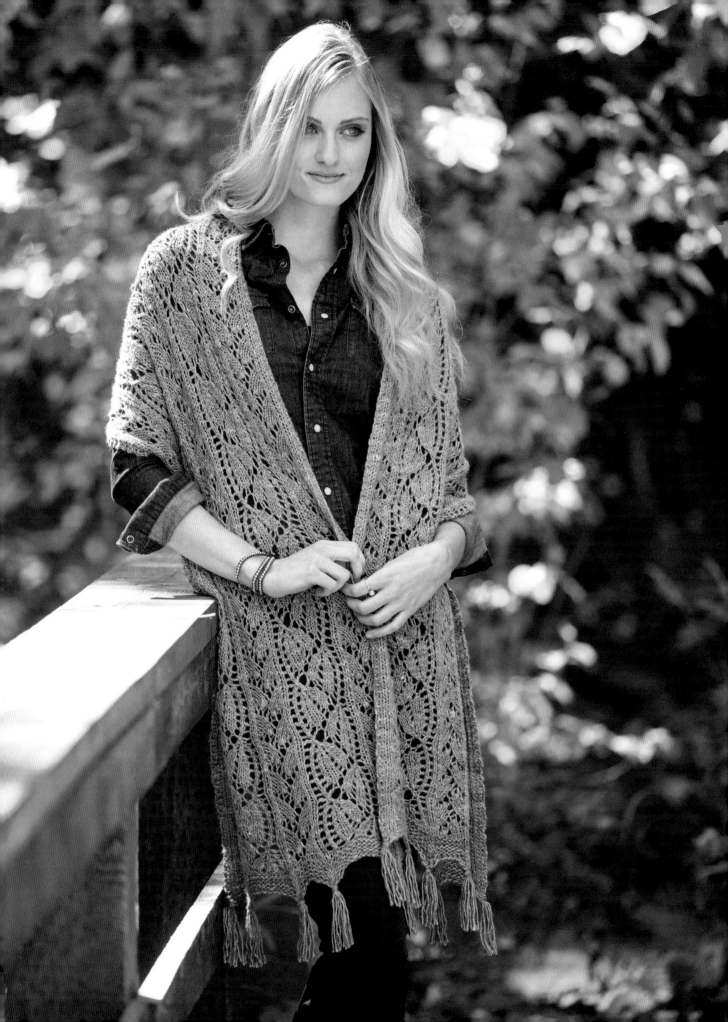

CHINQUAPIN
wrap

This elegant wrap will keep you warm during a chilly autumn walk through town or country. Worked straight from one end to the other in an Aran-weight yarn (some call this moose lace!), the wrap is a great project for any new lace knitter. The featured lace panel is interspersed with nupps (small Estonian bobbles) and accented with fringe at the ends for a chic look.

FINISHED SIZE
About 18½" (47 cm) wide and 76" (193 cm) long, excluding fringe.

YARN
Aran weight (#4 Medium).

Shown here: The Fibre Company Terra (40% baby alpaca, 40% wool, 20% silk; 98 yd [89 m]/50 g): Acorn, 8 skeins.

NEEDLES
Size U.S. 8 (5 mm): straight or circular (cir).

Adjust needle size if necessary to obtain the correct gauge.

NOTIONS
Tapestry needle; blocking wires; T-pins; one 4" (10 cm) piece of cardboard for measuring fringe; size G/6 (4 mm) crochet hook.

GAUGE
14½ sts and 21½ rows = 4" (10 cm) in charted lace patt, after wet-blocking.

notes

» This wrap is worked in a handcrafted yarn that varies in color from skein to skein, even within the same dyelot. In order to blend the tone and texture, work alternately from two skeins at once, switching skeins at the end of every second row.

» The stitch count of the chart does not remain constant throughout. It begins as a multiple of 26 stitches plus 15, temporarily decreases to a multiple of 22 or 23 stitches plus 15 in some rows, then increases back to the original stitch count again.

» Note that the left-leaning double decrease used in this pattern includes a k2tog through back loop (k2togtbl) rather than a k2tog so that the stitches lie flatter in this particular lace pattern.

» See Impeccable Nupps on page 40.

stitch guide

M1: Insert left needle tip from back to front underneath the strand between the needles, then knit the lifted strand through the front to twist it—1 st inc'd.

Nupp: Very loosely, work [k1, yo] 2 times, k1 in same st—5 sts made from 1 st. Purl the 5 nupp sts tog on the following row as shown on chart.

WRAP

Using the knitted method (see Glossary), CO 67 sts.

Work Rows 1–12 of Chart A once.

Work Rows 13–28 twenty-four times.

Work Rows 29–42 once—410 chart rows completed.

FINISHING

Note: The following bind-off creates a naturally stretchy edge, so there's no need to work it especially loosely.

BO as foll: K2, *return 2 sts onto left needle tip, k2tog through back loop (tbl), k1; rep from * until 2 sts rem on right needle, return 2 sts onto left needle tip, k2togtbl—1 st rem. Fasten off rem st.

Wash in wool wash. Gently squeeze out water, then roll in towels to remove excess moisture. Thread blocking wires along sides of damp wrap, place on a flat surface, and pin to measurements, pinning out the points of each St st rib at ends and each corner. Allow to air-dry thoroughly before removing wires or pins.

FRINGE

Apply 6 fringes to each short side of the wrap: 1 at each corner and the remaining 4 at the end of a 2-stitch St st column "point." For each fringe, wrap yarn seven times around a 4" (10 cm) piece of cardboard, then cut across

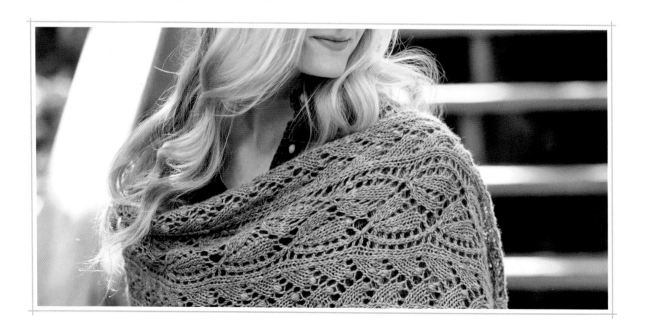

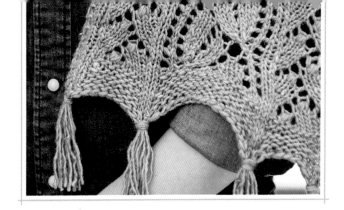

the loops at one end of the cardboard to make seven 8" (20.5 cm) strands of yarn. With WS facing, insert crochet hook through to RS at a St st point, hook the loop in the center of the folded strands and pull through to the WS. Pass the loose strands through the loop and tighten to secure. Trim ends to the same length.

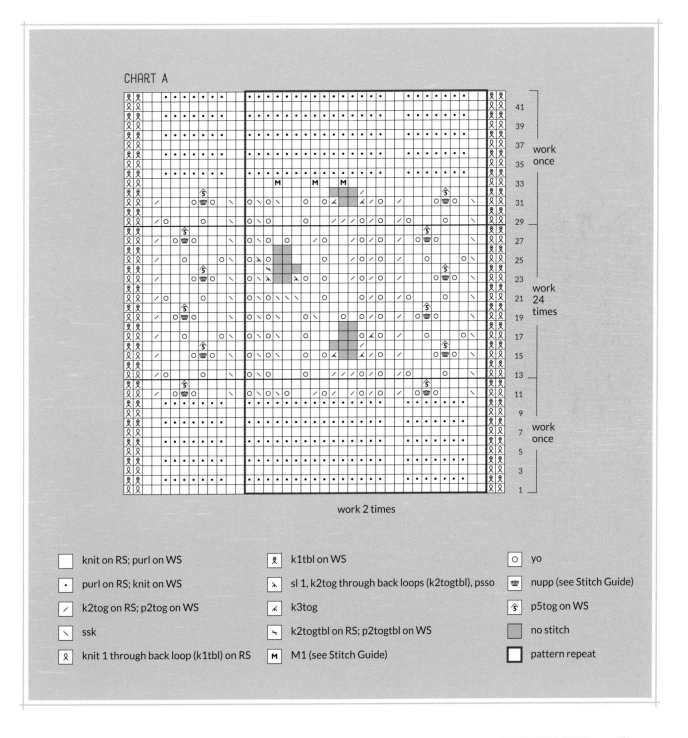

CHART A

work once

work 24 times

work once

work 2 times

	knit on RS; purl on WS		k1tbl on WS		yo
•	purl on RS; knit on WS	⅄	sl 1, k2tog through back loops (k2togtbl), psso	⍵	nupp (see Stitch Guide)
/	k2tog on RS; p2tog on WS	⅄	k3tog	Ŝ	p5tog on WS
\	ssk	↖	k2togtbl on RS; p2togtbl on WS		no stitch
ℛ	knit 1 through back loop (k1tbl) on RS	M	M1 (see Stitch Guide)		pattern repeat

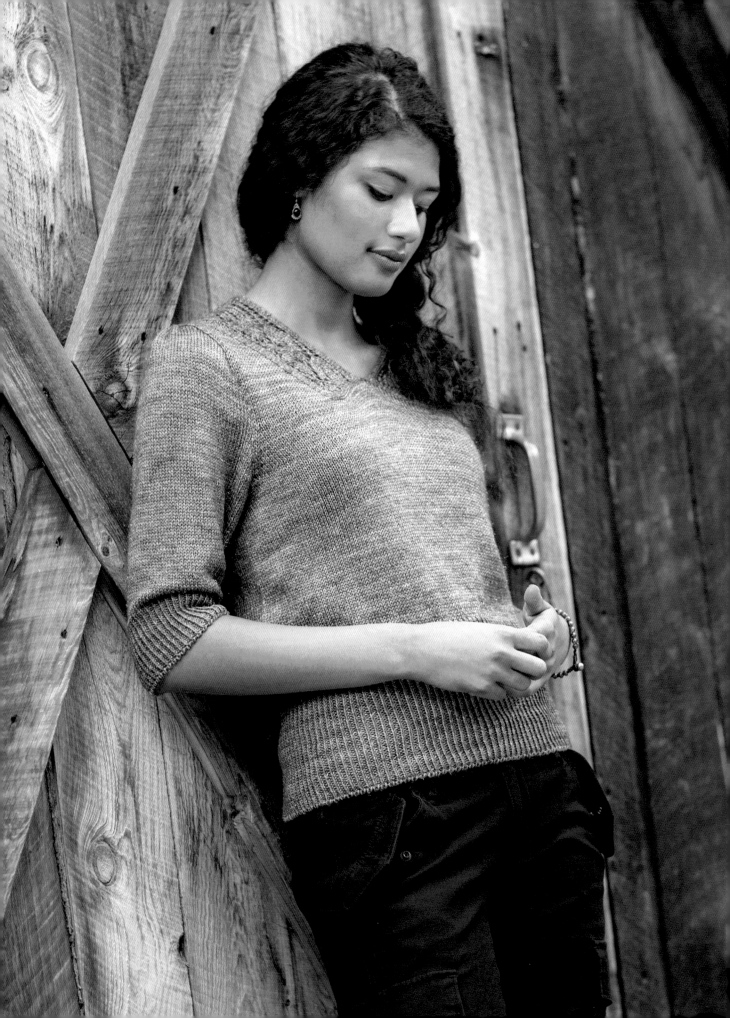

LITTLE CITY
tee

A small lace insert turns this otherwise unassuming sweater into a versatile top that's equally at home in an office, at a nightclub, or as a casual topper for a pair of jeans and cowboy boots. The lace panel featured in this chapter has been downsized to a simple subtle embellishment. The body of this top is worked in the round from the bottom to the armholes for easy knitting; the sleeve caps are pleated for gentle fullness.

FINISHED SIZE
About 33¼ (37, 40½, 44¼, 48)" (84.5 [94, 103, 112.5, 122] cm) bust circumference.

Sweater shown measures 37" (94 cm).

YARN
Fingering weight (#1 Super fine).

Shown here: Zen Yarn Garden Serenity Glitter Sock (80% superwash merino, 10% cashmere, 10% sparkling nylon; 400 yd [365 m]/100 g): Cocoa, 3 (4, 4, 5, 5) skeins.

NEEDLES
Body and sleeves: size U.S. 4 (3.5 mm): 16" and 24" or 32" (40 and 60 or 80 cm) circular (cir).

Ribbing for lower body and sleeves: size U.S. 3 (3.25 mm): 16" and 24" or 32" (40 and 60 or 80 cm) cir and set of 4 or 5 double-pointed (dpn).

Adjust needle size if necessary to obtain the correct gauge.

NOTIONS
Stitch markers (m); waste yarn; size E/4 (3.5 mm) crochet hook for provisional CO; tapestry needle; blocking wires; T-pins.

GAUGE
26 and 36 rows/rnds = 4" (10 cm) in St st on larger needles.

notes

» To minimize the chance of twisting the stitches, the first row of the body and each sleeve is knitted before being joined for working in rounds. The cast-on tail will be used to close the small opening created by the first row.

» The stitch count of the charts does not remain constant throughout. They begin with 18 stitches that are increased to 22 stitches. After that, the stitch count in the main 16-row pattern repeat (chart Rows 5–20) decreases to 19 stitches, then increases back to 22 stitches again. During neck shaping, always count each chart section as 22 stitches, even if it's on a row where the number has temporarily decreased.

BODY

With longer cir needle in smaller size and waste yarn, use the crochet-on method (see Glossary) to provisionally CO 108 (120, 132, 144, 156) sts.

Change to main yarn.

Next row: (RS; see Notes) *K1, yo; rep from * —216 (240, 264, 288, 312) sts.

With RS still facing, place marker (pm) and join for working in rnds, being careful not to twist sts.

Rnd 1: *Sl 1 purlwise with yarn in back (wyb), p1; rep from *.

Rnd 2: *K1, sl 1 purlwise with yarn in front (wyf); rep from *.

Rnd 3: Rep Rnd 1.

Rnd 4: *K1 through back loop (tbl), p1; rep from *.

Rep Rnd 4 for twisted rib until piece measures 6" (15 cm). Waste yarn may be removed from provisional CO after the first few rnds; the bottom edge of the rib will not ravel.

Change to longer cir needle in larger size.

Next rnd: K108 (120, 132, 144, 156), pm to denote side "seam," knit to end.

Cont even in St st (knit every rnd) until piece measures 13 (13, 14, 15, 16)" (33 [33, 35.5, 38, 40.5] cm) from CO, ending last rnd 6 (6, 7, 7, 8) sts before end-of-rnd m.

DIVIDE FOR ARMHOLES

Next rnd: BO 12 (12, 14, 14, 16) sts, removing end-of-rnd m when you come to it, knit to 6 (6, 7, 7, 8) sts before side m, BO 12 (12, 14, 14, 16) sts, removing side m, knit to end—96 (108, 118, 130, 140) sts each for back and front. Leave front sts with working yarn attached on needle; place 96 (108, 118, 130, 140) back sts onto waste-yarn holder.

FRONT

Cont back and forth in rows on 96 (108, 118, 130, 140) front sts as foll.

Beg with a WS row, BO 3 (3, 4, 4, 4) sts at beg of next 2 rows—90 (102, 110, 122, 132) sts rem.

Work 1 WS row even.

Dec row: (RS) K2, ssk, knit to last 4 sts, k2tog, k2—2 sts dec'd.

[Work 1 WS row even, then rep dec row] 5 (6, 7, 10, 11) times—78 (88, 94, 100, 108) sts rem.

Work 1 WS row even.

LACE INSERT

Row 1: (RS) K21 (26, 29, 32, 36), pm, sl 1 st onto cn and hold in front of work, *k1, then k1 from cn, sl last st worked from right needle tip onto cn and hold in front; rep from * until there are 35 sts on right needle after m; k1, pm, k1 from cn, knit to end—36 center sts between markers; 21 (26, 29, 32, 36) sts outside m at each side.

Row 2: (WS) Purl.

Row 3: Knit to first m, slip marker (sl m), work Row 1 of Chart A over 18 sts, inc them to 21 sts as shown; place next 39 (44, 47, 50, 54) right front sts onto waste-yarn holder—42 (47, 50, 53, 57) left front sts rem; armhole measures 2 (2¼, 2½, 3, 3¼)" (5 [5.5, 6.5, 7.5, 8.5] cm).

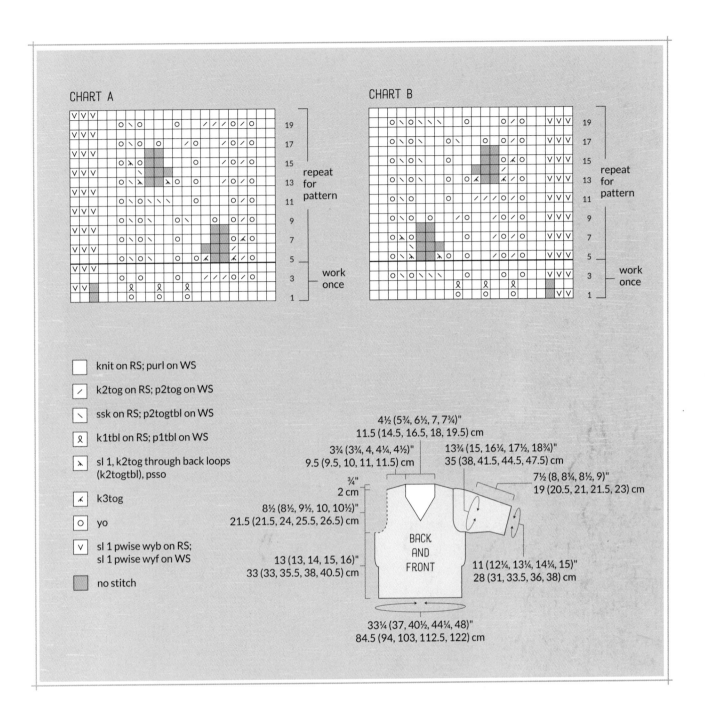

LEFT FRONT

Cont on 42 (47, 50, 53, 57) left front sts as foll.

Next row: (WS) Work Row 2 of Chart A to m, sl m, purl to end.

Next row: (RS) Knit to 2 sts before m, k2tog, sl m, work Row 3 of Chart A over 21 sts, inc them to 22 sts as shown—no change to st count; 22 chart sts, 20 (25, 28, 31, 35) St sts.

Next row: Work next row of Chart A to m, sl m, purl to end.

Dec row: Knit to 2 sts before m, k2tog, sl m, work next row of Chart A to end—1 st dec'd.

Rep the last 2 rows 14 (18, 20, 22, 24) more times—27 (28, 29, 30, 32) sts rem; 22 chart sts (see Notes), 5 (6, 7, 8, 10) St sts.

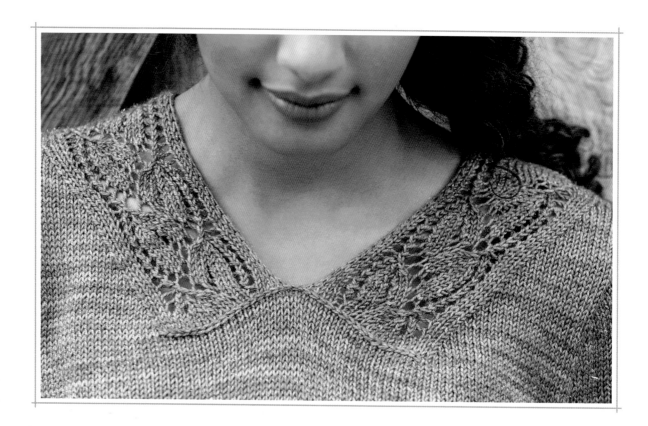

Work even in patt as established until armhole measures 8½ (8½, 9½, 10, 10½)" (21.5 [21.5, 24, 25.5, 26.5] cm), ending with Row 10, 12, 18, or 20 of chart when stitch count has been restored to 22 sts.

Shape Left Shoulder

Change to St st, removing m next to lace section as you come to it.

Row 1: (RS) BO 8 (9, 10, 11, 11) sts, knit to end, working each st that lies directly above a yo from the final chart row as k1tbl—19 (19, 19, 19, 21) sts rem.

Row 2: (WS) Sl 3 sts purlwise wyf, purl to end.

Row 3: BO 8 (8, 8, 8, 9) sts, knit to end—11 (11, 11, 11, 12) sts rem.

Row 4: Rep Row 2.

Row 5: BO 7 (7, 7, 7, 8) sts, return st rem onto right needle after last BO to left needle, k2tog, k2—3 sts rem.

Place sts onto waste-yarn holder to work later for I-cord back neck edging. Cut yarn.

RIGHT FRONT

Return 39 (44, 47, 50, 54) held right front sts onto working needle and rejoin yarn at center front ready to work a RS row.

Next row: (RS) Work Row 1 of Chart B (see page 155) over 18 sts, inc them to 21 sts as shown, sl m, knit to end—42 (47, 50, 53, 57) sts.

Next row: (WS) Purl to m, sl m, work Row 2 of Chart B.

Next row: Work Row 3 of Chart B over 21 sts, inc them to 22 sts as shown, sl m, ssk, knit to end—no change to st count; 22 chart sts, 20 (25, 28, 31, 35) St sts.

Next row: Purl to m, sl m, work next row of Chart B.

Dec row: Work next row of Chart B to m, sl m, ssk, knit to end—1 st dec'd.

Rep the last 2 rows 14 (18, 20, 22, 24) more times—27 (28, 29, 30, 32) sts rem; 22 chart sts, 5 (6, 7, 8, 10) St sts.

Work even in patt as established until armhole measures 8½ (8½, 9½, 10, 10½)" (21.5 [21.5, 24, 25.5, 26.5] cm), ending with Row 10, 12, 18, or 20 of chart when stitch count has been restored to 22 sts.

Shape Right Shoulder

Change to St st, removing m next to lace section as you come to it.

Row 1: (RS) Sl 3 sts purlwise wyb, knit to end, working each st that lies directly above a yo from the final chart row as k1 through back loop (tbl).

Row 2: (WS) BO 8 (9, 10, 11, 11) sts, purl to end—19 (19, 19, 19, 21) sts rem.

Row 3: Sl 3 purlwise wyb, knit to end.

Row 4: BO 8 (8, 8, 8, 9) sts, purl to end—11 (11, 11, 11, 12) sts rem.

Row 5: Rep Row 3.

Row 6: BO 7 (7, 7, 7, 8) sts, return st rem onto right needle after last BO to left needle, p2togtbl, p2—3 sts rem.

Place sts onto waste-yarn holder to work later for I-cord back neck edging. Do not cut yarn.

BACK

Return 96 (108, 118, 130, 140) held back sts onto working needle and rejoin yarn ready to work a WS row.

Beg with a WS row, BO 3 (3, 4, 4, 4) sts at beg of next 2 rows, then purl 1 WS row—90 (102, 110, 122, 132) sts rem.

Dec row: (RS) K2, ssk, knit to last 4 sts, k2tog, k2—2 sts dec'd.

[Work 1 WS row even, then rep dec row] 5 (6, 7, 10, 11) times—78 (88, 94, 100, 108) sts rem.

Work even until armholes measure 8½ (8½, 9½, 10, 10½)" (21.5 [21.5, 24, 25.5, 26.5] cm), ending with a WS row.

Shape Shoulders

BO 8 (9, 10, 11, 11) sts at beg of next 2 rows, then BO 8 (8, 8, 8, 9) sts at beg of foll 4 rows—30 (38, 42, 46, 50) sts rem. Leave back sts on working needle.

BACK NECK EDGE

With yarn threaded on a tapestry needle, sew front to back at shoulders as invisibly as possible.

With RS facing and needle holding back neck sts in your left hand, slip 3 held right front sts onto beg of working needle—33 (41, 45, 49, 53) sts total; first 3 sts on the needle with RS facing are 3 right front sts.

Work 3-st I-cord BO as foll: *K2, k2togtbl (last front st tog with 1 back st), return 3 sts onto left needle tip; rep from * until 3 I-cord sts rem on left needle and all back sts have been BO.

Cut yarn, leaving a 10" (25.5 cm) tail. Place 3 held left front sts on spare needle. Using tail threaded on a tapestry needle, use the Kitchener stitch (see Glossary) to join live I-cord BO sts to left front sts.

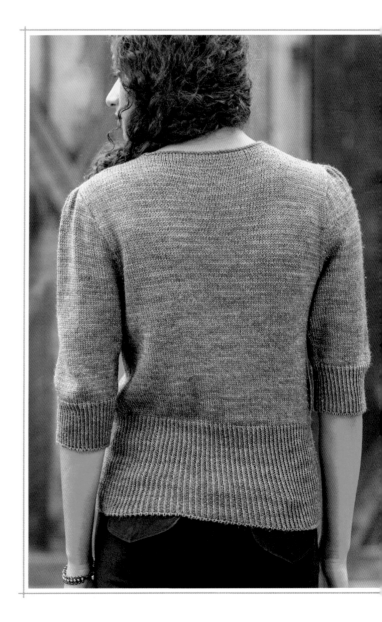

SLEEVES

With shorter cir needle in smaller size and waste yarn, use the crochet-on method to provisionally CO 36 (40, 43, 46, 49) sts. Arrange sts as evenly as possible on 3 or 4 dpn.

Change to working yarn.

CUFF

Next row: (RS; see Notes) *K1, yo; rep from *—72 (80, 86, 92, 98) sts.

With RS still facing, pm and join for working in rnds, being careful not to twist sts.

Rnd 1: *Sl 1 purlwise wyb, p1; rep from *.

Rnd 2: *K1, sl 1 purlwise wyf; rep from *.

Rnd 3: Rep Rnd 1.

Rnd 4: *K1tbl p1; rep from *.

Rep Rnd 4 for twisted rib until piece measures 3" (7.5 cm). Waste yarn may be removed after the first few rnds.

Change to shorter cir needle in larger size.

Knit 8 rnds.

Inc rnd: (RS) K1, M1L (see Glossary), knit to last st, M1R (see Glossary), k1—2 sts inc'd.

[Work 3 rnds even, then rep inc rnd] 8 (8, 9, 10, 11) times—90 (98, 106, 114, 122) sts.

Work even if necessary until piece measures 7½ (8, 8¼, 8½, 9)" (19 [20.5, 21, 21.5, 23] cm) from CO, ending last rnd 6 sts before end-of-rnd m.

SHAPE CAP

Next rnd: BO 12 sts, removing end-of-rnd m when you come to it, knit to end—78 (86, 94, 102, 110) sts rem.

Change to working St st back and forth in rows.

BO 3 sts at beg of next 2 rows—72 (80, 88, 96, 104) sts rem.

Dec 1 st at each end of needle every RS row 5 (6, 7, 8, 9) times—62 (68, 74, 80, 86) sts rem.

Dec 1 st at each end of needle every 4th row 4 times—54 (60, 66, 72, 78) sts rem.

Dec 1 st at each end of needle every RS row 2 (3, 4, 5, 3) times—50 (54, 58, 62, 72) sts rem.

BO 3 sts at beg of next 10 (10, 10, 10, 12) rows—20 (24, 28, 32, 36) sts rem.

BO all sts.

FINISHING

Use CO tails to close small openings at start of lower body and sleeves.

SLEEVE PLEATS

Mark the center 16 (18, 20, 22, 24) sts of each sleeve cap's BO edge—2 (3, 4, 5, 6) BO sts on each side of marked sts. Fold marked section in half with WS facing tog. Bring the marked ends of center section together to meet at the fold in the middle, forming three pleats as shown at left. With yarn threaded on a tapestry needle, secure the pleat by sewing through all layers, then sew sleeve cap into armhole.

Wash in wool wash. Gently squeeze out water, then roll in towels to remove excess moisture. Thread blocking wires through sides of damp lace insert and pin each lace panel to about 3" (7.5 cm) wide to open up patt. Block body to measurements, taking care not to stretch ribbings. Allow to air-dry thoroughly before removing wires or pins.

Weave in loose ends.

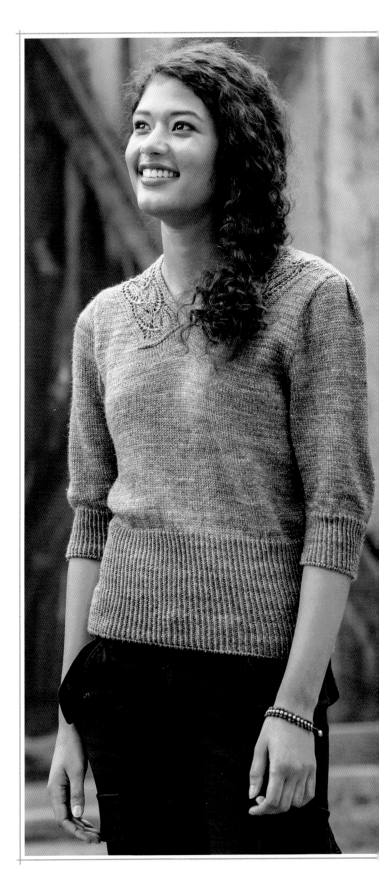

GLOSSARY OF TERMS AND TECHNIQUES

ABBREVIATIONS

beg(s) begin(s); beginning

BO bind off

cir circular

cm centimeter(s)

cn cable needle

CO cast on

cont continue(s); continuing

dec(s)('d) decrease(s); decreasing; decreased

dpn double-pointed needles

foll follow(s); following

g gram(s)

inc(s)('d) increase(s); increasing; increase(d)

k knit

k1f&b knit into the front and back of same stitch

k2tog knit 2 stitches together

kwise knitwise; as if to knit

m marker(s)

mm millimeter(s)

M1 make one (increase)

oz ounce

p purl

p1f&b purl into front and back of same stitch

p2tog purl 2 stitches together

patt(s) pattern(s)

pm place marker

psso pass slipped stitch over

pwise purlwise; as if to purl

rem remain(s); remaining

rep repeat(s); repeating

Rev St st reverse stockinette stitch

rnd(s) round(s)

RS right side

sl slip

sl m slip marker

sl st slip st (slip 1 stitch purlwise unless otherwise indicated)

ssk slip, slip, knit (decrease)

st(s) stitch(es)

St st stockinette stitch

tbl through back loop

tog together

WS wrong side

wyb with yarn in back

wyf with yarn in front

yd yard(s)

yo yarnover

***** repeat starting point

****** repeat all instructions between asterisks

() alternate measurements and/or instructions

[] work instructions as a group a specified number of times

BIND-OFFS

STANDARD BIND-OFF

Knit the first stitch, *knit the next stitch (two stitches on right needle), insert left needle tip into first stitch on right needle **(Figure 1)** and lift this stitch up and over the second stitch **(Figure 2)** and off the needle **(Figure 3)**. Repeat from * until one stitch remains on the right needle. Cut the yarn, leaving a 6" (15 cm) tail, then pull on the loop of the last stitch until the tail comes free to secure the last stitch.

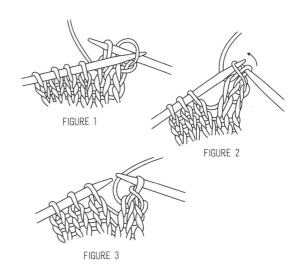

FIGURE 1

FIGURE 2

FIGURE 3

TUBULAR K1, P1 RIB BIND-OFF

Cut the yarn, leaving a tail three times the circumference of the knitting to be bound off, and thread the tail onto a tapestry needle.

Step 1. Working from right to left, insert the tapestry needle purlwise (from right to left) through the first (knit) stitch **(Figure 1)** and pull the yarn through.

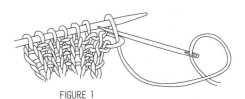

FIGURE 1

Step 2. Bring the tapestry needle behind the knit stitch, then insert it knitwise (from left to right) into the second stitch (this will be a purl stitch; **Figure 2**), and pull the yarn through.

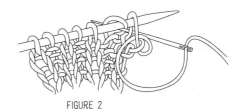

FIGURE 2

Step 3. *Insert the tapestry needle into the first (knit) stitch knitwise and slip this stitch off the knitting needle (i.e., knit into the first st and slip it off the needle).

Step 4. Bring the tapestry needle in front of the first (purl) stitch, then insert it purlwise into the second stitch (this will be a knit stitch; **Figure 3**) and pull the yarn through (i.e., purl into the second st and leave it on the needle).

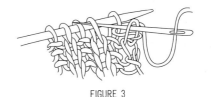

FIGURE 3

Step 5. Insert the tapestry needle into the first (purl) stitch purlwise and slip this stitch off the knitting needle (i.e., purl into the first st and slip it off the needle).

Step 6. Bring the tapestry needle behind the knit stitch, then insert it knitwise into the second stitch (this will be a purl stitch; **Figure 4**), and pull the yarn through (i.e., knit into the second st and leave it on the needle).

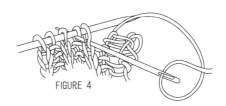

FIGURE 4

Repeat from * until 1 stitch remains on the knitting needle. End by inserting the tapestry needle purlwise through the first (knit) stitch of the round (the first one slipped off the needle) and draw the yarn through, then purlwise through the last stitch and draw the yarn through.

CAST-ONS

BACKWARD-LOOP CAST-ON

*Loop working yarn and place it on needle backward so that it doesn't unwind. Repeat from *.

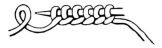

CROCHET-ON (CHAIN) PROVISIONAL CAST-ON

Make a slipknot of waste yarn and place it on a crochet hook held in your right hand. Hold a knitting needle in your left hand. Bring the yarn under the needle, use the crochet hook to grab a loop over the top of the needle, then pull it through the slipknot—1 loop on crochet hook. *Bring the yarn under the needle, use the crochet hook to grab a loop over the top of the needle, then pull it through the loop on the hook. Repeat from * for the desired number of stitches on the needle minus one. Transfer the loop on the crochet hook to the needle for the last stitch.

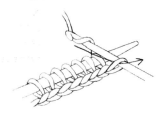

CROCHET PROVISIONAL CAST-ON

With waste yarn and crochet hook, make a loose crochet chain (see page 163) about four stitches more than you need to cast on. With knitting needle, working yarn, and beginning two stitches from end of chain, pick up and knit one stitch through the back loop of each crochet chain (**Figure 1**) for desired number of stitches. When you're ready to work in the opposite direction, pull out the crochet chain to expose live stitches (**Figure 2**).

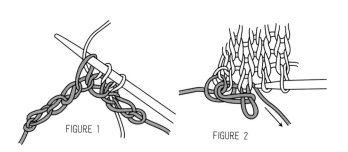

FIGURE 1 FIGURE 2

EMILY OCKER'S CAST-ON

Make a loose loop of working yarn. *Use a needle to draw a loop of yarn through this loop, then draw another loop through the loop on the needle. Repeat from * for the desired number of stitches. After a few inches have been knitted, pull the loose end to tighten the initial loop and close the hole.

INVISIBLE PROVISIONAL CAST-ON

Make a loose slipknot of working yarn and place it on the right needle. Hold a length of contrasting waste yarn next to the slipknot (or tie it together with the slipknot) and around your left thumb; hold working yarn over your left index finger. *Bring the right needle forward under waste yarn, over working yarn, grab a loop of working yarn (**Figure 1**), then bring the needle back behind the working yarn and grab a second loop (**Figure 2**). Repeat from * for the desired number of stitches. When you're ready to work in the opposite direction, place the exposed loops onto a knitting needle as you pull out the waste yarn.

FIGURE 1 FIGURE 2

KNITTED CAST-ON

If there are no stitches on the needles, make a slipknot of working yarn and place it on the left needle. When there is at least 1 stitch on the left needle, *use the right needle to knit the first stitch (or slipknot) on left needle (**Figure 1**) and place new loop onto the left needle to form a new stitch (**Figure 2**). Repeat from * for the desired number of stitches, always working into the last stitch made.

FIGURE 1 FIGURE 2

CROCHET

CROCHET CHAIN

Make a slipknot and place on crochet hook, *yarnover hook and draw through a loop on the hook. Repeat from * for the desired number of stitches. To fasten off, cut yarn and draw tail through last loop made.

DECREASES

KNIT TWO TOGETHER (K2TOG)

This type of decrease slants to the right.

Knit two stitches together as if they were a single stitch.

SSK

This type of decrease slants to the left.

Slip two stitches individually knitwise (Figure 1), insert left needle tip into the front of these two slipped stitches, then use the right needle to knit them together through their back loops (Figure 2).

FIGURE 1

FIGURE 2

GRAFTING

KITCHENER STITCH

Arrange stitches on two needles so that there is the same number of stitches on each needle. Hold the needles parallel to each other with wrong sides of the knitting facing together. Allowing about ½" (1.3 cm) per stitch to be grafted, thread matching yarn on a tapestry needle. Work from right to left as follows:

Step 1. Bring tapestry needle through the first stitch on the front needle as if to purl and leave the stitch on the needle (Figure 1).

Step 2. Bring tapestry needle through the first stitch on the back needle as if to knit and leave that stitch on the needle (Figure 2).

Step 3. Bring tapestry needle through the first front stitch as if to knit and slip this stitch off the needle, then bring the tapestry needle through the next front stitch as if to purl and leave this stitch on the needle (Figure 3).

Step 4. Bring tapestry needle through the first back stitch as if to purl and slip this stitch off the needle, then bring the tapestry needle through the next back stitch as if to knit and leave this stitch on the needle (Figure 4).

Repeat Steps 3 and 4 until one stitch remains on each needle, adjusting the tension to match the rest of the knitting as you go. To finish, bring the tapestry needle through the front stitch as if to knit and slip this stitch off the needle, then bring the tapestry needle through the back stitch as if to purl and slip this stitch off the needle.

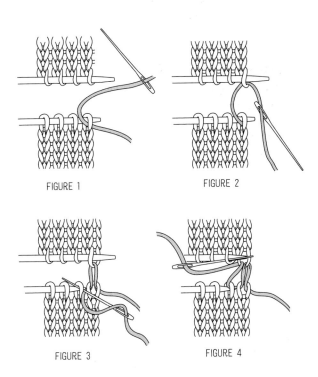

FIGURE 1

FIGURE 2

FIGURE 3

FIGURE 4

I-CORD

STANDARD I-CORD

Using double-pointed needles, cast on the desired number of stitches (usually three to five). *Without turning the needle, slide stitches to the other end of the needle, pull the yarn around the back, and knit the stitches as usual. Repeat from * for the desired length.

INCREASES

KNIT INTO THE FRONT AND BACK (K1F&B)

Knit into a stitch but leave the stitch on the left needle (**Figure 1**), then knit through the back loop of the same stitch (**Figure 2**) and slip the original stitch off the needle (**Figure 3**).

FIGURE 1

FIGURE 2

FIGURE 3

PURL INTO THE FRONT AND BACK (P1F&B)

Work as for k1f&b but purl into the two loops instead of knitting through them.

RAISED MAKE-ONE (M1) INCREASE

Right Slant (M1R)

Use the left needle tip to lift the horizontal strand between the two needles from back to front (**Figure 1**), then knit the lifted loop through the front to twist it (**Figure 2**).

FIGURE 1

FIGURE 2

Left Slant (M1L)

Use the left needle tip to lift the horizontal strand between the two needles from front to back (**Figure 1**), then knit the lifted loop through the back to twist it (**Figure 2**).

FIGURE 1

FIGURE 2

YARNOVER

This type of increase is formed by wrapping the yarn around the right needle tip. The way that the yarn is wrapped depends on whether it is preceded or followed by a knit or purl stitch.

Between Two Knit Stitches

Wrap the yarn from front to back over the top of the right needle (**Figure 1**).

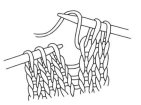

FIGURE 1

After a Knit Stitch and Before a Purl Stitch

Bring the yarn to the front under the right needle, around the top, then under the needle and to the front again (**Figure 2**).

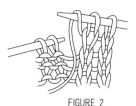

FIGURE 2

Between Two Purl Stitches

Bring the yarn from the front to the back over the top of the right needle, then around the bottom and to the front again (**Figure 3**).

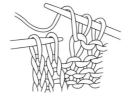

FIGURE 3

After a Purl Stitch and Before a Knit Stitch

Bring the yarn from the front to the back over the tip of the right needle (**Figure 4**).

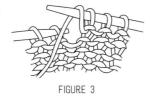

FIGURE 4

POM-POM

Cut two circles of cardboard, each ½" (1.3 cm) larger than desired finished pom-pom width. Cut a small circle out of the center and a small wedge out of the side of each circle (**Figure 1**). Tie a strand of yarn between the circles, hold circles together and wrap with yarn—the more wraps, the thicker the pom-pom. Cut between the circles and knot the tie strand tightly (**Figure 2**). Place pom-pom between two smaller cardboard circles held together with a needle and trim the edges (**Figure 3**). (This technique comes from *Nicky Epstein's Knitted Embellishments*, Interweave Press, 1999.)

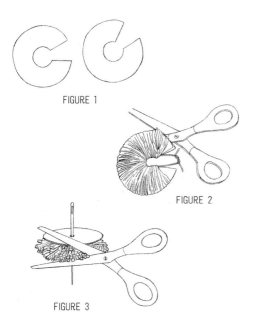

FIGURE 1

FIGURE 2

FIGURE 3

SHORT-ROWS
SHORT-ROWS KNIT SIDE

Work to turning point, slip next stitch purlwise (**Figure 1**), bring the yarn to the front, then slip the same stitch back to the left needle (**Figure 2**), turn the work around and bring the yarn into position for the next stitch—one stitch has been wrapped and the yarn is correctly positioned to work the next stitch.

When you come to a wrapped stitch on a subsequent row, hide the wrap by working it together with the wrapped stitch as follows: Insert right needle tip under the wrap (from the front if wrapped stitch is a knit stitch; from the back if wrapped stitch is a purl stitch; **Figure 3**), then into the stitch on the needle, and work the stitch and its wrap together as a single stitch.

FIGURE 1

FIGURE 2

FIGURE 3

SHORT-ROWS PURL SIDE

Work to the turning point, slip the next stitch purlwise to the right needle, bring the yarn to the back of the work (Figure 1), return the slipped stitch to the left needle, bring the yarn to the front between the needles (Figure 2), and turn the work so that the knit side is facing—one stitch has been wrapped and the yarn is correctly positioned to knit the next stitch.

To hide the wrap on a subsequent purl row, work to the wrapped stitch, use the tip of the right needle to pick up the wrap from the back, place it on the left needle (Figure 3), then purl it together with the wrapped stitch.

FIGURE 1

FIGURE 2

FIGURE 3

TWISTED STITCHES

Twisted stitches are worked through their back loops.

TWISTED KNIT (K1TBL)

Holding the yarn in back, insert the right needle tip through the back loop of the stitch on the left needle from front to back (Figure 1), wrap the yarn around the needle, and pull a loop through while slipping the stitch off the left needle (Figure 2) to twist the stitch.

FIGURE 1

FIGURE 2

TWISTED PURL (P1TBL)

Holding the yarn in front, insert the right needle tip through the back loop of the stitch on the left needle from back to front (Figure 1), wrap the yarn around the needle, and pull a loop through while slipping the stitch off the left needle (Figure 2) to twist the stitch.

FIGURE 1

FIGURE 2

SOURCES FOR YARNS

All for Love of Yarn
Etsy.com/shop/
AllForLoveOfYarn

Anzula
740 H St.
Fresno, CA 93721
anzula.com

Artyarns
70 Westmoreland Ave.
White Plains, NY 10606
artyarns.com

Baah Yarn
baahyarn.com

Brooklyn Tweed
34 Danforth St., Ste. 110
Portland, ME 04101
brooklyntweed.com

**Kelbourne Woolens/
The Fibre Company**
228 Krams Ave.
Philadelphia, PA 19127
kelbournewoolens.com

Kolláge Yarns
3591 Cahaba Beach Rd.
Birmingham, AL 35242
kollageyarns.com

**Madelinetosh Hand
Dyed Yarns**
3430 Alemeda St.
Ste. 112
Fort Worth, TX 76126
madelinetosh.com

Quince & Company
85 York St.
Portland, ME 04101
quinceandco.com

The Royale Hare
royalehare.com

Shibui Knits, LLC
1500 NW 18th, Ste. 110
Portland, OR 97209
shibuiknits.com

Sincere Sheep
sinceresheep.com

Swans Island Company
231 Atlantic Highway
(U.S. Rte 1)
Northport, ME 04849
swansislandcompany.com

SweetGeorgia Yarns Inc.
110-408 E. Kent Ave. S.
Vancouver, BC
Canada V5X 2X7
sweetgeogiayarns.com

**Tahki Stacy Charles,
Inc./Filatura di Crosa**
649 Morgan Ave., Ste. 2F
Brooklyn, NY 11222
tahkistacycharles.com

**Westminster Fibers/
Rowan**
165 Ledge St.
Nashua, NH 03060
westminsterfibers.com

Windy Valley Muskox
windyvalleymuskox.net

Zen Yarn Garden
zenyarngarden.com

INDEX